CN00801298

DESIGNIN
AND PAINTING
MURALS

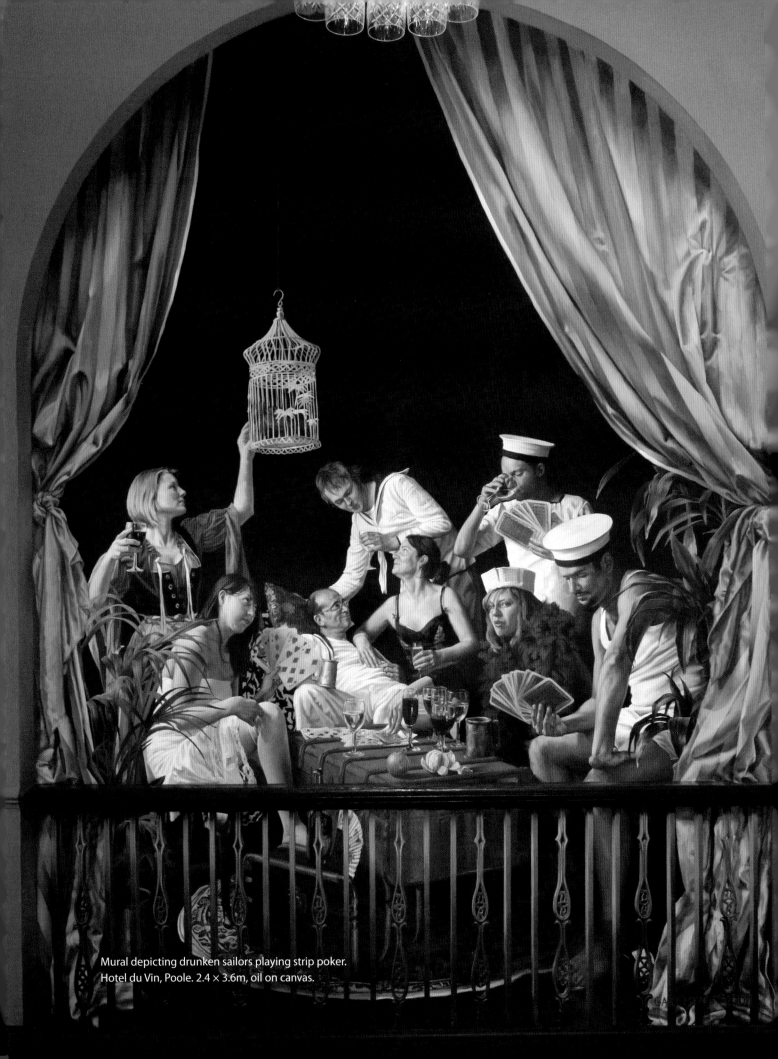

Mural depicting drunken sailors playing strip poker.
Hotel du Vin, Poole. 2.4 × 3.6m, oil on canvas.

DESIGNING AND PAINTING MURALS

To Jas
Love & Best wishes
G. Myatt x

GARY MYATT

CROWOOD

First published in 2019 by
The Crowood Press Ltd
Ramsbury, Marlborough
Wiltshire SN8 2HR

www.crowood.com

© Gary Myatt 2019

All rights reserved. No part of this publication
may be reproduced or transmitted in any form or
by any means, electronic or mechanical, including
photocopy, recording, or any information storage and
retrieval system, without permission in writing from
the publishers.

British Library Cataloguing-in-Publication Data
A catalogue record for this book is available from the
British Library.

ISBN 978 1 78500 573 2

Dedication

This book is dedicated to Amanda Bradshaw, without
whose unflagging support a lot of the work documented
in this book would not have happened.

Graphic design and typesetting by Peggy & Co. Design Inc.
Printed and bound in India by Replika Press Pvt Ltd

Contents

Acknowledgements

I really appreciate all the help I've had over the years in making happen the many commissions I have produced, and I cannot let this opportunity pass without saying thank you to all the artists who have put in much of their time, produced excellent work, and put up with my demands, including: Amanda Bradshaw, Mel Holmes, Melinda Matyas, Sydna Younson, Kelly Anne Davitt, Rebecca Parkin, Lorna Roughneen, John MacGoldrick, Kathy Barker, Desmond Mac Mahon, Aylin Myumyunova, Nick Boulter, Noel Kelly, and Katia Potapova.

I would also like to express my gratitude to those who have commissioned these works, helped collate the references to be used in this book, and offered consultation in producing it. Thank you to Sir Peter Michael, Robin and Judy Hutson, Robert Cook, Martin Brudnizki, Jonathan Brook and all at Martin Brudnizki Design Studios, Lilly Newell, Zoe Haldane, Claire Beaumont and all at Annabel's, Anne Sajeev, Santhosh Idicheria and all at Fragrant Nature, Ray Begley, Jonathan Livesey, Michael Benster, and all at Hotel du Vin/Malmaison, Danny Boggi at Marchio Design and Photography, John Biggins at Aerta Design, Anthony Misquitta, Maria Hipwell, Ravi and Anindita Gupta, Kevin and Olga Muscat, Tess Townsend, Vanessa Pethybridge, Julien Adams, Lisa Crewe Read, Claudia Dorrell, Mike Foster, Simon Herrema, Steven Spurrier, George Taber, Nige Young and Lorraine Clarke from Euroart Studios, Jonathan Coulthard, Matte Hulme, and last but certainly not least, Angelica Fernando.

Apologies to anyone I may have inadvertently omitted.

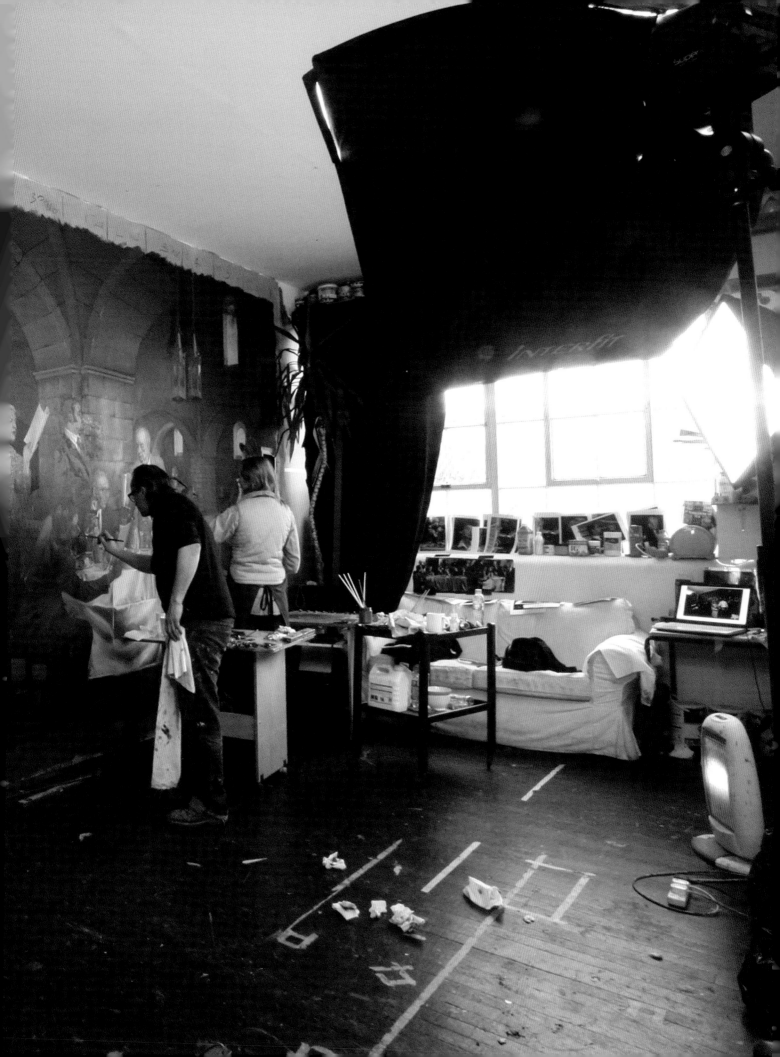

Digitally manipulated presentation image for *Misty Morning on the Thames* mural.

Introduction

Throughout the many years I have worked as a mural artist I have learned, discovered, struggled to work out, and been fortunate enough to have passed on to me by those with more experience, a lot of tricks, tips and information that has helped me greatly improve my own practice as an artist. What I have set out to do here is impart to you as much of this as I can within the confines of one book.

The book is divided into eight chapters, each of which is dedicated to a specific theme. The book begins by discussing the fundamentals of art practice and picture making, and continues to develop progressively, looking at more complex ideas and examples with each subsequent chapter.

I have demonstrated many of the methods and techniques with a series of step-by-step illustrations that will hopefully give clear advice to help you along the way. Equally instructive are the details regarding how best to approach certain subjects and problems, and the thought processes behind these approaches. As such the book deals as much with the 'whys' of designing and painting murals as with the 'hows' – information, when combined, I consider to be of great value to an artist making mural work.

Read the book; follow the illustrations; learn about the pros and cons; the dos and don'ts; and the general good guidance given, and see the big improvements in the quality of your own mural work as a result.

Materials and equipment

Knowing what brushes, colours and medium to use is nothing but beneficial to making good work. (Photo: Danny Boggi)

Materials and equipment

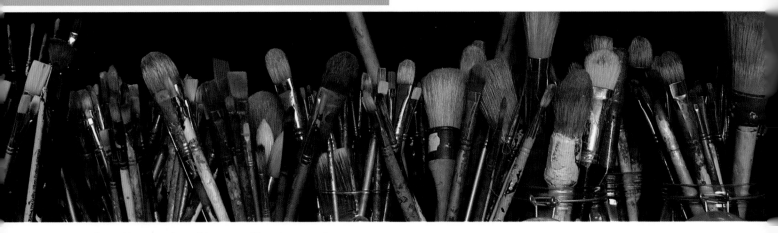

In making murals a wide range of brushes are often used, including synthetic and natural bristles.

Painting murals is an engaging business. Working on such a large scale can be quite stimulating; holding the promise of excitement and challenge. It can also be quite demanding. Planning a mural to be painted within a given time and budget is complex work, but the challenge of that is part of the fun. As is the opportunity for gestural mark-making with big brushes on large surface areas. Much time and effort goes into making a mural and if you take into consideration the time spent on research and design, as well as the painting and installation, you would ordinarily expect the whole operation to take several weeks at least, more often than not several months. All that hard work, however, can be very rewarding. If you know how to tackle each stage of the process that will obviously help reduce the challenge, which in turn will increase the reward. Put simply, if you are thinking of making murals – regardless of the size of the project you have in mind, what your subject matter may be or how long you wish to spend on producing it – knowing as much about the process as possible can be nothing but beneficial.

With that in mind, and before discussing the part where we start throwing paint around, I think the most constructive approach to beginning this book is to examine a few fundamentals that are key to making a painting. As such, primary concerns including materials and equipment, basic colour theory, and rudiments of composition and perspective are topics that will all be covered in the first chapters. Whilst it is only to be expected that these topics may not necessarily be applicable for all tastes and purposes, the suggestions made are generally considered to be sound, tried-and-tested methods that will get you started and help you make murals that will not only look good for many years to come, but will also stand the test of time in the physical sense too.

BRUSHES

When it comes to building up a reliable kit for making your mural work, and deciding which brushes to opt for, you will soon realize that there are many from which to choose. As a mural artist your brushes are the most important tools of your trade and taking your time to choose wisely is only to be encouraged.

If you are genuinely considering taking up painting professionally, or even semi-professionally, then you need to think seriously about the amount of money you are prepared to invest in the materials and equipment you will be using. You don't have to buy the finest or the most expensive items on the market, but if you want the best from your artwork then buy the best materials and equipment that your money can buy. There are a lot of cheap products available these days and it stands to reason that many people will find their relative inexpensiveness appealing. The benefit of saving a few pounds in the short term, however, is often outweighed by the subsequent inconvenience of time spent picking bristles out of your artwork, or forever having to replace your brushes after only a few uses because they have little durability.

If you shop around you will find that there are some relatively decent mid-range brushes on offer. But whatever you opt for, you should always bear in mind that this is an investment and, like any good investment, it will pay dividends in the long run. The bottom line is that good-quality brushes will obviously cost more, but if they are looked after and maintained well they will last and you will get a lot of use out of them. Poor brushes, on the other hand, can prove detrimental to good painting. The maintenance and cleaning of brushes will be addressed a little later on, but for now let us look at the different types of brushes you will need to select from.

Types of brushes

Brushes, in reference to their bristle-type, basically come in two categories: natural and synthetic. The former are made using bristles and hairs from animals such as the ox, hog, badger and squirrel, and the latter, as the name would imply, incorporate synthetic filaments such as nylon.

Some of these brushes are suitable for only one system of painting, oils or acrylics for example, whilst some can be used with both. Knowing which is which will always ensure that you will be using the best brush for the job at hand.

Hog hair, which are white-bristled brushes, are generally considered the best type of brush to use with oil colours and are not suitable for use with acrylics. Synthetic brushes are primarily designed to work with acrylics, but there are some good and relatively inexpensive nylon-bristled brushes that can be used with oils too. I occasionally use Pro Arte Sterling Acrylix with oil colours and they can be quite effective, though I find that their lifespan and versatility can be a little limited. They are good brushes for use with acrylic paints and useful for certain functions with oils, though as all-round brushes for oil colour they never quite compare with the capabilities of a good-quality hog hair. That said, I know artists who have painted many staggeringly good murals using nothing but synthetic bristle brushes, quite often producing the bulk of the work with large decorating brushes. Again it comes down to personal preference and that is why I would always advocate trying out a variety to find out which ones work best for you.

Ferrules

A ferrule is the metal sleeve that holds the bristles and attaches them to the handle. The best ferrules for fine art brushes are made of nickel-plated copper, though there are many less expensive alternatives. The ferrule tends to be crimped to the handle, which fixes it in place, and the more notches you see on the ferrule the sturdier the brush will be. On a very good-quality brush you might see three notches, though two notches seems to be the norm for many brushes I would consider adequate for the purpose of painting murals. If only one notch is apparent then it would suggest the ferrule is not secured sufficiently, and it may soon become loose and affect the handling of the paint application.

Handles

Brush handles are generally made of wood, and shaped round or flat according to the style of brush. The cheaper brushes tend to have plastic handles, or the wooden handle is left unvarnished. The better, more expensive varieties will have wooden handles that are treated with a varnish or lacquer.

A good selection of brushes for mural painting

Artists' oil brushes mainly come in three major shapes known as flats, filberts and rounds. By and large they will be of the white hog hair variety. These brushes are graded in number, with the larger numbers indicating the larger brushes, and the smaller number indicating the smaller brushes. Remember that, when you are painting murals, large areas will require rapid blocking in with broad brushstrokes, so make sure to stock up on a variety of sizes. There is nothing better than trial and error when it comes to determining which brushes suit your own methods best, but if you start off with a fair selection of medium- and large-sized flats and filberts it will put you in good stead.

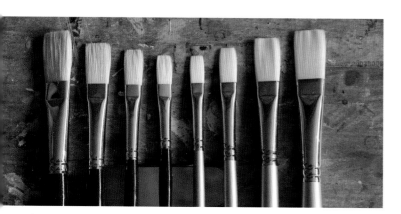

Flats – the hog hair variety (seen here on the left) are generally used with oil paints only whereas the synthetic, nylon bristles (seen on the right), are more versatile: primarily designed for acrylic paints, they can be used with oils too.

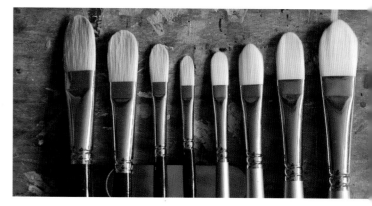

Filberts – once again we see here the hog hair variety on the left of the image, and the synthetic, nylon bristles on the right.

Spalters and varnishing brushes

Spalters and varnishing brushes are large, flat brushes, usually made from soft hog hair. These brushes can be really useful with most projects, and they come in a wide variety of widths (I tend to use Whistler or Omega varnishing brushes with 70mm, 80mm and 100mm widths). They have a relatively thin ferule for their size, but they can be loaded with a lot of colour and can cover large areas in a short space of time. I find these brushes easier to handle and more sympathetic to the kind of mark making that I like than the ordinary decorators' brushes, though the latter also have their uses.

Decorating brushes

Decorating brushes are a very useful component of any mural artist's kit, especially for blocking in those really big areas of colour like skies and landmass. These large brushes can be loaded with paint that can then be dispatched efficiently in broad strokes, and their stiffer bristles lend themselves to vigorous blending and scumbling. Decorating brushes are not overly expensive and will last if looked after, and it is always beneficial to have a broad range of sizes at your disposal. I tend to use these cheaper decorating brushes for the larger areas that are to be kept loose in their handling, and I reserve the use of the better quality fine art brushes for the more detailed areas such as fabrics, props and portraits that may accommodate the middle distance and foreground of a composition.

I always carry a selection of decorating brushes around in my kit but I'm quite selective as to when I use them, preferring more often to use the spalters and varnishing brushes mentioned earlier, though where the surface is not so smooth the stiffer bristles of the decorating brush will always prove the better choice.

Specialist brushes

In the category I refer to as 'specialist brushes' I would include fan or blending brushes, stencilling brushes, softeners and stippling brushes. As their names imply these are all brushes used for specific operations. Although I always have a selection of these brushes with me they may not be brought out of the box unless there are specialist techniques to be incorporated into the mural, such as marbling, wood-graining or stencilling.

Fitches

The round fitch is a great brush for mixing up large quantities of colour and it can also be used for scumbling glazes over pre-worked areas. Scumbling is the name given to the technique where a mixture of colour is rubbed over a surface that has previously been painted and allowed to dry, with the intention of modifying the colour or effect of the area being treated.

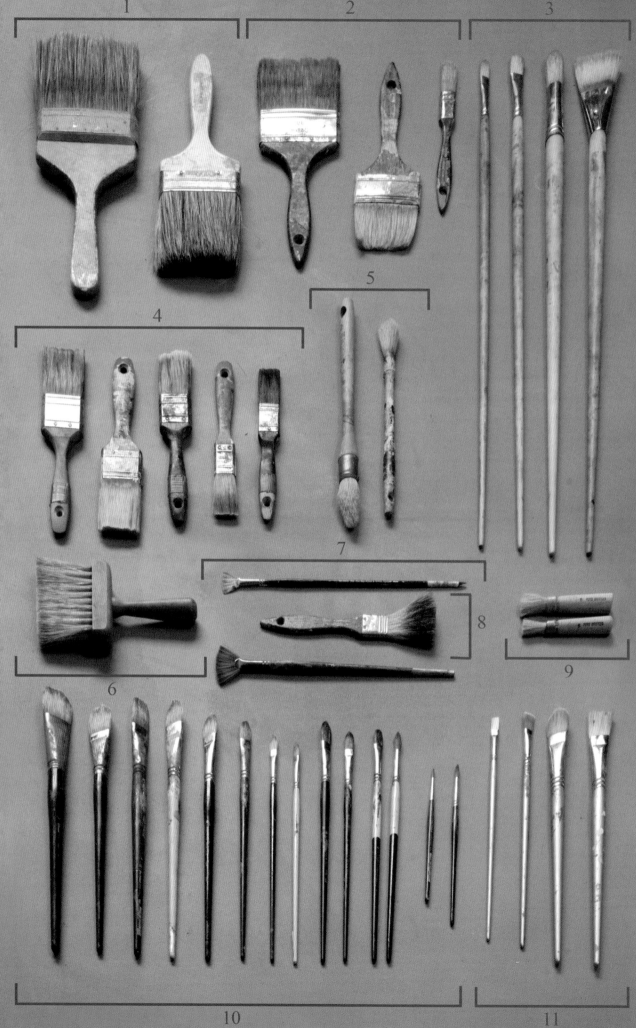

1. Large decorators' brushes – natural-bristled brushes that can be used with both oil-based and water-based paints. They come in a variety of sizes with the much larger brushes sometimes being referred to as 'wallopers'. These are ideal for laying in large areas with broad strokes of colour.

2. Varnishing brushes – natural-bristled brushes that come in a variety of sizes from 20–100mm wide. They have thin ferrules but can still hold a lot of colour. They are great for working on large areas that require sympathetic brushwork that is not easily achieved using the regular decorating brushes. They can be used with oil-based or water-based paints.

3. Long-handled brushes – natural-bristled brushes dedicated for use with oil colours only. They are ideal for working up areas from a good distance from the canvas or wall, enabling you to see more of the image whilst working, thus preventing you from being drawn in to unnecessary detail.

4. Small decorating brushes – with these smaller sizes I tend to use nylon-bristled brushes, made by Purdy or Wooster, and usually only the 25mm, 40mm and 50mm sizes. They can be quite versatile and very useful when quickly working up relatively large-detailed areas. These brushes can be used with both acrylics and oil-based paints.

5. Round fitches – natural-bristled brushes that are ideal for scumbling and applying glazes over areas of your work. They also make perfect brushes for mixing large batches of colour.

6. Dusting brush – this is just a cheap decorators' dusting brush. These have natural bristles and if kept in good condition can be very useful for brushing over large areas of wet paint to achieve softer transitions of colour and tone. They can also be used to create a stipple effect – if, however, the stipple effect is to cover a sizeable area then you would be advised to invest in a proper stippling brush.

7. Fan brush – ideal for blending and softening smaller detailed areas. Can be used with both oils and acrylics.

8. Badger bristle – these are very expensive brushes but ideal for blending and softening. For softening, these are considerably more delicate and sympathetic than the dusting brush and are essential for any marbling effects.

9. Stencilling brushes – these come in a variety of sizes and are used mainly for stencilling, though they can also come in useful for certain types of mark-making characteristic of this shape of brush.

10. A broad selection of fine art brushes – these are natural-bristled filberts, flats and rounds, dedicated only to oils.

11. Fine art brushes with synthetic bristles – these are primarily for use with acrylic paints yet I find them occasionally useful with oils too.

How to clean and look after your brushes

The best way to preserve your brushes, though admittedly it is not always possible or convenient, is to clean them thoroughly after each day's painting. Neglect this detail too often and your brushes will very quickly become unusable. When and where possible, bearing in mind the amount of money you have spent on these important features of your kit, try to leave enough time at the end of each painting session to clean your brushes.

Using the appropriate solvent (turpentine or white spirit for oils, and water for acrylic), rinse out your brushes immediately after use.

Rinse out the brushes several times in a clearer solution each time, cleaning off with a rag in-between each rinse, to make sure that all traces of colour are removed from the brush. The brushes can then be washed through with warm water and a little soap. I tend to use washing-up liquid for this, though the old-school approach would recommend using a bar of common household soap, preferably containing plenty of lye. Lye is a strong alkaline solution (traditionally potassium hydroxide, though sodium hydroxide is more commonly used these days), which is excellent for breaking down the oil paint.

With one hand cupped, deposit a small amount of soap into the palm as in step 1.

Adding warm water, work the brush into your hand using a swirling action, as seen in step 2, making sure that the warm, soapy water gets to the base of the bristles as well as the tip.

Finally, as seen in step 3, wash out the brush taking the time to ensure that all traces of the soap are rinsed out under the running warm water.

After removing any excess water, by either flicking the brushes or wiping with a rag, you can reshape the bristles using a pinch of Vaseline between finger and thumb, and tease the bristles of the brush back to the original form.

Being environmentally aware

Try and be environmentally friendly when using turpentine or white spirit. Recycle by filling up a large, lidded container with your used and contaminated thinner. Once full, let it sit there for several weeks until all the pigment has settled on the bottom of the container. At this point, and whilst being careful not to disturb the settled residue, the recycled thinner can be poured off into a clean container and reused.

Note: the solvent will be slightly discoloured but it is perfectly reuseable. The sludge at the bottom of the container can be poured into another container used for the sole purpose of collecting such sludge and, when that is full, it can be disposed of in the correct manner via the relevant refuse site in your neighbourhood. If you are not sure of the locality of such a site, contact your local council and enquire about hazardous waste disposal.

Reshaping with Vaseline is only suitable for brushes that are being used with oils, and prior to using these brushes again you will need to rinse them in the appropriate solvent before wiping with a rag to ensure that all the grease has been removed.

For brushes used with acrylics, the cleaning process is carried out using only warm water and soap. The reshaping can be done using a small amount of shampoo or washing-up liquid. If need be, the larger brushes can also be wrapped in paper to retain their shape (as shown in step 4).

When it comes to storing brushes that are still wet from cleaning, it is not advisable to have them standing upended and left to dry. Any moisture that is still in the bristles will work its way through the ferrule and into the wooden handle, causing the wood to swell and the lacquer to crack. This, in time, will compromise the security of the ferule's attachment to the handle. Always lay your newly cleaned brushes flat on a horizontal surface. Once they are dry, you can store them upright in a jar or similar container.

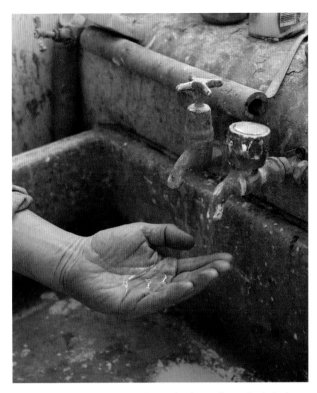

Step 1 Remove excess paint and solvent from the bristles using a rag or paper towels, and then soap (or washing-up liquid) with warm water can be used to clean your brushes.

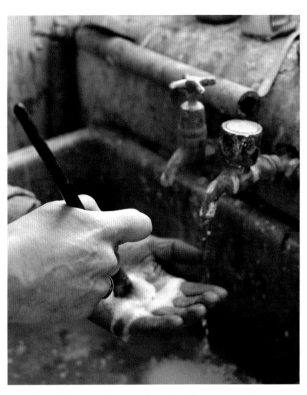

Step 2 Using a swirling motion with the soap and warm water, lather the bristles of your brush.

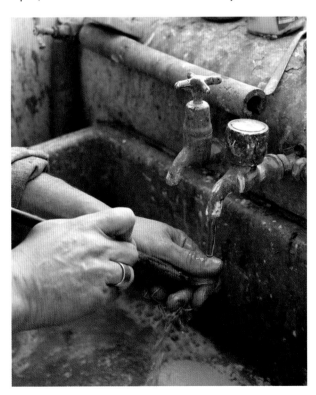

Step 3 Rinse out all the soap and paint residue from the bristles under warm running water.

Step 4 To retain the shape of larger brushes, after the cleaning process wrap them up in newspaper, store laid flat, and leave to dry.

As well as the range of colours, note the different brands and variety in the quality of the paints.

PAINT

There are many paints on the market these days, and there is so much to choose from. Each will have its own list of advantages and disadvantages, but all paints are basically composed of three elements, which are: the pigment, the binder, and the solvent.

Pigment

A pigment is the substance that gives paint its colour and can be either organic (derived from animal or vegetable origins), or inorganic (processed from mineral sources). Since the mid-nineteenth century onwards there has also been a significant increase in the production of synthetic pigments.

Getting to know about paints and pigments and their particular characteristics is a worthwhile endeavour and doing so will really help you get to grips with the versatility and limitations of each colour. Get to know as much as you can about the materials you use, and the colours you include on your palette:

How pure or impure is the colour? How many pigments are used to achieve the colour in the tube?
Artist quality colours are much purer than student quality as the colours are usually achieved from one pigment, whereas the cheaper quality paints tend to use several pigments to imitate the more expensive quality colours.

Are the pigments opaque or transparent? Which would best suit your purposes?
Transparent pigments are excellent for making glazes and pure tints, but fairly useless if used to adjust a sizeable mix of paint.

Are the pigments lightfast or fugitive? Will they retain their colour over time, or fade as a result of exposure to daylight?
Acrylics are superior paints in terms of being lightfast, meaning they will endure exposure to sunlight and/ or shade without losing their colour. Oils on the other hand can suffer from both, depending on the quality of the paint and the nature of the pigment used.

How strong is the pigment's tinting strength? Will it oversaturate mixes when added with other colours used on the palette?
Some colours can be quite overwhelming and need to be used sparingly when mixed with other colours. Cadmium Orange is a colour that springs to mind; beautiful in its own right and a very useful colour to have on a palette but it can very easily overpower any subtle mixes if not used carefully.

These characteristics will ultimately affect your painting in both its making and its longevity and are therefore quite decisive details if you want the best for your work. Most tubes and pots of paint will have these characteristics printed on the labels and it pays to familiarize yourself with the specifics.

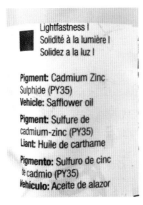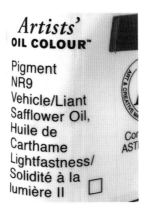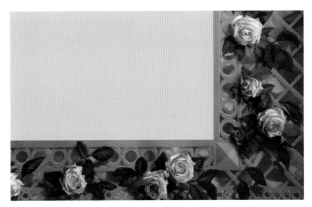

Here we see the labels of two tubes of Windsor and Newton artist quality paint. The one on the left is from a tube containing Cadmium Yellow pale, and the one on the right containing Rose Madder genuine. These labels indicate three characteristics of the pigments used: the pigment colour index name; the level of opacity or transparency; and the level of lightfastness.

The pigment index names here are PY35 and NR9, standing for Pigment Yellow 35 (cadmium zinc sulphide), and Natural Red 9 (extracted from madder root – rubia tinctorum).

The first label shows a solid square in the upper left hand corner of the label – this indicates that the colour is opaque. The second example, the Rose Madder label, shows an empty square in the lower right hand corner – that indicates that the pigment is transparent. If the square shown is half solid/half empty that indicates that the pigment is semi-transparent.

The lightfastness of a pigment is graded from I to V with the lower number indicating an excellent lightfast quality, and the higher number indicating a very poor and fugitive quality. In the examples we can see that at grade I, the Cadmium Yellow has excellent lightfastness and the Rose Madder, graded at II, has very good lightfastness. Grade III would indicate fair but perhaps not permanent, and IV would indicate poor lightfast qualities.

Binder

The binder is basically the adhesive liquid in which the pigment particles are suspended. When this liquid vehicle dries and oxidizes, it forms a film that adheres to the surface on which it is applied. The pigments used to colour paints are pretty much universal, being used in all sorts of paint, but it is the binder

This is a section from a mural painted using both acylics and oils. All the background colours and trompe l'oeil latticework were painted in acrylic paints and the roses were subsequently painted on top in oils. The lattice was stencilled and required several layers to build up the trompe l'oeil effect and the quick-drying qualities of acrylic made it the ideal medium to use. For the roses, however, I wanted them to be painted in a more fluid and painterly fashion and therefore the slower-drying qualities of the oils were more suited. It is sound practice to use oils on top of acrylics, but not the other way round. And you should never attempt to mix the two. (Detail from a mural painted for Annabel's Private Members' Club, Mayfair, London.)

that distinguishes between the different types: oils or acrylics for example. Linseed oil is the most common binder for oils, and acrylic polymer resin is the binder in acrylics. The primary characteristics of any paint are determined by how the paint is formulated, and the value of knowing the pros and cons of these individual characteristics can never be underestimated. I tend to use oils for any fine art painting and acrylics for any paint effects and trompe l'oeil. Occasionally I will use both where it is deemed the best way forward in terms of quality of finish and efficiency of procedure. When using both, you must remember that it is OK to paint oils over acrylics but never the other way round unless the oil layer is completely dry and treated to accept the acrylic. This can be achieved with Fuller's earth or an application of clear shellac, but I would recommend avoiding acrylics on top of oils if possible.

Solvent

The regulation of a paint's consistency is maintained by the use of a solvent. When added to paint to thin it further, it is referred to as a thinner. As a rule one would use turpentine, or white spirit, with oils, and water with acrylics. Paints that contain and can be thinned with the former are described as oil-based paints, with the latter being referred to as water-based.

Oil and acrylics

No matter how much personal preference you have for one particular paint system over another, it is quite often the case that the nature of the project will dictate which system you ultimately opt for:

How big is the mural?
Very large murals would usually be painted in water-based paints: either acrylics or even good-quality commercial paints, depending on the nature of the work or the expected lifespan.

How much time do you have to paint it?
The slow-drying quality of oil paints makes them impractical for certain projects.

Is it to be painted on canvas, a panel, or directly onto a wall?
Either oil or acrylic can be used on any of these surfaces, but you will need to ascertain the nature of the substrate and prime it accordingly. If in doubt, speak with the paint manufacturer to get the best advice.

Is the mural interior or exterior?
Exterior murals should always be painted in acrylics as the colours are lightfast and less susceptible than oils to the effects of sunlight or shade.

Oil paints have a much slower drying rate than acrylics, which allows for greater versatility and manipulation. They are ideal for many effects and can be used to achieve smooth blending and subtle gradations of tone. Another advantage with oils is that there is little or no change in colour between their wet and dry states. On the other hand, because they are notoriously slow drying, they can seriously impede the production time of your work as you wait for any layers to dry before working over them. Another disadvantage of using oils is that there can be a tendency for a painting to darken if in too much shade for long periods of time. If exposed to too much sunlight, the opposite is true and your painting may become bleached. It is possible, however, to reduce any potential deterioration of the painting by using good-quality materials and adopting sound methods when you paint. There are also anti-UV varnishes that are readily available which can be used to reduce damage caused by sunlight. Generally speaking though, it is for these reasons regarding lightfastness alone that oils should never be considered for exterior work.

One advantage of acrylics is that they are light-fast, meaning they will retain their colour and are not susceptible to the detrimental effects caused by ultraviolet light. They are also rapid-drying paints, and can therefore be advantageous when needing to complete some complex passages of painting, including the building up of layers, in the same session. On the downside, this same rapid-drying quality can be a hindrance when trying to achieve some of the finer blending that can be done with oils – though there are retarders that can be mixed with acrylics to slow down the drying rate. Another negative aspect of acrylics, for me, is that the colours have a tendency to dry slightly darker than their appearance when wet. This can cause problems when matching pre-painted areas.

In all I would say that my preference is to work with oils where and when I can. This is because of their slow-drying time, their flexibility, ease of

manipulation, and the wide range of varied effects that can be produced with them. That is not to say that these characteristics are unachievable with acrylics; it's just easier for me to use oils, as they are more suited to my methods of working.

Paint medium

When grinding pigments to make oil paints, linseed oil is the most commonly used to formulate the binder. Linseed oil can be used in paint mediums and glazes, which can be added to change the consistency and manipulative properties of your paint, and help the paint flow more easily. But if you are going to use linseed oil to make glazes make sure to use refined linseed oil, and not the more commercially available raw or boiled linseed oils, as these are more susceptible to yellowing.

Stand oil, which is basically heat-treated linseed oil, is quite a viscous substance, but when thinned with turpentine is very useful in glazes and paint mediums, as it is much paler in colour than other linseed oils and less likely to yellow over time.

Thinners

For oils, the two most widely used thinners are turpentine and white spirit. The former, which is a greasier spirit than the latter, is generally used to make glazes and thin down artists' oils. It also evaporates more slowly than the white spirit, meaning that it remains open longer and gives a higher sheen. The advantage of white spirit on the other hand is that it is less expensive than turpentine, making it more appealing to many mural artists. Care should be taken when using either of these products, as over-exposure to them can be hazardous. Always read the labels and follow the advice given.

Varnishes

Once you have finished a mural you will need to protect it with a coat or two of varnish. The varnish serves many purposes in that it will provide a uniform finish across the whole image, improving the overall look of your mural. It will also protect the paint from exposure to humidity, spillages, and minor contact or abrasion. Should the mural ever need cleaning, once it is varnished it can be carefully wiped clean with a soft cloth and warm water.

There are many varnishes on the market and which one you use really comes down to personal preference. For the work I make using acrylic paint I will use Polyvine varnish, which is a really nice, clean and easy-to-use varnish. On murals painted in oils I tend to finish with a microcrystalline wax varnish, made by Roberson, which is relatively easy to use and reversible (meaning that, if need be, it can easily be removed using the appropriate solvent – white spirits/mineral spirits). Another varnish that is easy to use with very good results and practically odourless is Gamvar varnish, made by Gamblin. This is also reversible, and like the Polyvine and Roberson varnishes it is available in matte, satin or gloss finish. Depending on the mural and its location, I will mix matte and satin varnishes together to achieve the desired sheen. If you are going to try this method then it is always advisable to test your mix on an independent surface first. If the mural is painted in acrylics there are many acrylic varnishes that can be used, either straight from the container or, as mentioned above, they can be mixed to a desired sheen. With regard to levels of finish your varnish will produce, it is never a good idea to have too much sheen on a mural as it will encourage light reflection and glare, which will interfere with the reading of your image.

MISCELLANEOUS EQUIPMENT

1. Spirit level – a spirit level is essential when working on murals. Any centrelines required during the initial workings out, or any horizontals or verticals in your finished work will require the use of a reliable spirit level.

2. Meter rule – a good meter rule, preferably made of steel, with clear markings will always serve you well when you are measuring or requiring a straight edge for drawing or cutting purposes.

3. Adjustable beam compass – this will occasionally be useful when you need to describe very neat circles, though in the case of having to draw out large curves, in a foreground architectural arch for example, a length of string with a pin in one end for the centre, and a pencil tied to the other end can be equally useful.

4. Tape measure – a retractable and lockable tape measure is a must. Get a good-quality one and make sure it is of adequate length – 5m should work for most scenarios.

5. Laser measure – if you can afford one, these are great; especially during initial site visits when estimating size and cost on a project. They are incredibly accurate, when used correctly, and they don't require a second person to hold the other end as with a tape measure.

6. Surgical scalpel and blades – you will use these a lot, for many purposes, and when cutting stencils they are indispensable. That said, I cannot stress enough that they should be handled with care at all times – they can be lethal!

7. Charcoal – when drawing out my murals I will ordinarily use charcoal. The charcoal sticks come in different grades – thin, medium, thick, extra thick and scene painters for example – I tend to use a variety of these depending on what aspect of the mural works best with either fine or heavy description. The charcoal leaves heavy lines and these will contaminate your paint if not treated. The trick is to slightly erase them by using a rag in a gentle flicking action. This will remove a large part of the lines, leaving an adequate residue of outline to work with. At this stage a fine spray of fixative should be applied which will stabilize the remaining charcoal and prevent it from discolouring your paint.

8. Plastering spatulas – although these are designed primarily for drywall plastering I have always referred to them as 'paint-guards'. They have a rigid metallic blade, which can be held up against the canvas or wall, and used to influence the application of paint. They are really useful when needing to produce straight lines quickly and efficiently. They can also be employed to protect or guard areas of your painting with one side of the blade, whilst manipulating wet paint on the other side. These are very handy bits of kit that come in various sizes and are available from specialist decorators' merchants.

9. Stanley knife – this is a heavy-duty, hard-wearing craft knife. Stanley knives are best kept for heavy-duty work, with the surgical scalpel being preferable for most other cutting jobs, especially stencil work.

10. 5-in-1 painters' tool – this is a versatile odd-job tool that can be used for scraping or spreading paint, opening tins and cleaning roller heads amongst many other functions.

11. Laser level – these are expensive, but many projects I've tackled would've been made very difficult without one of these. On really large projects – say, anything over 4 meters – or projects that incorporate more than one wall, and for anything that involves a complex, repeat pattern, a laser level is a huge bonus.

12. Staple gun and staples – if you intend to make your mural on canvas before installing in situ, then a staple gun is a must. Avoid buying cheap versions, they tend not to last long. Invest in a mid-range, mid-sized one made by a renowned manufacturer such as Stanley or TacWise. In my experience these suit most purposes. The big heavy-duty staplers are good but will be too aggressive for the smaller projects.

13. Palette knife – this is just a standard kind of palette knife used to mix paint and occasionally apply it too.

14. Masking tape – masking tape will always be a part of a mural artist's kit and there are different grades for different purposes: standard decorators' masking tape will perform most tasks sufficiently, but you will also need some low-tack adhesive tape when working on surfaces that require a more delicate approach. The brands I use are Easy Mask, Kleenedge, or Frog Tape.

15. Disposable paper palette – pads of tear-off, disposable paper palettes are really useful, and I use them a lot in conjunction with my glass and wooden palettes. You will occasionally require having more than one palette on the go and, whilst keeping the glass or wooden one as the primary palette, these disposable palettes make perfect supplements.

16. Scissors – good-quality dressmaking fabric scissors are a great advantage when cutting your canvas to size, for cutting up rags or for the many other situations you will come across on site or in the studio.

17. Rolls of polythene – these are of little use as a protective floor covering, where heavy-duty plastic is the preferable choice, but they are ideal for covering furniture or walls that need to be protected from any dust, paint splashes or overspray whilst you are working. They can be purchased in most decorators' merchants or general hardware stores.

18. Hairdryer – this one always raises an eyebrow, and occasionally laughter when on site, but it is a much-valued part of the apparatus, especially if working with acrylics when it is necessary to constantly clean and dry brushes. The cleaning prevents any paint, medium or varnish hardening and ruining the bristles, and the rapid drying means they can quickly be put to use again.

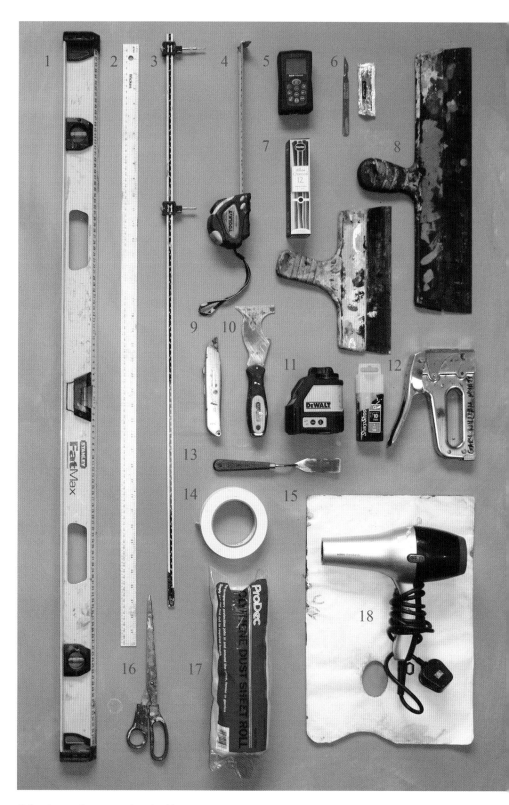

Other items that prove invaluable when making murals include cameras, overhead or digital projectors, and studio lights, all of which are discussed in subsequent chapters.

A chalk line reel or 'snap-line' is a really useful tool for marking out straight lines over long distances. These devices are very efficient and easy to use, but be careful to reduce the amount of chalk dispensed to minimize the corruption of subsequent paint applications.

Another item that is good to have in your toolbox is a chalk line reel. These are used to mark out straight lines over great distances. They are easy to use when needing to achieve lines quickly and effectively. You will find that this device is at times indispensable, especially when drawing out centre lines and parameters, or whenever you need to grid up large surface areas.

Access equipment

When working on large murals, access is obviously something that needs to be considered. The murals I make are usually never more than 3 or 4 metres in height, so I can rely on stepladders and a small, folding, mobile, lightweight, alloy scaffold tower to access the higher areas of the painting. These can be purchased easily and are obviously incredibly handy to have around if you require them regularly. That said, they take up space, even when folded, and they can cost a fair amount of money. Alternatively, ladders and platforms can be hired on a day-to-day basis from a local plant-hire company.

Canvas

The majority of my mural work is painted in my studio, on canvas, and installed on completion. This is a convenient way of working for me, as it means I can work any hours required and not be subject to any interruption. It also works out more conveniently for the client, as there is less disruption on the site. This means the production of the work takes less time, and therefore costs less. Another of the many benefits of working in this fashion is that the canvas, when installed, lines the wall in question but is not subject to any cracking that may appear owing to minor movements of the substrate. Unless otherwise stated, all the examples of my mural work in this book are painted in this way.

The canvas I use is called Polymural canvas and is made by Fredrix. This canvas is composed of a 100 per cent polyester fibre that is durable and compatible with traditional paint media like oils and acrylics. Being a synthetic fabric it does not suffer the same moisture absorption as normal canvas and therefore does not warp or shrink in the same way, meaning that your canvas, when completed, can be cut exactly to size, and installed without worrying about having to pre-empt any shrinkage or trimming. This makes it ideal for mural work. The canvas that I use also comes

When requiring access equipment for on-site work

When working on site – either painting or installing a mural, and plant is required to access any areas of your work – you will need to check in advance with the project manager, or whoever else is overseeing the onsite work, to see what specifications and regulations need to be met regarding any equipment used.

Pin your canvas loosely to the wall by fixing a staple in each corner where indicated by I, II, III, and IV. Always begin by stretching the canvas by pulling at the centre of the top edge and fixing in place with a staple (A). Then follow this same process on the opposite edge of the canvas (B). Then pull, and staple, at the centre of one of the upright edges (C) and then again on its opposite side (D). Follow this procedure with a staple fixed either side of each centre staple (E and F, followed by G and H; and then J and K; and so on and so forth), working outward from the centre to the corners, pulling and stapling as you proceed. When you near the corners of your canvas you can remove the initial staples I, II, III and IV, and stretch and staple the corners as per the rest of the canvas.

pre-primed, so there is no need for priming, and once stretched to the wall the canvas is ready to go.

It should go without saying that if you intend to work in this fashion you will obviously require a space big enough to work in, with enough wall space to accommodate your canvas.

The canvas is stapled directly onto the wall using a pair of canvas pliers and a staple gun. No stretcher bars are required – you just need to make sure that the surface of the wall behind the canvas is as smooth as possible.

Pin your canvas loosely to the wall by fixing a staple in each corner making sure it is straight and parallel to the floor/ceiling. These corner staples are only temporary to hold the canvas in place, and will be removed as it is stretched progressively tighter from the centre outwards. You should always begin stretching the canvas by pulling at the centre of the top edge and fixing in place with a staple. Then follow this same process on the opposite edge of the canvas (in this case the bottom edge). From here you then pull, and staple, at the centre of one of the upright edges, and then again on its opposite side. You will then need to follow this procedure with a staple fixed either side of each centre staple, working your way around the canvas, always moving from one side followed by its opposite and so on and so forth, working outward from the centre to the corners, pulling and stapling as you proceed. When you near the corners, you can remove the initial staples and stretch the corners as per the rest of the canvas.

There may appear to be a bit of slack in the canvas at this stage but once you have applied a thin layer of your ground colour it will dry back tight, removing any slack. The ground colour is discussed in greater detail in Chapters 7 and 8.

This principle is the same no matter the size of your canvas – the only difference being that over a certain size, you'll need help doing this.

Basic colour theory

Detail of colours and mixing methods from a limited palette.

Basic colour theory

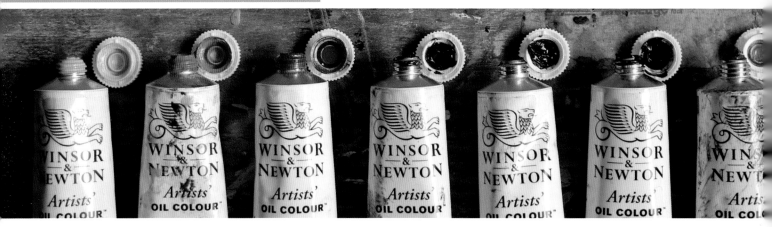

A selection of oils closely approximating the primary and secondary hues of the simplified colour wheel.

Colour theory is an incredibly complex topic, as indicated by the many volumes written on the subject and to fully comprehend it would require special study beyond the scope of this book. That said, I think it is instructive to at least consider a brief overview of the basic theoretical understandings of colour and light, and I will address the salient points in this chapter. Suggested further reading for this topic, and those covered in other chapters, is listed at the back of this book.

THE ADDITIVE SPECTRUM

As many of you will already know, Sir Isaac Newton (1643–1727) was able to separate white light into the spectrum of colours that we associate with a rainbow by refracting it through a glass prism. The separated colours were listed as red, orange, yellow, green, blue, indigo and violet – always taught during my days at school accompanied with the mnemonic 'Richard Of York Gave Battle In Vain'. By joining the two ends of the spectrum (red and violet), Newton was able

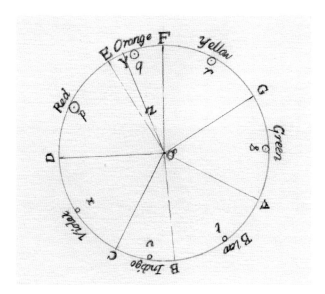

In the Newtonian colour wheel there are seven nominated colours. The simplified version used today omits the colour indigo.

to visualize this continuous gradation of colour as a circle, or colour wheel. Although he identified seven colours in his initial diagram, the subsequent tradition has been to simplify this to only six colours (leaving

out the indigo). The six colours that constitute this traditional spectrum are divided into two categories: three primary colours, and three secondary colours. In principle the primary colours are the basic colours that cannot be achieved through the mixing of any other colours, and from which we can mix all other colours. When we mix two primary colours together we produce what is known as a secondary colour. For example, mixing red with blue will give us violet – the first two being primary colours and the resultant admixture being a secondary colour. When a third primary is added this gives us what is known as a tertiary colour.

In Newton's system we are dealing with the attributes of pure light and how it behaves according to the laws of physics. The three primary colours when referring to the spectrum of light are red, green and blue. This is the same RGB system you will see within the settings menu for your TV or computer screen, where the colours of any given image are made visible from combinations of red, green and blue light waves.

If we were to mix the red and the green light of the aforementioned light primaries we would achieve a secondary colour of the light spectrum, which in this instance would give us yellow. The green with the blue would produce cyan; the blue with the red would yield magenta. When we mix all these primary colours together, providing that they are of the correct wavelength and added in equal measure, the combination will produce white light. This is known as the '*additive* spectrum', because in the mixing process, each new colour added brings with it more light.

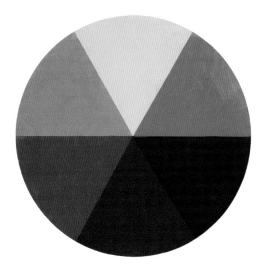

This is a simplified version of the Newtonian colour wheel that serves as a convenient way of conveying theories about colour and light.

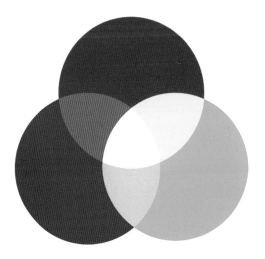

The RGB colour spectrum shown here illustrates the three primary colours of light (red, green and blue), and how, when mixed, they produce yellow, cyan and magenta.

THE SUBTRACTIVE SPECTRUM

The additive spectrum deals with the attributes of pure light. When we perceive objects in light, however, or when we mix pigments to match perceived colours, we are faced with a different set of physical laws.

Light is an essential component of colour perception. We become aware of objects when light falls upon them, and their colour is perceived as a result of how each object behaves in light: some light waves are absorbed by the object, and some light waves are reflected back at us. Something that is vermillion for example, a warm red-orange, would absorb all the blue wavelengths and some of the green, leaving all the red light waves and some of the green to be reflected back. It was explained earlier how green and red, when mixed in the additive spectrum of light, produces yellow, and it is this partial green addition to the reflected red light waves that will give, in this instance, the orangey quality of vermillion. An object that appears white absorbs little or no light, with all the light waves reflecting back at us. Something that appears black absorbs most of the light and reflects little back. When an object is perceived as being grey it is because equal parts of every wavelength are being absorbed and reflected.

Any colours we mix using pigments will behave like objects in light, in that they absorb and reflect light waves. This is known as the 'subtractive spectrum' because in the mixing process, with each new colour added, more light waves are absorbed and less reflected back at us.

In printing, a system is used known as the CMYK colour system. This is a subtractive spectrum, with the primary colours being cyan, magenta and yellow. The secondary colours in this system are red, green and blue. You may well have seen the CMYK abbreviations in the settings menu of your computer's printer. The CMY refers to the primary colours used in this colour mixing system (cyan, magenta and yellow). The K refers to the black.

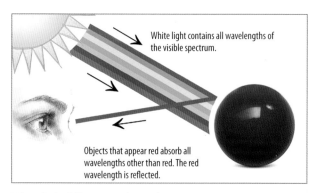

When light falls on an object that appears to us as red, the object is absorbing all the light waves except red. The object reflects the red light waves enabling us to perceive it as that particular colour.

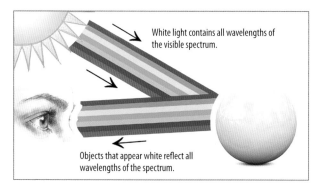

An object that appears to us as white absorbs no light waves and reflects them all. As described in the text, when all light waves are mixed together they produce white, and it is this mix of the reflected light waves that creates the perception of an object appearing white.

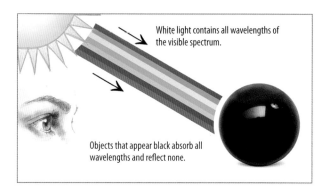

With an object that appears to us as black all the light waves are absorbed by the object. No light waves are reflected back, and it is this total absence of colour that creates the perception of an object appearing black.

You may have already noticed how the primary colours of the CMYK subtractive spectrum are equal to the secondary colours of the additive spectrum of light, and vice versa. When we blend two of the subtractive spectrum primaries together, therefore, we get red, green or blue, which are the primaries of the additive spectrum. When mixing all of these primary colours together using the cyan, magenta and yellow pigments in equal measure it will produce black. This is because of the subtractive nature of the mixing process as mentioned above – with each new colour added more light waves are absorbed and less are reflected.

So you can see that in the additive RGB model, white is achieved when mixing all the colours together. This is because each time a colour is introduced you are adding more light, and the combination of all the light waves produces white light. It follows that, in the same system, the complete absence of light will give us black. In the CMY system however, the opposite happens and the complete absence of any colour will yield white, in other words the white of the printing paper – note that there is never a white ink cartridge included in the set of inks that come with your printer. (The pigments used in the CMYK printing process are transparent, which enables such a wide range of colours to be produced and allows the white of the paper to be instrumental within the spectrum.) Theoretically, the mixing together of all these CMY primaries in equal measure will produce black, but in the printing process the primaries are not quite pure and, combined, they will only engender a muddy brown. This is why a fourth colour, black (K), is introduced to the printing process, helping to give good contrast and create acceptable deep blacks, and as such it is referred to as the 'key', hence the 'K' in CMYK process.

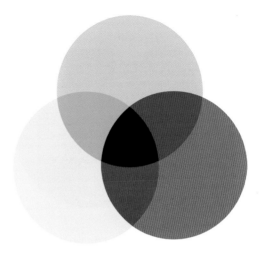

The CMYK spectrum is used in printing processes. Here you can see how the three primary colours are cyan, magenta and yellow. The secondary colours produced by mixing the primaries are red, green and blue. The primaries in this spectrum are the same as the secondaries in the RGB model and vice versa.

THE ARTISTS' SPECTRUM

As artists dealing primarily with oils and acrylics, we are more concerned with what is known as the 'artists' spectrum', which like the CMYK system is a subtractive spectrum in that it involves using pigments and not light to mix colour. In this system however, the three primaries are considered to be yellow, red and blue. From these we can mix our secondaries: yellow and red to give us orange; red and blue to produce violet; and blue and yellow to achieve green.

Given the task of selecting colours that most resemble the three primaries of the artists' spectrum, most people would opt for something along the lines of Cadmium Yellow pale, Cadmium Red medium, and Ultramarine Blue. These are just approximations and any colours that may be selected as primaries will always have their limitations because they never have the same purity as light. There will always be discrepancies when mixing other colours with them. A particular blue may be ideal for mixing a pure green, for example, yet inadequate for mixing a

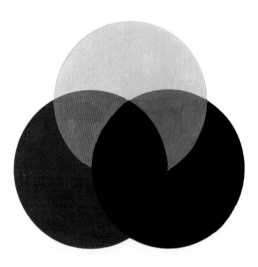

The artists' spectrum is a subtractive spectrum like the CMYK model in that the addition of more colour results in the subtraction of more of the light waves likely to be reflected. The primaries in this model are red, yellow and blue.

Artists using the additive spectrum

The French Impressionists, and Neo-Impressionists such as Georges Seurat, attempted to use the additive mixing process in their work. They did this by placing small strokes and spots of pure colour adjacent to each other in such a way that, when viewed from an adequate distance, they mix optically to create secondary and tertiary colours. This method of painting allowed the colours to retain their purity and reflect more light than would be the case when colours are physically mixed on the palette, which subsequently absorb more light as a result.

pure violet. That is because that particular blue leans more towards the blue/green side of the spectrum, and be considered a warm blue. To mix a purer violet one would require a blue that leans more towards the blue/violet side of the spectrum, which is considered a cooler version. This is why it is good practice to occasionally have supplementary colours on your palette, and to acquire an understanding of the pros and cons of warm and cool colours.

There is also a lack of consistency between brands – a particular colour by one manufacturer may be quite different from another, in spite of having the same name and being made with similar pigments.

I said earlier that, as artists, we are more concerned with the artists' spectrum and yet I still mention all the above systems. Admittedly, these systems can appear confusing, but I believe that they are interconnected and learning about them ultimately helps in our understanding of how we perceive colour and light, and how we can mix and use colour to translate our perceptions onto the canvas.

COMPLEMENTARY COLOURS

Any two colours positioned diametrically on the colour wheel are known as complementary colours, with the most obvious pairings being yellow/violet, red/green, and blue/orange.

Notice how the primary colour within each pairing is complemented by a secondary that consists of a combination of the two other primaries. (For example, the pairing of yellow and violet – yellow, the primary, has a complementary in the colour violet which is formed by mixing the remaining two primary colours of the artists' spectrum; in this instance, red and blue.) In this sense the term 'complementary' is to be understood as completing, in that the bringing together of a primary and a secondary completes the trio of the primaries of the colour wheel.

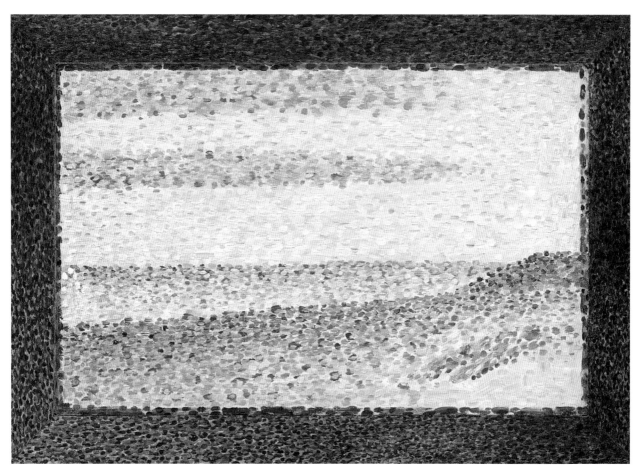

George Seurat – *Seascape* (Gravelines), 1890. Note how George Seurat has here applied small dabs, spots and strokes of pure colour in ways that are intended to mix optically when viewed from an adequate distance. This optical mixing produces tertiary colours in a way that is more akin to the additive spectrum in that the colours do not absorb light in the same way when pigments are physically mixed together. (Image courtesy of the National Gallery of Art, Washington)

Complementary colours can be useful in several ways: used in close proximity they will enhance the attributes of one against the other, because one colour will absorb all the portions of light that are reflected by the other, and vice versa; and, obversely, when mixed together they will subdue each other, eventually cancelling each other out to produce a grey hue of no identity. Don't underestimate how effectively this simple knowledge can be put to use.

HUE, VALUE AND CHROMA

Colours are described as having three main attributes: hue, value and chroma. When learning to understand colour, how we perceive it, and how we translate it on our palette, we should think about it in terms of these characteristics.

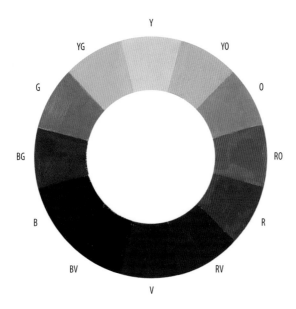

The twelve outer hues of the colour wheel. This simplified version of the colour wheel is a convenient aid to learning about and identifying colours, using the main hues comprising primary, secondary, and tertiary colours.

Hue

The first term, hue, refers to the basic colour. For ease of reference we can learn and use these names in accordance with the colour wheel in the diagram illustrated, which includes the primary, secondary, and major tertiary colours. We can therefore simplify the names of colours to the twelve seen here: yellow (Y), yellow orange (YO), orange (O), red orange (RO), red (R), red violet (RV), violet (V), blue violet (BV), blue (B), blue green (BG), green (G), and yellow green (YG).

Value

The value refers to how light or dark a colour is. We can easily assess a colour's value by making a grey scale gauge which we can hold up in comparison with whatever colour we are to match. To make a grey scale gauge you will need a strip of paper or card, divided into seven equal segments of about 30mm × 40mm. The top segment needs to be painted white, and the bottom segment painted black. The squares that are positioned between these two squares are painted in smooth tonal gradations, shifting from white to black. This will give you a gauge against which colour values can be assessed (level 2 or level 3 for example).

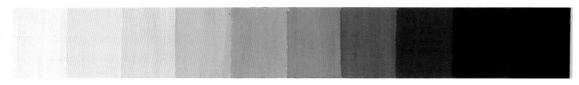

A value scale can be used to gauge the strength of tone within your drawing or painting.

Other scales that will prove useful when learning to mix colours are tints, shades and chroma scales – tints are usually made by adding amounts of white to a colour; shades are darkened variations of a colour. In the illustration I have mixed red with black to produce my shades but it is also possible to mix shades using colours other than black. Mixing complementary colours will produce interesting greys and subdue the chroma or intensity of either colour. These scales will help you attune your coordination between seeing and mixing colour.

Chroma

The chroma of a colour refers to the colour's intensity. The intensity of a colour can be reduced by the addition of its complementary colour.

Tints and shades

A colour that is darkened is known as a shade of the original colour, and a colour that is lightened, usually with white, is said to be a tint.

Make time to play around with colour combinations: mixing permutations of primaries and secondaries; mixing with cool colours; and mixing with warm. Start with a pure colour and mix it down with increasing quantities of its complementary colour and notice how this mutes the intensity of the original colour. The more of the complementary you add, the more muted the colour becomes, until a neutral grey is achieved. Really push these colour-mixing exercises and get to know your colours. You will not only discover some beautiful and sensitive mixes but you will also begin to think about colour in a more useful and pragmatic way.

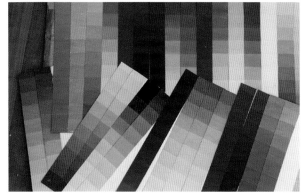

It's not essential to go to such lengths as mixing as many colour scales imaginable but it's good to get to know the colours you're working with, and putting them through their paces will prove rewarding.

A glass palette is ideal for mixing colours, as it provides a hard-wearing surface, with no porosity, and is easy to clean. (Photo: Danny Boggi)

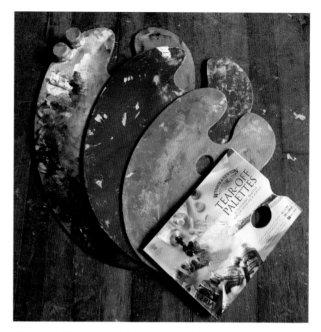

When working on murals it is often the case that you need to work from several palettes at the same time. This is when these small, hand-held and disposable palettes will prove to be a great asset to your kit.

PALETTES

A palette can refer to both the surface on which you choose to mix your colours and the selection of colours you use on it.

When working in my studio I tend to use a glass palette that I was able to construct easily, using an A1 sheet of 6mm glass purchased from a local glazier's shop, cut to size, and ground to eliminate any hazardous sharp edges. The glass is placed on an A1 drawing board and secured to a mobile home-office computer trolley, using clamps or screws to fix it into place. Sandwiched between the A1 board and the glass is a sheet of paper, which can be left white or coloured to match the ground colour of the canvas being worked on. This enables me to get a fairly accurate reading of how the colour mixed on my palette will read when applied to the canvas. Whilst not exactly a top-grade

taboret, this is a really quick and inexpensive way of making an excellent and efficient mobile workstation that is ideal for storing brushes and paints and various other items needed close at hand when painting.

Because the trolley is set on castors it makes the whole palette ensemble easy to move around the studio, quickly and efficiently, which is really useful when working on large mural canvases. It also has wheel locks, which can be applied whenever more stability is required.

Needless to say this is not so handy when working on sections of a mural that are high up and the glass palette on the ground is not so easy to reach. When working from a ladder or scaffold tower you may need to employ a small hand-held or a disposable palette, both of which are light in weight and easy to manage in difficult situations.

Colour selection

When selecting colours for your palette, regardless of what mural you are working on, you should opt for good-quality colours to paint with. It is not always practical however to use only the best quality artists' colours, as there will rarely be the budget to justify it. Fortunately, in the larger scheme of things, this is not necessarily such a hindrance because mural paintings, which are invariably large scale, are usually best painted using a sympathetic palette with colours of relatively low intensity, making the cheaper, student quality colours quite adequate for this purpose. Using colours that are high in saturation on a mural that is several meters in height and width can result in something quite garish if you are not careful. By all means use high chroma colours, but use them sparingly as accents that will help lift the painting and not make it dazzling or appear to be screaming for attention.

Bear in mind that colours evoke mood and that warmer tones, if too vibrant or saturated, will create an intense ambience, whilst the cooler colours will often evoke tranquillity. From personal experience I have found that limiting the saturation of my colours and restricting the contrast of my palette usually contributes to more harmony and balance in a mural. When laying out an adequate palette of colours for your intended work, remember that pigment is less pure than light. There is no such thing as a perfect yellow, red or blue and you will find that, as touched on earlier, the pigments that closest represent the primary and secondary colours of the spectrum all have their limitations. You may therefore need to supplement a red that leans toward the yellow/orange, with one that leans toward the blue/violet and so on and so forth. This will, for example, enable you to mix both pure orange using the warmer red, and pure violet using the cooler red. The same obviously goes for a yellow that leans toward the red/orange and one that leans toward the blue/green, and a blue that leans toward the red/violet and one that leans toward

Student quality paints

Student quality paints are less expensive than the artist quality, and if you shop around you can find some reasonable colours for mural work. Be careful though as manufacturers are able to keep costs down when making these cheaper versions by using a mix of low-grade pigments to approximate the more expensive ones. Another trick used by manufacturers is to bulk out their paints with fillers or inert materials to achieve various properties such as tooth, hardness or softness. These tricks obviously impinge on the overall quality of the paint, but sometimes it will just dull the colour slightly, which is often no bad thing when it comes to large-scale mural work. Oftentimes, however, the paint is so heavily adulterated, being composed of several pigments to attain proximity of the original colour, as to render them useless. Shop around and experiment with different paints until you find the brand that suits you and your subject best.

the yellow/green. But be careful not to add too many different pigments to your palette just for the sake of it, and steer clear from adding too many pigments to your mix because the more pigments involved, the muddier it will become. Some of the less expensive colours such as the student-quality paints will already contain a mix of pigments to simulate the purer, more costly variants of say a Cadmium or Vermillion. In this case they will be referred to on the labels as Cadmium Red (hue), and Vermillion (hue) and so on. (Hue) in this sense refers to the colour being a simulation of the real thing, where the real thing is only available in the more expensive ranges.

Warm and cool colours – colour temperature

Usually reds, oranges and yellows are perceived as warm colours, and blues, greens and violets are considered cool. There are, however, cool reds and

there are warm yellow greens, and these can be used to influence your mixes accordingly. Knowing your cool colours from your warm colours is a fundamental that should not be overlooked. This knowledge is crucial when mixing colours and, when used with care and consideration, will be of great value when controlling the colour balance of your paintings. Wonderful effects can be created using, say, a predominantly cool palette with accents of warmth or a warm painting with cool shadows. The use of warm and cool tones working together can also greatly enhance the rendering of form within a pictorial space.

This area of study, like any other, becomes easier with practice, and the more practice you get with understanding colour temperature the more subtle and more rewarding your results will become.

Transparent and opaque pigments

Another important characteristic of a pigment is the degree of its opacity or transparency. Each has its own set of pros and cons when mixing colours. Transparent pigments, for instance, are used to great effect in glazes – when it comes to mixing glazes it should really only be the transparent, or semi-transparent, pigments that are used to achieve the greatest effects. The purity of transparent pigments means they also really come to life when adding white to mix tints. But they can be a disadvantage if you need to mix a solid colour. In these circumstances, even if the desired colour is achieved, there is always the danger that your colour will appear dramatically different once the painting is exposed to different lighting conditions, owing to the complex behaviour of light as it transmits, refracts, and reflects, depending on the transparency or opacity of the pigmented layer of paint film.

Ground colour

The ground colour is a term that refers to the base colour of any canvas or wall you intend to paint on. As mentioned above, when falling on an object, light can be absorbed, reflected, refracted and transmitted. In the case of light acting upon films of paint it will do all these things to varying degrees. This is why the choice of ground colour and any underpainting of the work is so important.

Some artists will opt for the ground colour to be as white as possible and will then proceed, superimposing darks over lights, to achieve more radiance in the colours used. The Pre-Raphaelites, for instance, would paint onto a white ground, enabling the likes of William Holman Hunt and John Everett Millais to achieve the beautiful luminosity in their colours, reminiscent of stained glass. The ground colour you use and how you proceed obviously depends entirely on your style of painting, and the results you desire. In my opinion an off-white or mid-grey ground works best for me. These are personal preferences and I would advise that you try out a variety of ground colours to see which ones best suit your subject or your methods.

Selecting a palette

There is what appears to be a limitless list of colours to choose from when preparing a palette and over time you will no doubt develop preferences for a selection, or selections, of colours to make up your palette arrangements. I use the plural here, as different projects will often require different palettes to achieve different overall colour balances. Don't restrict yourself to one set of colours.

I have listed below a selection of three different palette arrangements as examples that I have found to be useful for various occasions.

The top illustration shows a basic palette. This is a versatile palette comprised of low-chroma colours, which are ideal for most mural purposes.

The bottom illustration shows a more comprehensive palette that contains some high-chroma artist quality colours, and lower-chroma student colours. Because some of the low-chroma variants are described as 'student' colours doesn't mean that they are only suitable for student work – the colours that are lower in intensity are often more suited for large mural work. Artist quality pigments can be used when painting murals too, of course, but you would be well advised to avoid the use of too many dazzling colours, and to avoid a large materials' bill that is hardly covered by the budget.

Basic palette

- Titanium White
- Lemon Yellow
- Cadmium Yellow (hue) deep
- Yellow Ochre
- Vermillion (hue)
- Alizarin Crimson
- Burnt Sienna
- Raw Umber
- French Ultramarine
- Oxide of Chromium
- Ivory Black

The first of these is an inexpensive palette that is made up of mainly student quality paints and, although this makes use of a selection of low chroma pigments, it will nonetheless give you a broad range of colours to work with. This low intensity palette will also rein in any newcomers from going overboard with bright, high chroma colours, whilst at the same time introducing the more subtle nuances of colour mixing. This is by no means to be considered as a beginner's palette though, as any range of pigments can be put to good use depending on the experience of the artist mixing the colours. It is, however, beneficial for someone relatively new to painting to start off with fewer pigments and become familiar with the characteristics and mixing qualities of each.

This palette is fairly reliable and can be used to create harmonious compositions but can always be enhanced by adding one or more of the high chroma pigments from the following example.

A comprehensive palette

- Flake White
- Cadmium Yellow pale
- Cadmium Yellow
- Yellow Ochre
- Cadmium Orange
- Cadmium Red
- Rose Madder
- French Ultramarine
- Cobalt Blue
- Cerulean Blue
- Terre Verte
- Ivory Black

A limited or restricted palette, as seen here, will have some of you pleasantly surprised by the range of colours that can be achieved from such a minimal selection.

The second palette given here is comprised of both student and artist quality pigments and will serve you well in a wide variety of circumstances, though some of the colours are very expensive and should therefore be used sparingly, or even substituted with less expensive variants that have not been overly adulterated. It is not impermissible to use paints of lesser quality than the top range, it is just strongly advised that you shop around and be careful not to just settle for any old substitute. There are some relatively good paints out there in the middling price-range but there are some very poor paints out there too.

Limited Palette
- Titanium White
- Cadmium Yellow pale
- Cadmium Orange
- Rose Madder
- French Ultramarine
- Ivory Black

It is not only possible to obtain a satisfactory range of colours from a very limited palette, but this restricted approach will help create harmonious compositions too. This particular palette has become a personal favourite of mine, and has been used on several of my more recent projects, one of which is discussed in the later chapter on landscapes.

Despite there being only four colours, excluding the white and black, I have always been able to achieve all the colours needed for the paintings I've chosen to make with this palette. The colours selected cover the red, yellow and blue parts of the spectrum, with a variety of cool and warm colours (the Cadmium Yellow pale, Rose Madder and Ultramarine Blue being cool, and the Cadmium Orange providing the warmth). Whether used independently or combined with each other they cover a wide range of the spectrum.

Palette arrangements

When it comes to the placement of colours, you may wish to arrange your palette so that the colours run from light to dark, or from warm to cool, or vice versa. There is no set rule for this, but it would be wise to find a layout that works well for your mixing methods and you should familiarize yourself with it to the point where you almost instinctively know where each colour is positioned. With a finely laid-out palette, and a good, clear method of mixing, your palette should look something like the illustrations shown. This method provides a whole array of colours and tones to be at your disposal at all times during the painting session. A poorly laid-out palette with unclear mixing methods will, on the other hand, cause confusion and slow the progress of your painting.

When mixing your colours on a palette it helps to have a clear system of mixing. Try to avoid having colour clusters in a haphazard and confusing scatter across your palette as this can cause frustration when locating the colour you need and it will slow down your practice.

Here again there is a clear system of colour mixing at work. In this example the palette is comprised of the inexpensive palette colours discussed in the main text; the colour mixes are variations and blends of a set of warm and cool greys. The sizable glass palette provides adequate space to mix quite freely, in large amounts. Note also that there are two sets of brushes being used – one for the warm tones and one for the cool. This helps maintain an efficient way of painting and minimizes confusion.

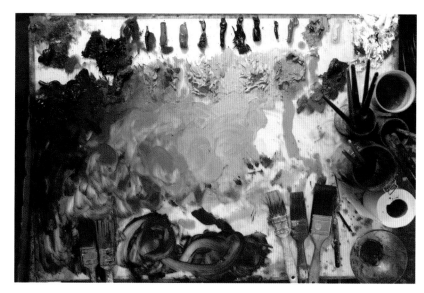

COLOURS MENTIONED IN THE ABOVE PALETTES

Whites

Titanium White
Titanium white is perhaps the most popular of the white paints, and I presume this is because of its opacity and level of whiteness.

Flake White
I prefer to use Flake White if I can get it, though this has become increasingly difficult to obtain because it is lead based and therefore has a high level of toxicity, though there are still manufacturers who make it. Flake White is an opaque, warm white with lower tinting strength than the Titanium White and is relatively quick drying. Both these qualities I find advantageous to my method of working.

Flake White hue is an adequate substitute, approximating the qualities of the original.

Yellows

Yellow Ochre
Yellow ochre is a dull, iron oxide-based earth colour that is quite a versatile addition to a palette. It is semi-transparent and moderately quick drying. Amongst its many uses I find that it can be a good colour to use when mixing flesh tones.

Cadmium Yellow pale
This is an expensive pigment but one that I think is worth every penny. It is not the fastest drying of paints but it is a bright, strong, and opaque yellow that is excellent for mixing, and comes very close to a primary yellow.

Browns

Burnt Sienna
Burnt Sienna is another iron oxide-based earth colour. It has strong tinting strength and it can be a little bit overpowering when not used carefully.

Raw Umber
This is a fast-drying earth tone that is perfect for quickly painting in a tonal underpainting as discussed in Chapter 8.

Reds

Vermillion
I tend to use a Vermillion (hue) from the Georgian range made by Daler Rowney. It is not too overpowering and it helps keep cost down. This particular colour, in this particular brand, works well for me in conjunction with other colours on my palette, though a lot of these (hue)s can be way off the mark and of such poor quality that I find them useless.

Cadmium Red
Yes, it is expensive but you shouldn't need much of this colour. The Cadmium hues, as an alternative, in my opinion just don't cut it. Some hue variants are so bulked out with adulterants that they become unusable. This is a rich, opaque colour with good covering properties, but the real cadmium is a toxic paint so please read the product safety data sheet before working with this colour.

Rose Madder
This is a beautiful colour and one that I tend to have on my palette a lot these days. Unfortunately it is incredibly expensive and not really always conducive for large mural work. It is not terribly lightfast, though if kept out of direct sunlight it will last. It is a transparent pigment and can be used very well in tints and glazes.

Alizarin Crimson

Alizarin Crimson is a cool red with bluish under-tones that is often useful to have on your palette and can, if necessary, be used as an alternative to the Rose Madder if that proves too much for the budget.

Blues

Ultramarine

Ultramarine is a very popular blue and one that is never off my palette. It has good tinting strength and is useful for making beautiful violets when used with the Rose Madder or Alizarin Crimson. As a transparent pigment, or semi-transparent depending on the brand, it is also effective when used in glazes.

Cobalt

This is a more expensive blue than the Ultramarine and one that I will use very infrequently, but it is a pure, cool blue that is always useful to have in stock. Care needs to be taken when using real Cobalt Blue pigment, as it is toxic, so please read the product safety data sheet before using.

Cerulean

This can be a useful greenish blue when used in landscapes and seascapes. It is an opaque colour with good covering power.

Greens

Oxide of Chromium

Oxide of Chromium is an opaque colour, with little tinting strength. However it has good covering power and can be put to many uses. For a green is it quite muted and a little earthy.

Terre Verte

Terre Verte is a semi-transparent pigment with very weak tinting strength, but it is a useful colour when introduced to glazes.

Blacks

Ivory Black

Ivory Black is pretty much the only black I use. It is a semi-transparent pigment that I find has a warmer feel to it than other blacks, and it suits the kind of work I make. Ivory Black can be very slow drying.

Ultimately, it is up to you how much or how little research you undertake regarding pigments and colour. Admittedly, there is a lot to learn, and it is understandable if it all seems a little overwhelming getting to know all the ins and outs of such a complex subject, but it doesn't take a long time to get an understanding of some of the fundamental elements, and even just learning the basics will bring about great benefits to your work.

Experiment with the colour palettes suggested above and any others you wish to try out. Above all, take time out to just mix colours, making all the mixtures you can from any given selection of colours. Try out the permutations and make notes. You don't have to be too obsessive about this but practice makes perfect and there is no substitute for first-hand experience. Get to know which pigments make the purest colours, and which ones don't. Familiarize yourself with hues, values and chroma. Play around with the juxtaposition of colours and explore the characteristic differences between opaque and transparent pigments. See how differently they behave when mixing solid colour and glazes, tints and shades. Don't be put off if this all sounds like dry academic study; putting colours through their paces can be an engaging pursuit, and it will be very instructional at the same time.

Composition and perspective

In this detail of a Georgian mural painted for the Hotel du Vin, Tunbridge Wells, it can be seen how the careful placement of characters and details are orchestrated so as to draw the eye in and around the composition, maintaining rhythm, balance and interest.

Composition and perspective

In this detail of a mural commissioned for Cameron House, Loch Lomond, notice the positioning, movement and gesture of the characters, and how that helps create a sense of tempo and rhythm as the eye reads from left to right and back again.

Murals can be made in all manner of ways, incorporating various disciplines including mosaic, collage, stencilling and paste-ups but, as the title of this book suggests, the focus in these pages is on the more traditional format of painting onto a two-dimensional surface. As such, two things of real importance that will need to be considered are the fundamentals of composition and perspective. If you are seriously thinking about painting murals, it is important to become acquainted with at least the nuts and bolts of these aspects of picture making.

The first determinants that will govern any composition you are commissioned to design and paint will be the size and shape of the wall on which the mural is to be painted. Size and shape will, however, not be the only factors that influence the design and, before we discuss the finer details of composition and perspective, it will be worthwhile taking a quick look at some of the other considerations that you are likely to come across during the initial planning stages of a mural project.

WHERE TO START

When painting a mural you will need to adopt a different approach to how you would go about producing an easel painting. For one, you will not have the luxury of making big changes throughout the process once you start painting. Making something on a large, wall-sized scale will demand from you a more pragmatic approach: you will need to know how the whole thing will develop from start to finish, often via the execution of a complex series of processes and applications.

No two projects will be identical. Each mural will present its own set of problems that will need to be resolved, and finding solutions to any potential complications in these early stages is by far preferable to tackling issues during the production stage. Get into the habit of formulating a basic procedure of how to approach each project and think through any potential contingencies. Whilst every mural project will differ, your initial approach should always be the same: don't take anything for granted and do as much groundwork as you can before putting pencil to paper or brush to canvas.

Architectural elevations are really useful to ascertain dimensions, and also to use as a basis for any presentation drawings. Here you can see how a transposition of an architectural elevation has been used to work out the placement of the design. Additional information for a presentation can also be added as seen here, with some visual references to indicate intended colour palettes and styles of painting.

Bearing in mind that most mural projects are commissioned, your introduction to it will, in most circumstances, be in the form of a brief supplied by the client or designer. Sometimes the brief will be quite detailed, but don't be surprised when occasionally they are terribly vague. Either way, it is your job as the mural artist to translate the brief into a workable and aesthetically pleasing composition. Listen to what the client has to say and get a good understanding of what they are requesting. Also learn to get a good idea of a client's general tastes in order that it might give guidance to your design. Obviously, as an artist, the more latitude you are given for self-expression the more appealing the project will be, but even with the most prescriptive of briefs it is important

that you engage with the subject matter and encourage your imagination to be fired.

Examining the nature of the designated environment

The first thing to allow for is the architectural space in which the mural will be situated. It is critically important, where and whenever possible, to become acquainted with the space in person. Always take the measurements yourself: measure twice to eradicate any room for error. There is no substitute for ascertaining the proportions and dimensions of the designated wall within its context. This will give you a

better understanding of how the light behaves within the space; where the optimum vantage point for viewing the mural is; and whether or not there will be anything obscuring the painting, or parts of it, once it is installed. Put simply, it pays to get as much of a feel for the space as possible. Working from second-hand information at this stage is really not advisable and has the potential for oversights, which will pose problems as you progress.

If available, ask for architectural plans and elevations to work from as they are ideal for correlating measurements. They can also be used to make copies from, onto which you can rough out some quick ideas or work up detailed drawings.

As well as determining the dimensions, whilst on site you should take the opportunity to make sketches, notes and take photographs for future reference. Think about what information there is to find out about the wall, room, building and/or location, and get into this habit of questioning; it will help establish if there is anything that might be beneficial to the mural design or may appear potentially problematic. Listed below are some of the things you should consider, as they will be instrumental to how you design and produce your mural.

Is it possible to paint the mural on a canvas (or panels) in your studio, or does it need to be painted directly onto the wall?
Painting your murals in a studio on canvas which can later be installed on completion is usually the most convenient way of working for all parties concerned – client and artist alike.

Is the building an old structure, or is it a new construction?
If painting directly onto a wall with a plaster finish you will need to ascertain whether the plaster is lime-based or gypsum, as the type of primer and paint system you choose will depend on the type of plaster used. In most modern buildings this will be gypsum, whilst a lot of older buildings will have lime plaster on the walls.

With gypsum it is advised that you use an acrylic primer (firstly applying a diluted 'mist-coat' of one part water to four parts acrylic primer, and secondly applying an undiluted coat, once the previous mist-coat has dried and cured). This will provide a suitable base to work on using either oil or acrylic. With newly constructed walls, however, there will be a tendency for the substrate to crack as the wall settles over time, and that is another good reason why it is better to paint your murals on canvas as described above, as it will act as a membrane over the substrate giving it more support and covering any hairline cracks that may appear in the plaster.

Lime plaster has a high pH level, meaning that it is alkaline, which will be detrimental to any layers of oil paint applied on top of it. In this instance, something known as 'saponification' occurs. This is a reaction caused by combinations of the lime plaster, the metallic salts used in some paint pigments and the free fatty acids of the oil-based binder of the paint. Ultimately this reaction prevents the paint film from fully curing. As a primer you would need to use something that can be applied to a high pH level surface and prevent the saponification from taking place, such as Zinsser Gardz, which is available from special decorators' merchants. A more orthodox method would be to paint the mural on canvas, either when fixed to the wall as a lining, or beforehand in a studio and installed on completion. Either way, it would still be recommended to treat the wall with a suitable primer first.

In Grade I and Grade II listed buildings where the substrate has been rendered with lime plaster, the 'breathability' of these walls may need to be maintained and it would therefore be necessary to use a different system altogether such as a silicate primer; mixing your colours using dry pigments and a breathable binder. It is strongly advised that you enquire about these aspects as much as possible at the outset of any project and, where necessary, seek professional advice.

Painting a landscape or seascape through a trompe l'oeil arch, window or door is an idea much used by mural artists. This example was painted in Cap Ferrat in the South of France. The landmass in the distance of the painted scene is Monaco, which is visible from Cap Ferrat. Including details like this adds specificity to a design.

If the building is an old construction, what is the period and style of it, and will that bear any relevance on your design?

For example, I painted a Georgian mural (as seen in the illustrations) for the Hotel du Vin in Tunbridge Wells to reflect the Georgian architecture of the hotel and the history of the town.

Is the image to be a landscape, or is it architectural? If the latter, is it exterior or interior?

If the depicted architecture is to be interior can it allude to being a continuation of the room in which the mural is to be installed? Does the mural need to be sympathetic with its surroundings, or can it stand alone as an independent work of art?

Will your mural eventually be seen privately by a select few or will it be accessible to the public? Will it be seen mainly in daylight or at night under artificial lighting and, if so, what is the colour temperature and type of bulb that will be used: tungsten, halogen, LED or daylight for example?

Lighting is measured in units of Kelvin with commercial and residential lighting falling within a range of approximately 2700k to 6400k. The lower the number, the warmer the colour will be, which works in some cases but can have the detrimental effect of casting a yellowish light over your work and altering the appearance of the colours. A bulb that is 6400k will provide a much cooler coloured light and will approximate daylight, but be careful as some bulbs at this end of the spectrum can give off an unwanted blue cast.

The difference in lighting can seriously affect the colour balance of your work so enquire and run tests, or at least try and create the work in the same lighting conditions as it will subsequently be viewed. Paintings of any kind can be seriously compromised due to bad lighting.

Does the artwork need to be framed?
Another consideration that sometimes comes up in the planning stage is framing: will the finished piece need to exist within a frame (either a real three-dimensional frame fixed to the wall, or a trompe l'oeil frame of some sort), or will the image be painted up to the edges of the wall? Can the image be treated as a vignette in the centre of the wall, with a frame to look like a standard canvas? Quite often a mural artist will paint the image's surroundings to look like a window or doorway. It can be fun to play around with illusionistic tricks like this that employ architectural detail or suchlike, and it can also be used to solve problems caused by the limitations of mathematical perspective, as will be seen in the example at the end of this chapter.

It's obvious that not all these questions will be relevant to every project you work on, but become accustomed to mulling over these potentials and it will stand you in good stead – what at first may appear to be a straightforward project can soon throw up a whole raft of potential pros and cons. Taking as many of these factors into consideration at this early stage can make a big difference to both your design and production, and will help a great deal in making the artwork really suit the space in question.

COMPOSITION

For some artists, it is a moot point whether the academic study of composition theory is necessary. The use of mathematical perspective is equally debatable. Strictly speaking, neither the study of composition nor perspective is absolutely essential but, in my opinion, when used sensibly and with good judgement, they can be incredibly powerful resources to have at your disposal. Taking the time in learning and understanding the basic principles of these disciplines can ultimately make the difference between producing a strong and dynamic piece of artwork and a run-of-the-mill painting.

It should go without saying that how a composition is put together can, and will, affect the way in which the image is subsequently read and understood by others. From the outset you should have this in mind: how do you want your mural to be viewed, and how do you ultimately want your work to be interpreted? It might be the case that your design is a creative piece of artwork in its own right. You might, on the other hand, be required to depict a strict narrative: something that needs to be clearly followed and understood. Either way, when working on a commission, you will want to think about how the finished piece will look and how it will subsequently act as a statement that is sympathetic to the client's requirements, your intentions, and the interpretations of any potential viewers of the work. In short, there is more to making a mural than at first meets the eye, and the compositional aspect should never be underestimated.

Basic elements of composition

Once the brief has been discussed and understood and the dimensions for the composition are firmly established, the next part of the process is to start planning a rough layout of the image. As with most

of the examples throughout this book, the starting point for any of your designs is best worked out in the form of a series of thumbnail sketches to get your initial ideas down. Play around with the imagery at this stage and try not to be too critical, as it will prove seriously restrictive. Remember that no one will be expecting you to come up with a masterpiece with your first doodle or sketch. The chances are that some of these initial sketches will be relatively weak – it doesn't matter. What does matter is that you start jotting down your ideas on paper regardless: you will be surprised at how many good, strong ideas force their way to the surface as you sketch. As Picasso once famously said, 'Inspiration exists, but it has to find us working!'

Once you have several thumbnail sketches and a few details, you can start to hone in on what appears to be working and what doesn't.

It is important to keep in mind a feel for the overall design when working on your initial sketches and, whilst some particular features will require inclusion, you really need to avoid being drawn into too much detail at this stage. What really helps a composition come to life is its general rhythm, its tempo, and the balanced distribution of weight – be that of light and shade, form, or colour. The dynamism and vitality of a painting will be more or less palpable depending on the placement of these elements, how they relate to each other and, ultimately, how they relate to the whole. Consider your compositional components carefully and aim to create an engaging composition that draws the eye in and around the image, controlling the flow to and from the composition's more salient aspects.

The consideration of composition doesn't mean that everything has to be evenly balanced. Deliberate imbalance can often produce interesting results, but you would be advised to avoid the danger of producing an image where all the interest is weighted at one edge of the canvas.

Thumbnail sketches

Thumbnail sketches are loose jottings down of ideas that work as a form of shorthand notation for the artist. Get into the habit of sketching and making thumbnail drawings. Even the smallest doodle will give you an idea of what works and what doesn't. When your ideas start to pull together make sure to register what it is that's making them work for you, and try to retain the freshness and flow that is often generated in these thumbnails. Many is the time a beautiful image, jotted down rapidly in a sketchbook, will lose its vitality in a subsequent finished work that ends up being an over-laboured illustration of the initial idea.

Analogue versus digital

When I say the best starting point for any mural project is the sketchbook, for sketchbook you can also read 'digital tablet'. Digital tablets are excellent devices, and can be an incredibly impressive medium for communicating your ideas to a client, whether this be a final presentation image, a slideshow of your workings, or just as a means of getting some instant information down at the first meeting. Occasionally I've used an iPad to photograph the wall in question and, using a magnetic fibre-bristled brush and stylus, been able to make some rough sketches onto the image of the wall, giving the client a very clear impression of what my initial ideas entail.

I have recently started using my iPad more to work up presentation drawings and it has to be said that they are very efficient. There are, however, many impressive and less expensive tablets and painting/drawing apps on the market to choose from. Once you get used to the general layout, and the pros and cons of the software, it is possible to achieve impressive results within a very short space of time. The app I tend to use is Procreate, which is easy to learn and very versatile. Despite the efficiency of such apps, however, I am still not a complete digital convert and I have to confess to still producing the majority of my preliminary drawings using the tried and tested age-old method of pencil and paper.

Jotting down ideas using thumbnail sketches is a great way to work, and your ideas will be noted down quickly and embody the spontaneity and freshness of your thoughts.

Not all ideas will work, but making them manifest in a thumbnail sketch is an efficient way of distinguishing which ideas hold promise from those that don't.

Your sketchbook is a place where you can do anything you like without the fear of it being judged by anyone else, so scribble away and make notes too. These will immediately recall any ideas that may otherwise get forgotten.

These sketches trace the thought processes that fed into the design for a period piece set in the Georgian era, and you can see in this sketch how *The Rake's Progress* by William Hogarth has been blatantly appropriated to help suggest an early eighteenth-century feel with bawdy overtones.

Thumbnail sketches can be used to work out the general composition, and for making notes on any specific details, but don't get bogged down with too much detail at this stage. Here you can see, starting to germinate, the idea of incorporating a little street urchin corrupting the spring waters from Tunbridge Wells with London gin.

Doodles such as these are not intended for use as reference for the painting but they nonetheless play an important part in informing how the composition evolves.

In this large drawing made for the presentation of my idea to the client, you can see how all the stronger elements of the sketches have been brought together to form a coherent composition.

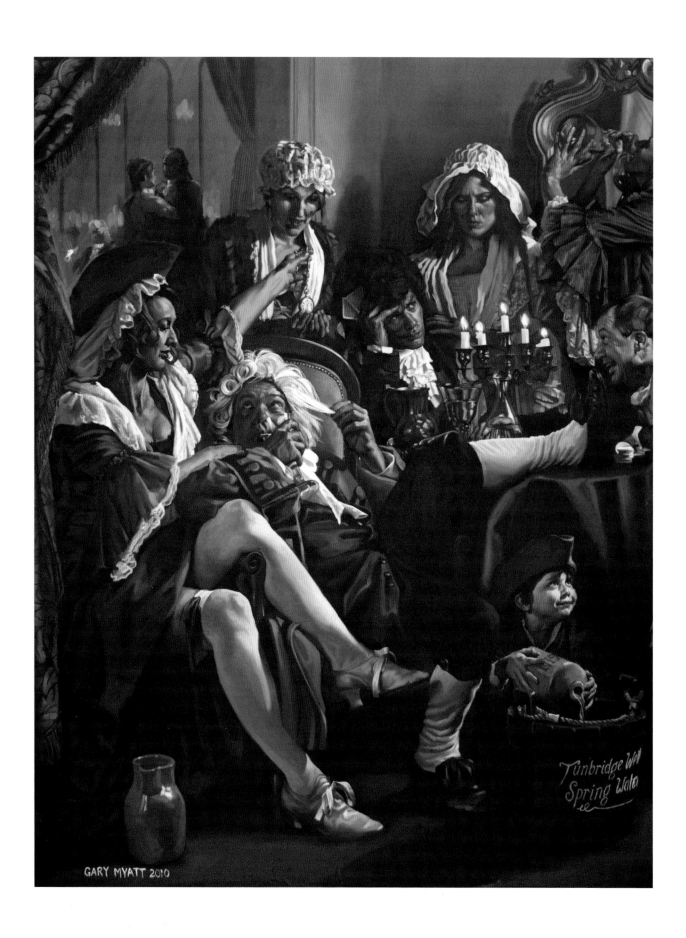

It is important to think about your compositions and how they will be viewed and understood by others. In this design all the action appears to be around the edges, with a void in the centre.

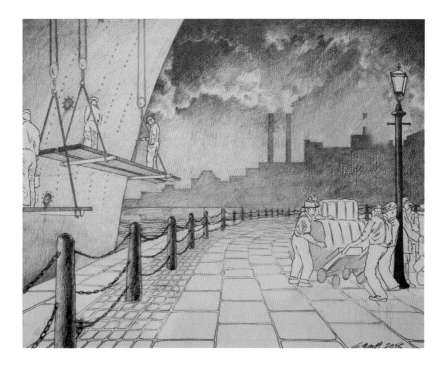

In this example the composition is much improved. The placement of the details creates more interest and leads the eye through and around the composition.

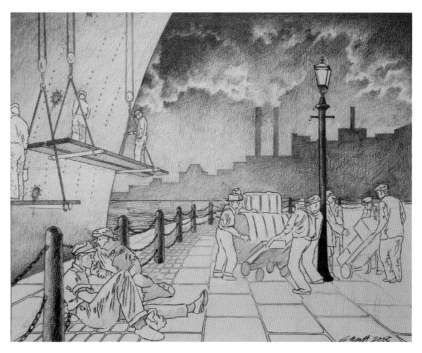

Opposite: The final painting has all the ingredients I'd worked out in the sketches: the gambling addiction; the street urchin corrupting the spring water; and the drunken aristocrat being relieved of his fob watch by the harlot cosying up to him. Note too how the stockinged legs of the female on the left-hand side of the painting lead the eye toward the lower section of the canvas and toward the urchin, appearing from under the gambling table to adulterate the health-giving Tunbridge Wells spring water with London gin, adding a light-hearted touch to the painting.

Rule of thirds

Different projects will require different approaches, and knowing a variety of methods of compositional construction is a great advantage.

A simple compositional device that is often used in painting as well as film and photography is known as the 'rule of thirds', and refers to the placement of

This drawing depicting Roger II on horseback creates a dynamic composition, largely because of the low vantage point employed. The viewpoint in your designs will colour how others interpret the image. By giving the impression that we are looking up at Roger II, this creates an impression of his magnitude and importance.

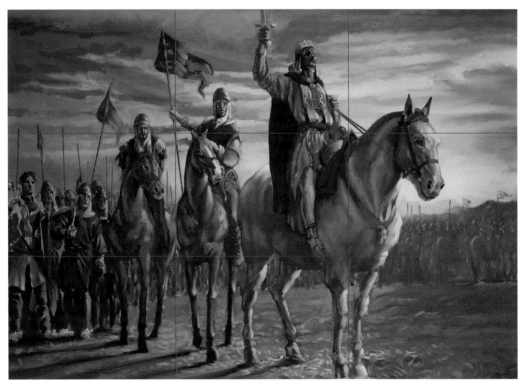

Another reason that this composition works is because it is based on the rule of thirds, where important details of the design are placed on, or near, the lines that divide the picture plane, vertically and horizontally, into thirds.

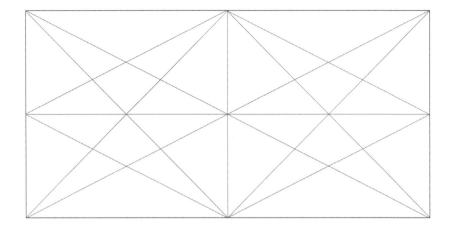

Armatures can be used to divide the picture plane, providing you with a geometrical underlying structure on which to hang your compositional design.

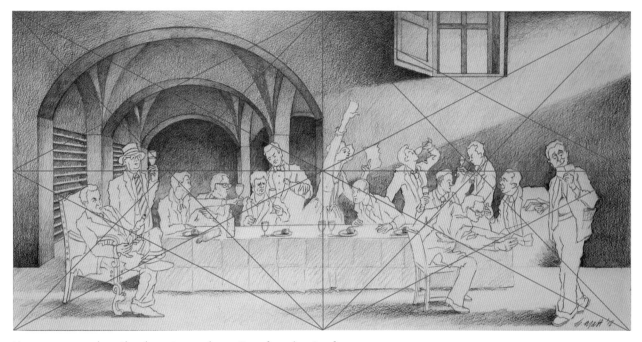

Here you can see how the characters and narrative of my drawing for *The Judgement of Paris* mural were built around the geometrical underlying structure provided by the armature of the rectangle.

dominant elements of a composition that are positioned on or near the lines that divide the pictorial plane, horizontally and vertically, in thirds. The rule of thirds is a basic arrangement, but as a starting point it is a sound and easy way of creating balanced compositions.

There are many ways of devising an underlying structure to a composition, and many more complex in design than the rule of thirds, such as the 'armature of the rectangle', 'root rectangles', and the 'golden

mean' or 'divine proportion'. These all have their roots in natural science and draw compelling similarities with mathematics and universal patterns found in music and nature.

For example, the armature of the rectangle is based on a classical belief that visual equivalents to the agreeable sound of the natural harmonics produced on stringed instruments could be achieved in art and architecture. When a picture plane is divided and subdivided by the fourteen different diagonals of the

armature of the rectangle, the long diagonals that stretch from corner to corner are divided in the exact same harmonic ratios as a musical stringed instrument: the intersections occurring at the one-quarter; one-third; half; two-thirds; and three-quarter intervals. This is the same as the perfect fourth; perfect fifth; and the octave. It was believed that the dominant aspects of a composition placed on or near one or more of these points of intersection would have the same harmonic resonance as their musical equivalent.

Throughout the history of Western art there have been many examples of artists employing harmonic ratios to divide up the pictorial space, and using this approach in your own designs can really help create a sense of balance to a composition. Personally, I think there is something quite magical and very beautiful in the way the geometry and rhythm of these underlying structures reflect a natural order, but I equally recognize the need for any artist to work to his or her own particular idiom, and that a classical slant may not appeal to all. Past masters held great store by this type of approach to compositional design but a lot of modern and contemporary artists find no use for these methods as an effective means of expression, with some artists wholeheartedly dismissing them altogether. Hans Feibusch (a modernist artist known mainly for his mural work), for instance, quite clearly stated that, *'there is nothing more deadening to an artist's feeling for colour than to work out his schemes according to some system, nor to his gift for designing than to measure out his drawing according to the Golden Mean'.*

Each to their own. There are no hard and fast rules; no 'correct' or 'incorrect' way of tackling composition as such and the methods I have discussed are merely a few possibilities – but possibilities nonetheless that are at least worthy of consideration. Look into as many approaches and techniques as you can; try to understand the methods of the artists you most admire; and cultivate the process that best suits the work you hope to make.

BASIC ELEMENTS OF PERSPECTIVE

'Downright witchcraft or coincidence' was Vincent Van Gogh's description of his understanding of perspective, written in a letter to his brother, Theo. It is an interpretation that has always stuck with me. Anyone who has ever taken an interest in making art will very early on stumble upon the subject of perspective and I imagine that most people practising art know enough about it to get by. I know artists who are fascinated by perspective and use it to full advantage, but I have also heard artists express frustration at and loathing of perspective – though it would be fair to say that this loathing is usually levelled at the study of the discipline and not at perspective itself. It can be fiendishly tricky at times, but don't let that put you off. Personally, I think it is worth persevering with and, if you intend to employ any trompe l'oeil elements into your design, I'd say that learning and understanding perspective is absolutely crucial.

The word 'perspective' derives from the Latin to examine, to look at closely, and to look through. It is used as a way of rendering solidity, distance, and spatial relationships onto a flat surface. In other words, it is a way of approximating something three-dimensional on a two-dimensional surface.

The use of perspective is not without its limitations and can throw up some real technical problems, especially when working on large-scale murals. But learning it is no waste of time. There are many ways of representing three-dimensional objects onto a two-dimensional plane, such as isometric projection, oblique projection, and anamorphic perspective to name a few, but it is really only linear perspective (single-point and two-point perspective), and aerial perspective that really needs to be considered here. Below is a list of the main features that will be useful in constructing your compositions.

Employing perspective to add emphasis

This batch of illustrations reveals a series of drawings I produced for a project in Southern Italy, depicting the court of Roger II, King of Sicily, and they illustrate how a design can be improved throughout the preparatory stage by adjusting the compositional elements and paying attention to the perspective to guide the eye and add emphasis.

This initial idea, for a mural depicting a historical narrative, works well but lacks any sense of grandeur that the subject warranted.

The second version of the design is flipped horizontally and the vantage point is pulled back to open up the field of view and create a sense of majestic splendour.

In this case I reverted to the original orientation of the design which tends to lead the eye from left to right, which is a more natural way of reading to the Western eye. It's worthwhile playing around with the orientation of your original ideas as it can sometimes throw up interesting and unforeseen aspects of the composition when viewed from another perspective.

You can see in the final composition how the central motif has been retained throughout, and all the main revisions to the design have centred on the field of view and foreground detail.

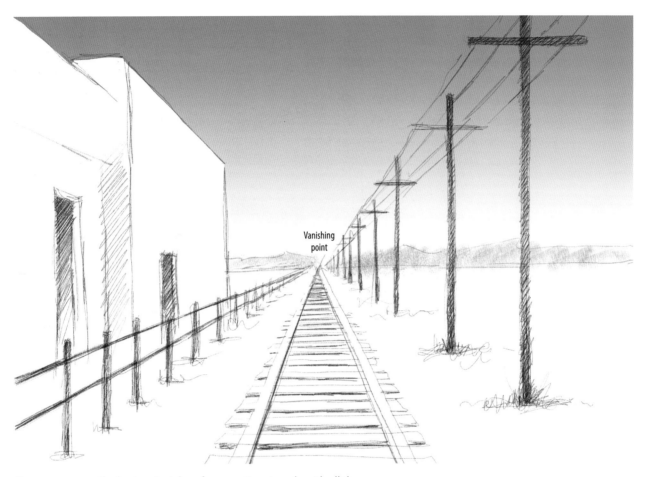

Vanishing
point

Here you can see the basic principles of perspective at work, with all the parallel lines that are perpendicular to us appearing to converge and meet at a distant point on the horizon. The point at which they meet is known as the 'vanishing point'.

Linear perspective

Diminution
When we look at a view in real life we notice that objects furthest away from us appear to be smaller than those that are nearest to us. This is known as 'diminution'.

Convergence
We also notice that parallel lines that are perpendicular to our faces appear to converge the further they recede – the classic example of this effect is when looking down the length of a rail track and seeing how the rails appear to meet at a point on the horizon. This is known as 'convergence'.

Foreshortening
A third phenomenon that we experience is that of 'foreshortening', where distances appear shorter than they actually are when viewed from various angles.

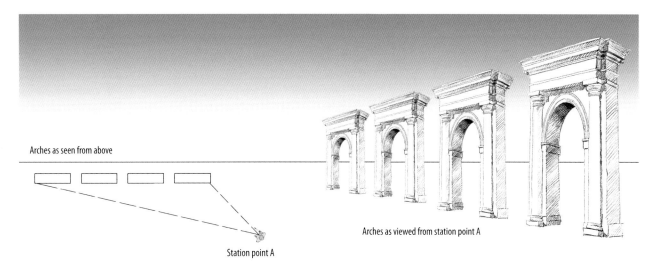

Arches as seen from above

Station point A

Arches as viewed from station point A

The angles of perspective and levels of foreshortening are wholly dependent on where you decide to position the observer's point of view, or station point. In this example, the observer is positioned near to and to the right of the arches, which therefore recede to the left.

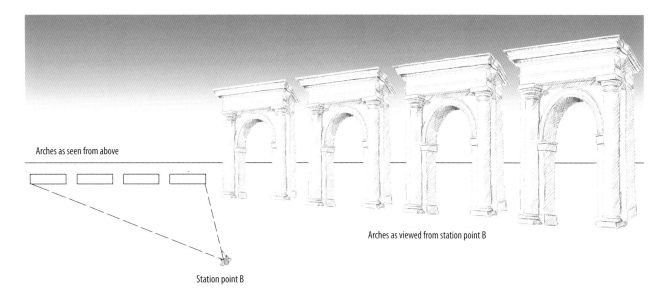

Arches as seen from above

Station point B

Arches as viewed from station point B

In this second example, the observer (or station point), is positioned further away from the arches, and slightly nearer to the centre so the arches recede to the left, but with less severity than in the previous example.

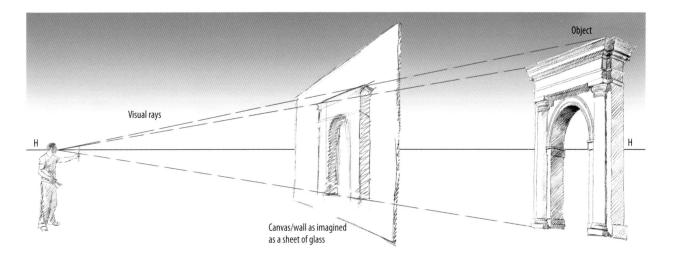

The image here illustrates how the picture plane is envisaged as a sheet of glass, with the perspective lines converging on the observer's eye. The points at which these lines 'pass' through the picture plane correlate with a close approximation of how the object is perceived in real space.

The picture plane

When working out perspective it can help to think of the picture plane as a sheet of glass, through which we perceive the object or scene that is to be depicted. The picture plane relates to both the surface area that is to be drawn/painted upon, and this imaginary, transparent plane, through which the cone of vision passes and converges on the observer's eye. If we were to trace these convergences as lines, and mark the points at which they make contact with the imaginary plane, this would correspond with their respective positions on the drawn/painted picture plane.

The horizon line

The horizon line is the line that runs parallel to the top and bottom of your canvas or wall. This may vary in height, depending on the kind of composition being designed, and depending on how the artist wishes his image to be read, but it is always on a level with the eye of the observer.

The station point

This is the point where the artist/observer is stood, or is imagined to have stood, whilst viewing or reproducing the scene in question and therefore will govern how the spectator views the image when the painting is on display.

Moving the station point closer to the picture plane will cause the perspective lines to be more severe, and if the station point is moved further away it will reduce the severity and have a tendency to flatten the image. If incorporating trompe l'oeil into your mural it is critical that you establish the optimum vantage point that the finished work should be viewed from and then calculate your perspective from the specific height and distance of that vantage point.

The line of sight

This is the line that runs from the observer's eye to where it strikes the horizon.

The principal vanishing point

This is also known as the point of sight. This is the point on the horizon directly opposite the eye of the observer. All lines running perpendicular to the front of the observer's face, and therefore parallel to the line of sight, will appear to converge upon this point like the rail tracks mentioned earlier.

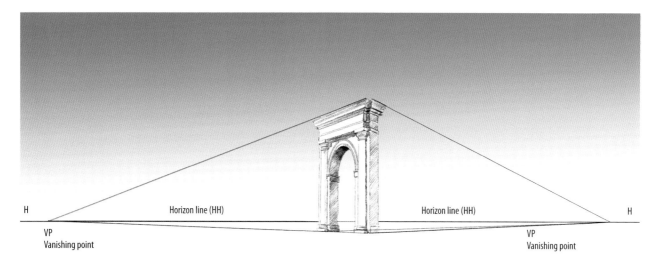

H Horizon line (HH) Horizon line (HH) H

VP
Vanishing point

VP
Vanishing point

Because the object here is not being observed face on, as in the earlier diagram of the rail tracks, there is more than one vanishing point employed. This is what is known as 'two-point perspective', with each set of parallel lines requiring its own vanishing point on the horizon.

Vanishing points

Each set of parallel lines will have a common vanishing point to which they will converge. This can become quite complex depending on the incline of the object in question, with vanishing points appearing below or above the horizon line. The examples shown here, for the sake of simplicity, describe those vanishing points that occur on the horizon line. Lines above will always run down toward the horizon, and those that are below the horizon will always run up toward it.

In the diagrams you can see an example of single-point perspective where all the parallel lines, perpendicular to the picture plane, converge at the same point. This is the point of sight mentioned earlier.

The second diagram regarding vanishing points shows an example of two-point perspective. In this example you will see that the parallel lines do not run perpendicular to the picture plane, or at right angles to the front of our face, and because of this they do not all converge at the same point. Instead, each set of parallel lines shares its own vanishing point on the horizon line: one to the left of the point of sight and one to the right of it.

As mentioned earlier, the distance of the observer, and therefore the station point, will greatly affect the severity of the perspectival angles of objects. You will

soon realize this latter point when problems occur, for example when tackling a tiled floor in your design. A tiled floor can look great and be very effective within the confines of the normal cone of vision, but as soon as you reach toward the edges of the image distortions become very apparent, and quite unsightly. The trick is to pull the station point further away from the picture plane so that the level of distortion is diminished. Unfortunately this too can pose problems: It will appear to flatten the image, as mentioned above, and it will also cause your vanishing points to be further away from the point of sight, and outside of the picture plane, making the perspective lines physically more difficult to draw. Perspective in mural work can get tricky and complex and this is why I would strongly urge anyone who is attempting anything adventurous along such lines, and especially where there is the intention of incorporating effective trompe l'oeil, to research and learn the finer points of linear perspective in more detail.

Tricks that artists have used in the past, myself included, might involve adorning the edges of the mural with heavy drapes or architectural details that sit on the picture plane. This serves to frame the image and obscure the unsightly distorted elements of the perspective at the outside edges of the image.

Conversation Piece, painted for the Hotel du Vin, Harrogate. The drapes painted in this mural serve both as a framing device for the main image and as a solution in obscuring the extremities of the tiled floor, where mathematical perspective often results in increasing distortion the further away it is from the station point.

Ultimately, mathematical perspective will only serve you up to a point, and it will at times pose great difficulties. Don't be surprised if you occasionally find the need to add to your knowledge of geometric perspective a fair amount of creativity and artistic license.

I can't stress enough here that this is an incredibly basic description of how perspective works, but it should be enough to help you with most of your needs when working out the rudimentary aspects of your design.

Aerial perspective

Aerial perspective is the term given to describe the effects of distance on observable objects. Atmosphere asserts its influence on objects positioned between the eye and the horizon and the greater the distance and atmosphere, the greater the effect. When looking at a view we notice that what appears bright and sharply in focus up close appears less focused, paler, and less saturated in colour as the distance between one's self and the objects increases. When painting you can accentuate this effect by adjusting your colours as you move from foreground to middle distance and from

Distant objects are made to look further away from the viewer when they are painted with less detail and in bluer, greyer tones. See how the distant rocks and hills are treated here in comparison with the foreground information. This is known as aerial perspective.

middle distance to background. More often than not these colours will become cooler, and adopt a bluer or greyer hue. In other circumstances they can become warmer in colour, as in a sunrise or sunset.

As well as adjusting the colour and saturation of the objects nearer the horizon, another technique that is often employed to create the illusion of distance is to paint the distant parts of the image in a broader, looser fashion, rendering the edges with less definition than those of the foreground. This method is a very effective way of achieving depth and focus.

The pictorial devices mentioned in the above text are nothing more than an introduction but even in its most basic form, this information, when put to use, will greatly improve the quality of your paintings. Try not to be put off by the work required to understand perspective, or the time spent looking into compositional possibilities; the rewards will always outweigh the time invested in learning.

CHAPTER 4

Planning, research and reference material

This detail of my Tyneside mural (Hotel du Vin, Newcastle) reveals a composition that was constructed from individually sourced references, and pieced together to make a coherent whole.

Planning, research and reference material

Detail of a cardboard mock-up for a trompe l'oeil version of the William Morris Acanthus leaf design. This was used to inform how the light and shade should be painted in a mural.

The sheer amount of work that is often required to complete a mural project can be a daunting prospect, but it is made so much easier by having a clear plan, from the outset, of how to move from one phase of the production to the next. A basic outline of the process can be broken down into three stages and thought of as:

(a) The thumbnail sketching stage where you free-form your ideas around a given brief and aim to establish a rough layout of your composition.
(b) The presentation stage, where you refine the loose sketch and bring further research to bear in a detailed drawing or mood board, with a view to presenting your ideas to the client.
(c) The painting stage, where you produce the final image.

The first stage of the process has already been discussed in the previous chapter. There I highlighted the importance of jotting down your ideas and using thumbnail sketches as a way of establishing a basic outline for a composition. In a sense, that is the easy part of the process. Having arrived at a general layout of your design you then need to know how to get from a loose sketch to a detailed presentation drawing, and from a presentation drawing to a full-colour, wall-sized painting.

Translating a sketch that is no bigger than the palm of your hand into a painting that is several metres in height and width requires a lot of planning. It will also require you supplementing your drawings with enough material that is good enough to act as reference when depicting any figures, costumes, props, texture, light, shade and any other detail that is to be painted in the mural. Painting a verbatim copy of the thumbnail sketch is obviously not an option – besides the fact that this would result in any minor discrepancies in the sketch being magnified in the larger image, there would simply not be sufficient detail for one to inform the other. You will need to research and stockpile adequate reference material to get from (a) to (b), and from (b) to (c).

From the early stages of the process you will need to be thinking about such things as:

What are the proportions of the wall being dealt with? Will the proportions pose any problems? Will the thumbnail sketch translate well as a much larger image? And how do you develop your initial thumbnails into a detailed presentation piece?

Moving on to the next stage, your considerations will more than likely turn to:

Will further detail and reference material be required to inform the making of a mural-sized, painted version of the presentation piece? And if so how do you go about acquiring such references?

And finally:

How will you transpose the designed image from the page or screen onto a large wall or canvas?

These are all important aspects that need to be taken into account when planning and making murals and this chapter will give you a good idea of what to expect. It will also provide step-by-step illustrations of how to deal with these issues, showing you several ways of putting together enough reference material and how to use it, starting with the making of a composite image.

The evolutionary process of a design, depicting the mythical character Icarus, can be seen here: the initial thumbnail sketch hastily jotted down in oils in one of my small A6 sketchbooks (top), and then the revised pose of the subsequent presentation drawing (bottom). The drawing was made from a clay maquette, made as a reference, which you can see here, superimposed over the upper section of the drawing.

Proportions and problematic wall shapes

Always work with the proportions of your wall in mind. Even at the thumbnail stage you should work within parameters that at least closely resemble these proportions. This will give you a good idea of how well your work will translate in the larger context.

Here I have included a series of thumbnail sketches that I worked on in preparation for a commission for the Hotel du Vin, Newcastle. This project serves as a good example of how to resolve an issue thrown up by problematic proportions.

At 5 × 4.2 metres, the working area was not a conventional landscape format and, at 4.2 metres in height, it was by far taller than anything that I had worked on up to that point. Painting my figures at life size would mean leaving over 2 metres of canvas at the top of the composition without much detail. I wanted the main features and narrative to play out in the lower half of the canvas and, at the same time, I didn't want the upper half of the painting to be just a huge expanse of sky. What to do? These kinds of problems are quite common when designing murals and you will need to learn how to think outside of the box to find solutions.

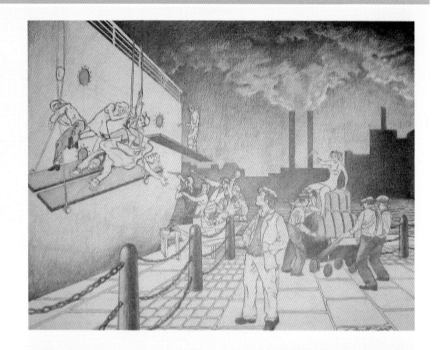

In this instance, you can see in the finished painting how I incorporated into the composition a very recognizable Newcastle landmark, the Tyne Bridge. Notice how depicting the bridge, running along the top of the canvas, acts as a framing device. This helped give the appearance of a more conventional landscape format to the lower section of the canvas, whilst adding interest to the upper section. This helped me to effectively crop the image to more aesthetically pleasing proportions; at the same time it adds an historically important landmark into the painting, lending specificity to the work; and with its network of girders on the right-hand side of the painting it conveniently helps lead the eye back to the main narrative.

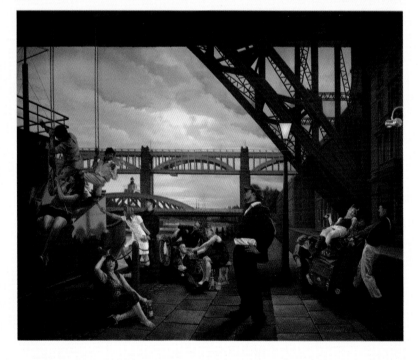

Step 1 A backdrop provides a basic framework onto which you can position and trace down your figures or any other aspects. Context is important and will obviously inform how your overall narrative is read, so give the setting adequate consideration.

COMPOSITES, CONSTRUCTS AND MAQUETTES

Once the general layout of your composition has been figured out in the thumbnail sketch, the next stage is to start building the composition in order to inform a presentation piece. How you build upon your initial concept – augmenting and fleshing out the preliminary drawing to a suitable standard – will largely depend on the subject matter of your mural. Outlined below are three different methods.

1. Constructing a composite from tracings and found imagery

Composites can be built up using elements from many different sources, using found or fabricated components, and simply drafting these features into a background image can be enough to serve your purposes in getting an idea over to a client.

Step 1 – Selecting a backdrop
When choosing this method you will firstly need an image that will act as a basic backdrop or setting that will ultimately accommodate your figures and props.

Step 2 – Researching your references
With your backdrop in place you can start to research any figures or other components and characteristics of the design.

Step 3 – Making a shortlist
Once you feel that your search is exhausted, review your amassed images and refine the selection to make a shortlist. Look at the references in greater detail, and envisage every character and prop in relation to each other, retaining those that show strong potential and dismissing those that don't. By this sifting approach you will arrive at a strong cast of candidates for the composite image.

Step 4 – Arranging the composite
Drafting figures and/or props into the setting can be done manually or it can be done digitally using image-editing software such as Photoshop. For the latter, any of your references that are not already in a digital format will need to be scanned and converted into digital files such as JPEGs. Using the software you can then select, cut and paste the figures and props onto your background image, resizing and positioning as you proceed, creating a multi-layered composite image.

Step 2 A selection of some of the visual references for the initial drawing for *Brighton Beach* mural – I wanted to set this mural in the period shortly after the pier was built (1899), so my research centred around scenes of late Victorian/early Edwardian bathers.

Step 4 One way of building up your composites is to use tracings that can be rearranged and flipped until you arrive at a satisfactory arrangement.

Tackling this process manually, on the other hand, requires time and patience, but it is a process that works just as well – using tracings and overlays is basically nothing more than an analogue version of the digital process using 'Layers' in Photoshop. The principle is the same. Once you have scaled your references – either freehand or by adjusting the scale of any photocopies or printouts – you can take separate tracings of each, which can then be laid over each other, arranging them in the desired fashion. The beauty of this method is that you can easily reposition the elements or flip them around to have them facing the opposite direction. The beauty of carrying

out the same process digitally, if you are accustomed to the software, is that it is quick, efficient, and you can back up each stage of the process, trying out and saving variations of the design as you work.

When working like this it is wise to keep an eye on the original design that caught your imagination and not give yourself too many options. It is good to keep an open mind and not be too rigid when working through the composite stage, but be careful not to venture too far from the original concept.

Once you have arrived at a montage you are happy with, it is time to move on to working up a more detailed presentation drawing.

You can see here how the traced figures have been arranged and then traced down into position, with the pier still clearly visible in the background.

Supplement your reference material with anything that may prove useful, and even work up some colour studies to help get a flavour of what you want your mural to express.

When I say 'detailed', it is important to remember that the presentation drawing is just a means of clearly communicating your idea of the composition to the client; the finer details will be refined further in the painting stage. By all means get the salient points into your presentation, but be careful not to waste unnecessary time including all the minutiae of detail.

Using this method of working will prove to be an adequate way of preparing yourself for the presentation drawing. For the painting part of the process, however, you would ordinarily need to supplement the references collated thus far with further details such as photographs of models, costumes and props. How best to approach this latter aspect is discussed in greater detail in Chapter 8.

2. Creating a low-relief model as reference for a decorative trompe l'oeil mural

For less complex subjects, making a low-relief model will be an ideal way of providing you with the information regarding the fall of light and shade needed for the finished work. In this instance the model was used for a mural project depicting an over-sized, trompe l'oeil, repeat pattern based on one of William Morris's Acanthus leaf designs. When requiring reference for something of this nature, where the intention is to paint the leaves with drop-shadows to

Figure out how your design will measure up by contextualizing it within the parameters of your given wall or architectural space. In this example, a hand-drawn copy of an architectural elevation was used to transpose my idea for a trompe l'oeil version of a William Morris Acanthus design.

The easiest way to transpose a complex design like this on to a wall or canvas is to use projection. For that purpose a clear drawing will be needed such as the one shown here. The illustration shown, however, was drawn to a scale of 1:1 and could therefore be used as a template for tracing out the mural too. The transferring of images on to the wall or canvas is discussed at the end of this chapter.

Acquiring references for the play of light and shadows is an important part of the process when making a piece of trompe l'oeil artwork, and in this example you can see how a cardboard mock-up works perfectly well for this purpose.

create the illusion that they are coming away from the wall and not just painted as a flat, block-print design, working from a low-relief model will prove to be a perfect solution.

Light and shade

Low-relief models like this can be very effective and easy to make too. By pasting printouts of the leaves onto flexible cardboard or Manila paper, when they are firmly fixed in place and dried, you can cut them out and piece together onto a backboard. The model can then be photographed using controlled lighting to achieve the desired highlights and shades.

Line

Getting good reference for light and shade is strongly advised when aiming to achieve convincing trompe l'oeil. The light and shade, however, is only one part of the equation and supplementing these low-relief models with good references of line and colour is to be much encouraged. Be prepared to make drawings and colour studies too. Having a clear drawing of your design will act as both reference and template from which to project or trace onto the wall.

Colour

For repeat patterns, like this, work out your colour scheme and have enough of each colour mixed and at hand before the painting commences to maintain consistency of colour throughout. Having your colour samples worked out will mean you have something to present to the client in advance of making the finished work, and something to work from when you are making it.

In this colour sample you can see that every aspect needed to carry out the work successfully was resolved before the work began. Produced to scale, this sample took a great deal of time to make, but the results meant that I was able to show the client exactly what my intentions were, whilst leaving little room for doubt how the finished work would appear.

The importance of game plans and teamwork?

For a project of this nature, where the level of work is intricate, and the amount of labour required very demanding, you will need to work with a team of assistants and fellow painters, and working as part of a team is another reason why it is vital to have a clear plan and have everything worked out in advance. In the case illustrated here, having a game plan, along with all my samples of line, colour, light and shade meant that there was sufficient reference and a strategy for a team of co-workers to follow. I can't deny that it was still a very demanding operation, but without any planning it would have been impossible. Never underestimate the importance of planning your projects.

3. Using artists' wooden mannequins and maquettes

Making and using what is known as a 'maquette' is another way of obtaining acceptable reference material to help with the painting phase of the process. A maquette is a small preliminary model, usually made of wax or clay that acts as a reference for later work. Maquettes are really useful, especially when needing to establish light and shade, cast shadows, reflected light, and overall form. It is no overstatement to say that making and using maquettes will make huge improvements in your finished paintings.

With compositions containing figures you may wish to use the artists' wooden studio mannequins that are readily available from most art shops. In my experience they are limited in their articulation, and I struggle to get satisfactory results from them – especially the smaller, cheaper variety. That said, they are not completely useless and they may provide exactly what you are looking for in specific compositions, it's just my preference nowadays to make my own clay figures and maquettes.

The illustration here shows me working on a large canvas for a mural made for Euroart Open Studios 2016. The references for this painting were largely acquired from a maquette made from clay and wood.

Maquettes

There is nothing new in making maquettes as reference for a final piece of work; it is a technique that has been employed by old and modern masters alike. One old master I greatly admire, Théodore Géricault, made such maquettes when creating his painting *Raft of the Medusa*, 1818–19, which depicted the tragic event of 1816. In homage to Géricault and his masterpiece, in June 2016, which marked the bicentenary of the event, I made a maquette to help me paint a mural-sized canvas, *Raft*, for Euroart Open Studios 2016, and concurrent exhibition 'Here Comes the Flood', curated by Dr Daniel Barnes.

Getting into the habit of making maquettes as a form of visual reference is not only worthwhile as a creative activity in itself, but they are also incredibly rewarding in the information they provide.

If the sum of your sketches, montage, and presentation drawing still lack enough information as reference material for making your final painting, and you want to create a more believable rendering of form, without having the advantage of being able to work from live models, working with maquettes is no bad substitute.

If you work with clay you will need to fabricate an armature which acts as an inner structure, holding your clay sculpture together and preventing it from sagging. It is helpful to think of these as wire skeletons.

Step 1, examples #1 and #2 Presentations can take many forms and it is often useful to create a mood board to demonstrate several ideas or interrelated aspects such as colour palettes, surrounding décor and fabrics.

In this section, by taking a recent commission as an example, I will illustrate the process of making a maquette and how it can be used to inform your painting. Maquettes are particularly excellent when used for trompe l'oeil work as they will help you see and understand how elements relate to each other in a physical sense, in any given environment, with the specific lighting you require.

Step 1 – Mood board or presentation drawing

With a small and relatively simple project such as this, no more than a basic drawing backed up by some other details to create what is called a 'mood board' will be all you need to express your ideas to the client.

Step 2 – Making an armature

Though it is possible to use wax or papier mâché to make one of these, here it is illustrated how to fabricate a maquette from clay.

Using clay like this requires an inner armature or framework. The framework serves to give the model a solid internal structure, which will support the weight of the clay, retain the pose, and stop it from collapsing. It is perhaps helpful to think of an armature as a form of skeleton. The skeleton will need to be firm enough to support the clay, and prevent any sagging, but it will also help to have a degree of flexibility to enable any further positioning. For these armatures it is best to use modelling wire, available in various gauges from most craft shops. The main frame of the skeleton should be formed from the thicker, more robust modelling wire, whilst the finer gauge can be used for padding-out, and for securing links or joints that require greater flexibility. A pair of long-nose pliers, preferably with a wire-cutting facility, will be needed to make a successful wire frame armature – they are available from most hardware stores and for this kind of work – not heavy duty or too demanding – you will only need a cheap to mid-range pair.

To sculpt the clay you will need nothing more than one of the very basic kits that can be easily found online. They are not expensive and far from top of the range, but one of these will meet all your needs when fashioning these crude models.

Using clay

The clay used to make these maquettes is an easy-to-use modelling clay, found in most art and craft shops, or on the internet. I tend to use Pebeo Gedeo non-firing clay. This is natural clay that, over a period of several days, dries slowly when exposed to air and does not require the use of a kiln. The clay can be weighty, but I really like the substantial feel these clay figures offer, giving them a very palpable and visceral quality. With reference to using the non-firing type of clay, a word of warning: the clay has a tendency to crack, especially if it begins to dry out too quickly. Don't be tempted to speed up the drying process by placing your freshly sculpted model close to a heater and always take care to cover your sculpture with a damp cloth or a sheet of polythene overnight whilst you are no longer working on it. This will help slow down the rate by which the moisture leaves the clay, minimalizing the appearance of cracks in your work.

To assist when fabricating these models it is advised to have at hand some visual references, so research and collate as much imagery that you think you will need to realize the model in three dimensions. In the case of the pigs I downloaded and printed off a whole host of pig imagery, seen from various angles.

Step 2 The wire frame or armature shown here is very loosely based on an anatomical diagram of a pig skeleton found online. Make sure your armature is strong enough to support the weight of the clay, but still retains a degree of flexibility to allow for further positioning should you need to adjust once the clay has been added.

Step 3 When starting to model your maquette it is important to work broadly and loosely, adding sizeable lumps of fresh clay until you mass out the general shape. This prevents cracking, because the fresh bits of clay are easily melded into each other when moist. Steer clear of working into detail before you have massed out the whole as it will encourage unwanted cracking during the drying stage.

Step 3 – Massing out the general body shape
When modelling your clay it is best to pack large amounts of fresh, wet clay around the wire framework, working fast, and roughing out the general shape of the figure. You'll then need to carve away the bits not needed whilst adding to the bits that are lacking, all the while referring to your reference imagery to check the proportions and general likeness; keep referring to your visuals and refining your model as you proceed.

Step 4 As with the painting process, leave the detail until last. The models seen in the illustrations lean toward a generic, almost caricatured, pig, but for the purpose of the maquette it is perfectly fine. When finished you can leave your clay maquette to fully dry. With non-firing clay, this usually takes three to four days.

Step 5 As you will see from the illustration, the piglets are quite crude in their making, being practically nothing more than tubes of clay with legs and ears stuck on, with a wire stuck in the rear end to serve as a tail, but they work perfectly well for the purposes required.

Step 4 – Adding the detail

Remember that these maquettes are not intended as finished articles in themselves and are only made to serve as reference to a given form in a spatial dimension, modelled by specific lighting conditions. As such, the specificity of the breed, or exactness of type, need not be a major concern.

Step 5 – Contextualizing the figures

It is not always necessary to contextualize your maquettes within a setting but it will add to the quality of your finished painting. In the example an old cardboard box, with the addition of a printout of some stonework, glue and strong tape, was all that was needed to make a reasonable model that served as a perfect reference for a piggery. With frayed string, added to look like hay, and a few piglets a whole scene was created quite quickly.

The painting process

Making a maquette allows you to position it and light it in any way that is desired, with a view to taking photographs from which you can then paint the final images. Below is a brief overview of the painting process.

A note on materials

These pigs, painted on separate panels, were installed in place of the existing doors of an actual piggery, and the surrounding front wall of the piggery painted with a trompe l'oeil stonework effect to match the stonework of the three other walls.

On an external project like this, where it is exposed to the elements, you will need to be aware of the different stresses and strains the painting will undergo, and you will need to use the correct materials accordingly. For this project I produced the paintings on 15mm marine ply. The marine ply is BWP grade, meaning it is weather-, water- and boil-proof; it is used in the manufacturing of yachts and makes a sound substrate for external artwork. The type of paint used for external projects should be acrylic because of its superior lightfast quality, making it more suitable for enduring the hazardous effects of sunlight than oils. If, for whatever reason, you have to use oils then it is strongly advised that you protect the finished work with several layers of a good-quality anti-UV varnish.

Step 6 Once drawn out, your image should be loosely blocked in, taking reference from the maquette (or photographs taken from it), and any other references you have at hand. The pigs were painted using a restricted palette consisting of Flake White, Yellow Ochre, Vermillion (hue), Raw Umber and black, and a little Naples Yellow for the highlights.

Step 7 When the blocking in is established, you can begin to work into the image with more detail.

Step 8 Finally add the small incidental details – such as the sharp highlights and strands of straw seen here – to really bring the painting to life. It is at this point that the Naples Yellow can be introduced to the highlights to give them extra warmth.

Step 9 If your work involves several panels, as was the case here, it is wise to paint them concurrently so your paint mixes will be consistent throughout. You will also need to be consistent in terms of perspective.

Step 10 Always bear in mind throughout the design and production of your work how it will look once installed within the context of its surroundings. In such circumstances you should look for ways to use this to your advantage. In the example here it can be seen how the male pig on the right has his nose painted on the actual door surround, which helps create the illusion that he is coming out from within.

Where possible, when including elements of trompe l'oeil to your mural work, aim to blur the boundaries of what is real and what is painted. This can be achieved by incorporating some of the architectural surround into the painted work, as seen here where the real stone work of the sides of the piggery has been replicated on the front wall surrounding the panels. Note how on the image included in the mood board this wall was covered with white-washed rendering.

SOME NOTES ON PHOTOGRAPHY

I tend to use photography a lot in my practice as it's a very efficient method of achieving good reference material and for resolving many issues that I'm faced with when designing and producing murals.

If you intend to use photographs of any models or maquettes as your main source of reference material, there are several aspects that you will need to take into account. When photographing your model, and when you are subsequently drawing out any images from these photographs, especially if you are making a piece of trompe l'oeil artwork which is intended to fool the eye, it is crucial that your eye-level/horizon lines and vanishing points are consistent throughout. When the artwork is eventually installed, the eye-level/horizon line and vanishing points need to be in concert with those of the camera's viewpoint to ensure compatibility with how the work was made and how it should be viewed. To do this you will need to consider and maintain the height and angle of the camera and its distance from your subject.

When using the camera, give it adequate thought and don't be inclined to just snap away randomly. As well as maintaining the horizon line and vanishing points, you will also need to consider the lens on your camera. If all you have at your disposal is a

basic point-and-shoot camera, or the camera on your smartphone, then you will be restricted in terms of what you will be able to use it for with any degree of satisfactory recording. With these cameras you need to remember that your lens will be a fixed wide-angle lens, which has a tendency to distort the person or object being photographed. The focal length of the lens on the majority of the point-and-shoot variety of camera is approximately 28mm, and the lens on an iPhone 6 is only 4.15mm, meaning they are, respectively, wide and very wide-angled lenses. The focal lengths of these cameras are calibrated to work with sensors of a smaller ratio to approximate a lens with a 43.2–50mm focal length on an SLR 35mm film, or full-frame DSLR camera, which is considered the nearest equivalent to the field of vision of the naked eye. They are, however, only approximations and distortion will occur. You only need to take a portrait of someone from close range with your smartphone to see how the facial features can become distorted and exaggerated with such lenses.

Conversely, when taking images that are not close up it is likely that you will end up with a huge field of vision that is way too much for the needs of your mural references, or the images you take are distorted with an over-convergence of straight lines and key-stoning of architectural details. Get to know the pros and cons and limitations of your camera and research as much as you can about ways of achieving realistic perspective. Ultimately, remember that a focal length of 43.2–50mm (or the equivalent) is comparable to the human eye and the more you deviate from that the more perspectival distortion you will end up with. Using photography to acquire reference material is discussed further in Chapter 8.

The methods listed above are just a few of the many ways in which you can obtain and use reference material to inform your artwork and develop it from sketch to presentation and so forth, but they will put you in good stead for most mural scenarios. An important part of the process as yet not discussed, and to which we will now turn our attention, is the business of how to get the design from your page or screen onto the wall.

TRANSFERRING YOUR IMAGE ON TO THE WALL OR CANVAS

There are several ways to transfer an image onto a wall or canvas and, whilst some methods are more involved than others, it pays to take a look at alternative procedures as it is not always practical, for instance, to use a projector.

Ways of transferring

1. Cartoons
In the original sense of the word, a cartoon is a preparatory drawing for a large painting, sketched out on sturdy paper. The drawing is made to the exact dimensions required for the final work and is used to transfer the image from the paper to the wall. Although the drawing is made to the exact dimensions required, this would usually be carried out in sections at a time rather than all at once, using a cartoon big enough to contain the whole image.

Once the image is drawn out, a pouncing wheel (a small, spiked wheel that is attached to the end of a handle) is rolled over the outlines of the drawing. When rolled over the design this spiked wheel leaves a neat row of pricked holes tracing the path of the outlines. Later, when the cartoon is offered up and fixed in place, a small bag made of a thin fabric such as cheesecloth or muslin, filled with powdered chalk or charcoal, is dabbed along the outlines. This action forces the coloured powder through the holes, leaving a series of small dots on the wall's surface.

This is a method rarely used these days but, occasionally, I've found that the powdering technique can still come in useful, especially when marking out the positive and negative aspects of laser-cut vinyl stencils.

2. Tracing

Tracing paper, when used to transfer images on a large scale, is used in pretty much the same way as you would use a cartoon, in that the image is drawn onto it at the actual size, and then transferred onto the wall or canvas. Again, this would be carried out in sections when working on large murals.

Firstly the image needs to be drawn onto a sheet of tracing paper, preferably using a soft leaded pencil. Once drawn, the paper needs to be flipped over so it is face down. A copy of the drawing is then made on the reverse side, following the lines that are visible through the paper. The next step is to offer up the tracing paper, facing the right way around, and to fix it into position using pins or tape. As you retrace your lines of the drawing, applying pressure to the tracing paper, it will leave a residue on the wall or canvas of the lines drawn on the back of the paper.

This can be a lengthy process compared to the projector but it is an effective way of transferring your images and one that I use quite frequently, depending on the dimensions and detail in question.

3. Gridding or squaring up

Gridding up is a widely used method of scaling up an artwork and transferring it from one plane to another. Firstly, the original image needs to be divided along its length and breadth into equal segments, using vertical and horizontal lines, until a gridded pattern of equal squares is achieved. The canvas or wall is then divided into the same number of squares, only larger, covering the whole surface intended for the mural. The next stage is to copy from the original image freehand, replicating the motif square by square. Breaking down the image in this way makes it more manageable and

less likely to result in the drawing being distorted or have exaggerated features.

4. Stencils

Using stencils can be a really efficient way of working up areas quickly, especially those involving complex repeat patterns. You can design and cut these yourself and there is a whole range of materials readily available that you can use for this purpose. If the stencils required are very intricate it is also possible to have them laser cut by a professional cutting company.

Personally I only use stencils when an intricate repeat pattern is involved in the design, but they are still, nonetheless, an efficient means of transferring your image. Making and using stencils is the subject of the following chapter.

5. Projection

A projector, seen in a purely pragmatic light, is incredibly useful and often essential for a mural artist. Spending money on a good projector, in my mind, is a good investment – the time saved when using a projector to tackle many aspects of drawing up and problem solving will mean that in a short space of time it will in effect have paid for itself.

I have used two kinds of projectors over the years: an analogue overhead projector (OHP), and a digital projector, and both have proved incredibly useful. The overhead projectors are fairly limited though in comparison with the digital variety and can be heavy and cumbersome when lugging them around. The last OHP I had was a portable one, making it more user-friendly, but it still had its limitations. With the OHP you will need to make a drawing on a sheet of clear acetate first, and use that, placed on the glass plate of the OHP, to project up your image. Overhead projectors are very handy but they do have a tendency to distort the projected image easily and you will need to monitor your use of them very carefully.

The example of an Elizabethan floral motif shown here illustrates how a drawing was refined and marked out onto a large sheet of tracing paper. Made to scale, this can be used to trace the motif onto your wall or canvas.

The same Elizabethan floral motif can be seen here drawn out in felt-tip pens to acquire a clear and monochromatic drawing which can then be photographed and used to project the motif.

Detail of the distressed mural, painted for The Pig Hotel at Combe House, Devon. Using a combination of the two methods illustrated above, the same Elizabethan floral motif can be seen here in situ, painted and distressed to give the appearance of an aged piece of decorative artwork.

The digital projectors, on the other hand, are excellent, though you'll probably have to lay out a fair amount of cash to get a decent one. There are cheap digital projectors available but they are limited in what they can do. The one I currently use is a 2:1 short-throw projector, which means that from say 3m distance, it will give me a 6m wide projection, which is ideal for my needs.

With a digital projector you just plug into your computer and work directly from the image on your computer screen, with no need for any tracings or acetate drawings. This means you also have more scope with the scaling and positioning of your work, as you can work directly from the computer screen or the projector itself.

What I have set out to do in this chapter is to demonstrate different ways of acquiring relevant reference material that will help you see and understand clearly the relevant details that you will need to translate into the painted aspects of your murals. In the following chapters we will move on to the next phase of getting paint on your canvas or wall, beginning with how to make and use stencils within your mural work.

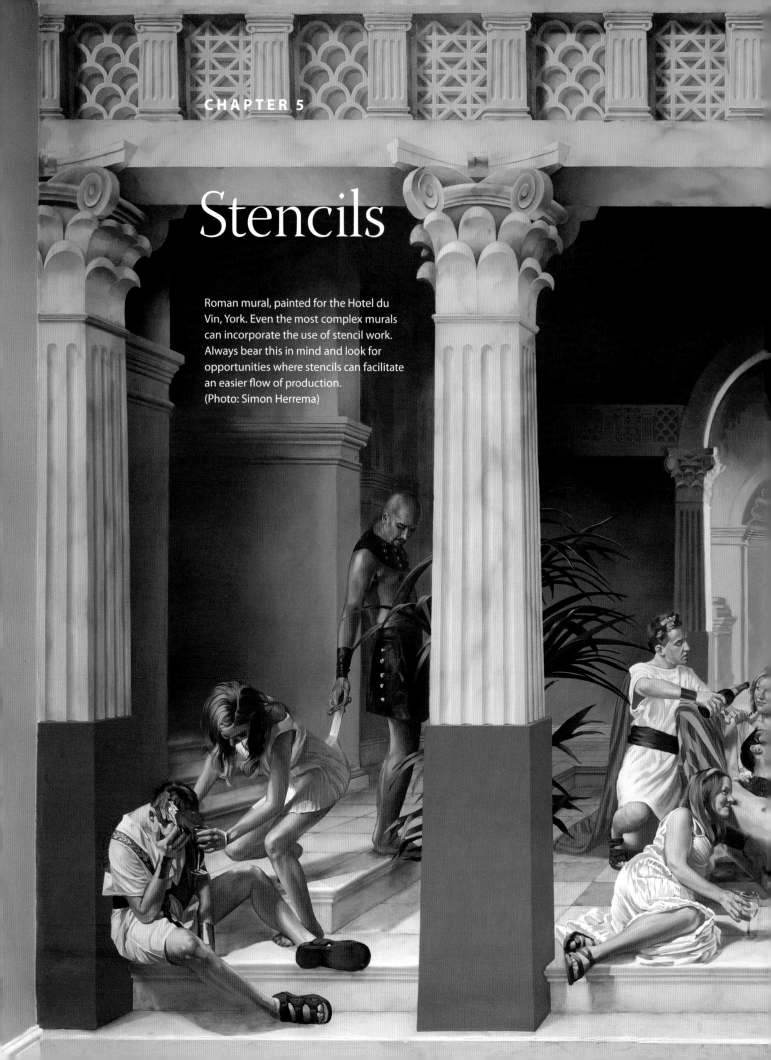

Stencils

Roman mural, painted for the Hotel du Vin, York. Even the most complex murals can incorporate the use of stencil work. Always bear this in mind and look for opportunities where stencils can facilitate an easier flow of production. (Photo: Simon Herrema)

Stencils

Repeat patterns, such as the lattice work and triglyphs of the frieze and cornice shown here, can be produced a lot more efficiently using stencils. (Photo: Simon Herrema)

The opening image to this chapter shows a mural that I was commissioned to paint for the Hotel du Vin in York. I've included it in this chapter as an example of how stencils can be used in conjunction with traditional painting methods and incorporated into a piece of representational, large-scale artwork. The repeat patterns along the architectural detail in the uppermost area of the painting, between the triglyphs of the marble frieze, were achieved using stencils. Used in this manner, the stencils provide a basic structure onto which it is possible to apply a simple marble effect. With the further application of glazes, indicating highlight and shade, the frieze can then be given its texture and form.

In recent years stencils have been very much at the forefront of our awareness, not least because of the huge rise of interest in street art and the popularity of artists such as Blek le Rat and Bansky. Whilst it enjoys the warm glow of its current popularity, it might be interesting to some to point out that the origins of stencilling date back 40,000 years. Some of the prehistoric paintings discovered in the caves of the Indonesian island of Sulawesi and El Castillo,

in Spain, which date back to 39,900 and 40,800 years respectively, are the oldest art forms discovered. It is generally accepted that some of these paintings were created using the hand as a form of stencil, whilst pulverized pigments were forced through the fingers, probably by blowing.

Stencilling has been around for a long time and seen some varied uses: there is evidence of stencil techniques being used in the tombs of ancient Egypt; in classical Rome; in China and Japan around AD100; and in Europe in the Middle Ages. By the late nineteenth and early twentieth century, stencil designs were widely used by craftsman and artisans. Stencilling later achieved the status of artistic expression when Robert Rauschenberg, Andy Warhol and Roy Lichtenstein employed stencilling-type processes of silk-screen and the Benday dot technique as part of the Neo-Dada and Pop art movements of the 1960s. It also played its part in the visual lexicon of the punk aesthetic and the graffiti explosion of the 1980s and 1990s, and it can currently be seen used to great effect in the street art of today.

In short, stencilling has had a long and varied history and this chapter will be used to demonstrate some of the diverse ways in which you can effectively put stencils to use in your mural work to achieve anything from decorative motifs to pictorial imagery. We'll start off looking at some simple but effective techniques and, as we work our way through the chapter, we will focus on more sophisticated and complex ways of using multi-layered stencils.

Materials

Designing and cutting your own stencils is not terribly difficult. It often proves to be the most cost-effective way of working and, as such, knowing a little about the tools and materials required will prove useful.

Stencil paper/card

A stencil refers to both the object through which the paint is forced and the resultant image made from it. A stencil can be cut from various materials, as long as it is strong enough to retain the form of the cut motif and can effectively mask off the areas surrounding it. Over the years I have used a variety of materials for my stencils, including different types of paper, card, plastic and vinyl, but for the majority of them I use oiled Manila stencil paper – a thin card treated with linseed oil to make it water-resistant. It is durable stuff, not terribly difficult to cut and relatively inexpensive. Manila paper is available from most good art supply shops.

Cutting mat

A cutting mat is a very useful bit of kit that will protect your work surface when cutting. These are quite sympathetic with the cutting blade as it manoeuvres around any intricate contours. If you opt to use either cardboard or wood to protect your work surface there is always a danger that the blade will be influenced by the grain, causing it to career away from its

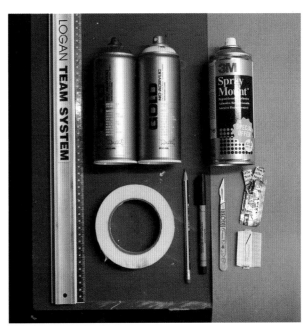

The tools and equipment for stencil work are available from most art suppliers and will not cost the earth.

intended course, potentially damaging your stencil. You can buy good-quality double-sided 'self-healing' cutting matts from most art suppliers. This kind of mat provides a tough, flexible base upon which to work. When used and stored correctly these should last you a long time. 'Self-healing' in this sense means that the rubberized mat closes up the fissures caused by fresh cuts, thus preventing the blade from being influenced from well-worn grooves.

Cutting implement

When cutting stencils you will find it best to use a stainless steel surgical scalpel. These scalpels are available from most arts and crafts stores, as are the blades that can be purchased separately. The blades are sharp and have an element of flexibility to them that will assist with difficult cuts. The blades retain their cutting edge for some time, though if you want the best from your stencils it is advisable to change the blades on a regular basis. When cutting with these scalpels it is best to cut slowly and carefully, applying only slight pressure to the handle. These blades are incredibly sharp, so remember to handle them with great care at all times: they can be lethal. Avoid

using the chunky variety of craft knives that come with snap-off blades. This type of knife is not suitable for negotiating the intricacies of most stencils.

Other items that will come in useful are: spray adhesive; low-tack adhesive masking tape; a straight edge; pencils; felt-tipped pens; the paint medium of your choice and the means to apply it.

Applying the medium

The method you use to get the pigment through the stencil and onto the substrate can inform how you make your stencil, and what you make your stencil from. There are many ways to make, cut and use stencils and as such there is no 'right' or definitive way. Below are some of the options you may wish to consider.

Spray

Spray cans are very efficient, giving you a quick method of applying paint. If sprayed correctly it will limit the amount of bleeding under the stencil, leaving you with cleaner edges. 'Bleeding' is the term given to describe the paint seeping into areas of the stencil where it is not intended to go. One of the downsides of using this method of application is that the solvents used in some spray cans are quite toxic. There also tends to be a lot of overspray to contend with. Be careful and cover all surrounding areas with plastic sheeting as a precaution when spraying. Always be sure to use adequate personal protection: at least a respirator mask with removable filters that will protect you from vapours, gasses, and dust particles. Cheap, throwaway paper masks are far from adequate for this purpose. It would also be advisable to wear goggles and latex gloves when using aerosols. Always calculate how many colours are needed and how much surface needs to be covered so you can compare the cost options at your disposal. Aerosols are not terribly expensive but the cost will soon add up if lots of colours are required.

When spraying, make sure that the nozzle of the can is perpendicular to the stencil and spray in even horizontal strokes. Remember also that it is better to spray several thin coats, building up to the required opacity rather than applying too much paint in one go and having it drip and bleed beneath the stencil. A method of slow and regular, even strokes in the same direction is better than a criss-cross application. This will give you more of an even finish and make it easier to establish which areas you have already coated. Spraying can be used with stencils cut from most materials.

Roller

Care needs to be taken when using a roller to apply paint through a stencil, so if this is your preferred method of application make sure to use a foam roller, or short pile mini-roller, and make sure that the roller head is not loaded with too much paint. Again it is better to build up in several thin applications rather than one heavy one. Ordinarily I would only advise using a roller in conjunction with stencils cut from vinyl with adhesive backing.

Stipple

Stippling is another method of paint application, and this is best achieved using proper stippling brushes, designed for this specific purpose. Used in a heavy-handed fashion, or loaded with too much paint, these brushes will cause the paint to bleed beyond the edges of the stencil. Again build up the layers of paint slowly and carefully. Another problem with using stencil brushes is that they can sometimes leave unwanted texture to the paint surface. Stippling brushes work well in conjunction with stencils cut from Manila paper or masking film.

Transferring and cutting

To demonstrate the basic principles of cutting and using a stencil, the example below will take you through each stage of an exercise where a simple fleur-de-lis design is cut and used as a single decorative gold-leaf motif. This can of course eventually be developed further into the repeat pattern of a decorative border or panel, but for our present purposes we will focus on a single image.

The first step of the process is to transfer the motif onto the material from which the stencil will be cut. Below are listed various methods of transfer:

Tracing paper method
A tried and tested way of doing this is by the age-old method of tracing, using tracing paper (as in the example shown) or tracedown paper. The advantage of using tracing paper is that, if need be, you can refine the design as you trace, and see both the original and the adjusted version simultaneously. In so doing it is possible to assess the level of *improvement* before committing the design to the stencil.

Printout method
A second method of transferring the design involves printing out the motif to the size and scale needed for the finished product and, using spray adhesive, fixing it to the stencil paper. When the printout version is firmly fixed in place the stencil can be cut through the printout and stencil paper simultaneously.

Photocopy method
Alternatively you can create a transfer from a photocopied image onto the stencil material using acetone. To achieve this an exact-sized photocopy of the image needs to be fixed in place on the stencil card, face down. Because this is being transferred with the image face down, your motif will need to be a reverse version of the desired image. Once aligned, it should be secured in place using low-tack tape. Holding the

Aim to be faithful with your tracing. Any digression from the original source, no matter how small, will cause an exponential deterioration of the motif each time the tracing is used. Translations of each newly traced image, in this instance, tend to distort like a visual form of Chinese whispers.

The tracing paper method is not always the quickest way, but it is nonetheless a very basic method of transfer that can be used in a lot of situations.

If you have a computer and printer at hand, the printout method is a very efficient technique that can be used when cutting stencils.

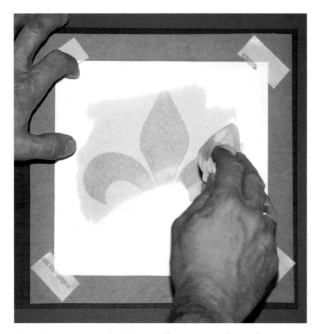

The photocopy method is an efficient way of transferring images. Acetone is relatively easy to get hold of from beauty salon suppliers such as Sally Beauty or Boots the Chemist. It is often used in nail polish remover too, though some nail polish removers are made with ethyl acetate, which will not work when transferring photocopied images. Always read the label.

Transferred image from the acetone and photocopy method. This method will only work with acetone on photocopied images. The toners used in the photocopying process and the acetone react perfectly with each other in creating this kind of transfer. The method will not work with a laser- or jet-printed image.

photocopy firmly in place, a piece of cotton cloth lightly soaked with acetone needs to be applied to the back of the photocopy and worked into it. The cloth should not be drenched, but should have enough acetone on it to make it wet. All areas that contain the design should be worked into. This will leave a faint but relatively clear transferred image on the stencil paper. The example shown uses a symmetrical image but it is important to get into the habit, when using this technique, of making sure the photocopies used are reversed, so as to get the correct transfer.

Acetone evaporates rapidly, so this exercise has to be carried out quickly and efficiently. If, however, a section of the design has been missed and the transfer is incomplete it is always possible to add more acetone to the cloth and repeat the procedure whilst the photocopy is still in place.

Before cutting you may wish to emphasize the outline using a fine, felt-tipped pen.

Acetone is considered a relatively benign solvent. However, I would still advise that you read the product label concerning safety precautions and act accordingly. In rare cases acetone can cause mild irritation to the nose, throat, eyes and skin. It is also flammable in liquid and vapour form, so keep away from any heat sources. Be sure to only use in an environment that is well ventilated.

Making multiples of the same stencil design

When making multiple stencils of the same design, the printout or photocopy methods are the most efficient ways to proceed. Using one stencil as a template through which to draw out a second stencil is not recommended. This will result in each of your subsequent stencil images being progressively reduced in size. Even though this is a marginal progression it soon becomes noticeable, especially in the narrow elements of the design.

Cut your stencils carefully with clearly defined edges, and always remember to include bridges, which will help hold your stencils together.

Cutting stencils

As mentioned earlier, cutting your own stencils can be beneficial in terms of cost and time, especially if your overall concept involves marking out repeated forms. However, that does not mean cutting your own stencils will always be the best solution. Most projects will require a bespoke approach in resolving all the issues needing to be addressed and cutting stencils can be very labour intensive. You will need to assess how intricate your design is and how many stencils will need to be cut. It may be more efficient in the long run to have them laser cut by one of the many companies out there offering such a service. These companies will cut designs from a variety of materials and I have found them to be very useful. Laser-cut stencils will facilitate the production of really complex and elaborate compositions, but knowing how to present the stencil artwork to one of these companies, in a way that will deliver the best results, is vital. If you choose to use this latter method, speak to the company in detail and ask what is required. It may involve having to use a computer software program, such as Illustrator, to convert your design into a vector

The holes that are cut out of a stencil are called 'windows'. These windows are the negative spaces through which the pigment is forced, governing the size and shape of the marks that will be made on the canvas or wall. The remainder of the cut stencil is known as the 'positive'. Let us take the example of having to make a stencil for a letter 'O'. Once cut, you will be left with the main positive of the stencil, a circular shaped 'window' marking out the 'O' shape, and a floating positive in the middle. This latter detail, the floating positive, is what is known as an 'island'. For the stencil to work correctly a narrow strip (known as a 'bridge') is needed to connect the inner circle (island), to the outer circle, or 'positive' mainland of the overall stencil. Bridges will always need to be factored in to your designs. Failing to do this will result in the island(s) dropping out as soon as the stencil is lifted off the cutting mat. It is advisable to incorporate a sufficient amount of 'bridges' to provide extra strength to the stencil, and stop it from falling apart.

The different parts of a typical stencil can be seen in this illustration.

diagram. Computerized laser cutters will only cut from the information they are given; any irregularities, no matter how small, will be included in the cut stencil. A rough sketch on the back of an envelope will not be good enough.

An alternative is to have the laser-cutting company do the artwork for you, though that will obviously be an added expense. Think carefully how you wish to proceed and what will work best. For now we will focus on designing and making our own stencils.

Take time to position your stencils carefully, using registration marks to help guide you.

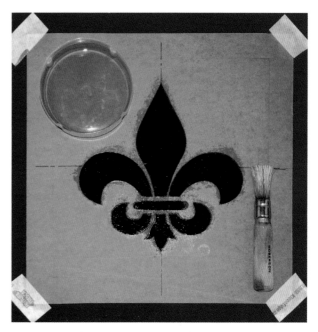

The size used for gold leaf is a type of glue that is designed for use with most types of metallic loose leaf or transfer.

If your design is to be rendered in a single colour then it is at this point, when the stencil is fixed in place, that the paint would be applied by one of the methods described above. In the example shown here the motif is to be a gold leaf fleur-de-lis, so rather than using a colour at this stage, an application of glue size is required. The size is used to adhere the gold leaf to the substrate. For this application I opted for a stippling brush.

Once stippled, the glue size needs to be left and allowed to dry until Sellotape tackiness is reached. Size comes in quick- and slow-drying formulas, so always work out what will work best for your needs and always read the label.

<div style="background:#888; color:#fff; padding:4px;">

Rebuilding bridges

</div>

Be careful not to cut through any bridges when cutting your stencil. If any bridges do inadvertently get damaged it is always possible to apply tape to stick the bridges back down again, and strengthen the connection, remembering to cut back any overhanging, excess tape.

The gold leaf transfer is laid on top of the sized stencil and then gentle pressure is applied using a piece of absorbent cotton. In the example shown I have used an artificial gold leaf transfer, otherwise known as Dutch metal or Schlag metal. This works very well in most circumstances and is a fraction of the cost of real gold leaf.

Importance of registration marks and overlaps

If your motif is part of a repeat pattern you will need to work out where the repeat pattern begins and ends. You will then need to factor this into your stencil, allowing for both the motif and the relevant space between each repeat. This is best achieved using registration marks on the stencil and on your surface, so each time the stencil is used you can align it properly. Work out all your calculations in advance so you know that your repeated pattern will fit perfectly within the given length, width or height. If that is not possible, as will often be the case, you will need at least to centre the design so that the results will be balanced. This

Anything even remotely abrasive will damage your metallic loose leaf or transfer. Always opt for cotton cloth or cotton wool.

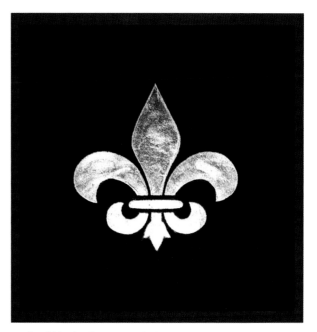

Real gold leaf will not tarnish, but imitation gold and most other metallic finishes will require a protective coat of varnish. There are many varnishes on the market that are specifically manufactured for use with gold and silver leaf, such as Kölner Leaf Protect.

latter solution will involve having the repeat pattern cropped evenly at both ends.

A simple motif can be repeated and incorporated into a border or panel like the illustrations shown. The examples given here are just two simple variations of limitless possibilities.

When using multiple stencils, and/or repeat patterns, there will always be the danger of what is referred to as 'migration'. This happens when each stencil is slightly out of alignment and causes the next one to be out of alignment also. When this happens the migration increases with each stencil applied, so it is of vital importance to draw out some registration marks beforehand, and line out your horizontal and vertical levels on the canvas or wall where and whenever possible. Alignment is key, even if you are producing an edgy piece of punk street art. Stencils just won't work if the elements of your designs are too haphazard, so make some contingency plans regarding how best to produce the final output.

As with most things, the amount of preparation you put into making stencils will affect the resultant quality of the final piece. With stencil work, I would say that about 90 to 95 per cent of the work goes into

Here we see how the underlying registration should look for a straightforward repeat pattern border.

Sound pattern arrangement will only be as good as the measuring and arranging of the layout of the design. Spend as much time as is required to get this right at the start of the process.

the design, cutting and planning of the procedure, and only 5 to 10 per cent goes into the painting aspect. So if you want to produce good stencil work, make sure your planning is good.

Here we see how the underlying registration should look for a staggered repeat pattern panel.

Sound pattern arrangement will only be as good as the measuring and arranging of the layout of the design. Spend as much time as is required to get this right at the start of the process.

This close-up detail helps illustrate further the complex pattern of trompe l'oeil decorative carving, achieved using stencils.

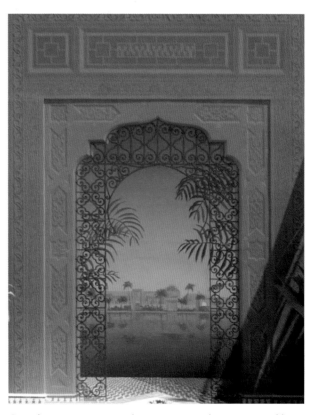

Complex repeat patterns become so much easier to tackle when using stencils. Stencils were used to create the patterning seen here on this trompe l'oeil Moroccan arch.

Here you can see a perspective drawing for a series of Moroccan arches that made up a trompe l'oeil frieze.

The exercise just covered allowed me to demonstrate the fundamental aspects of stencilling. They are basic elements that should now no longer require repeating as we work through the following examples. Taking the same principles as outlined above it is possible to apply them to other projects, including complex trompe l'oeil schemes and mural work.

In the next series of illustrations you can see how I developed an idea for a frieze, depicting trompe l'oeil arches that were to adorn a Moroccan-themed room. The idea for this project was to create the impression when looking up at the frieze that the viewer was looking out onto a dusky evening sky with a low setting sun. In the first image you will see the initial sketch, outlining the basic idea. The second image shows a 1:1 scaled mock-up of a lattice template for one of the arched windows, laid over some loosely painted dusky colours. Although very crudely put together this was enough encouragement for me to realize that the project would work.

The next stage was to design and cut some stencils for the actual frieze and I decided to opt for two alternating Islamic designs. Once developed into coherent forms I converted them into vector diagrams on my computer, using Illustrator. Needless to say, these designs are far more complex than the fleur-de-lis used in the previous exercise and, because of the sheer amount of arches required for the project, many stencils would be needed. Working on the assumption of being able to achieve three to four good images from each stencil, I therefore needed approximately twenty (ten of each design) to complete the fifty-eight arches that were to be painted. This was too laborious

Always try out your ideas before committing them to the wall or canvas you are working on. Even the crudest mock-up should give you an idea of what will or won't be successful.

If you intend to get your stencils cut by a stencil-cutting company then you will need to present them with a vector file of your design. That way you will avoid the cost of them re-doing your artwork and converting it into a vector file for you.

Working with stencils requires a way of thinking about the process that sometimes seems to go against a commonsensical approach. In this example, the first stage is to block out the main shape of each arch with the lattice colour – even though the lattice and frame will only be 10mm thick in the finished article.

Once the second stage of the process has been carried out, where you apply the dusky sky colours and the stencil has been removed, the image starts to make more sense.

With all the added elements of the pillars and outer arches, this simple stencil exercise starts to look quite effective.

a task to make cutting the stencils by hand a viable option. I had these stencils cut for me by a laser-cutting company and they were perfect for the job. One of the vector designs I provided them with can be seen in the illustration.

The process for tackling something like this is to paint out each arched screen section with the same brown lattice colour. Once dry, the lattice stencil can then be positioned and the gradating dusky sky colours sprayed through it. On removing the stencil you will be left with a clear image of the brown-coloured lattice, with the evening sky colours showing through

the negative spaces. Using a Naples Yellow to create a highlight colour, a fine line can be hand painted to the left and underside edges of the lattice details to create a further element of depth and warmth, suggesting a setting sun in the background.

STREET ART STYLE MURAL

Moving on to a more complex example, the following demonstrates the stages required when making an intricate two-tone mural in the style of street art. Although produced using only two colours for the bulk of the composition, this still involves making and using several stencils.

Even if this style of artwork interests you more than the previous exercises, the techniques discussed so far are still applicable. For this, like any other exercise, you will need to have a clear understanding of what you are setting out to achieve. What is your image to be? What is it you want to make? Do you want to produce a striking image, or something that

Stencils can be used on projects of many different sizes as is demonstrated by this piece, which measured over 3m in length.

is decorative? Is there a message you wish to convey? How, or where, can you get the visual references that will best suit your purpose? Does it matter whether you source your inspiration from an online search, or from books, magazines, or your own photo-library? You may wish to conjure up the image completely from your imagination, or perhaps make a composite from any number of the sources just listed. Whatever the case make sure to have some direction toward the intended output. When researching your reference material be guided by your initial motivation, but also let your creative juices flow here. Feel free, and don't be scared to play around with whatever may present itself and, most of all, don't restrict yourself to finding that one exact image that may forever be elusive. If you use any photographs as part of your reference material make sure that they are well lit and have good contrast. If your photograph is overexposed, or washed out, it will not work well as a stencil. Good stencils require good contrast and definition.

Artwork made with stencils work best when simple yet striking, so condense your idea and convey it in a way that is not too intricate, especially if the stencil is small. Ask yourself how simple or how complex the image really needs to be, and how many layers or colours will be required? How will your image work within the given size and scale?

For this demonstration I wanted something playful, but with an edge to it. Firstly I downloaded a couple of images from the internet of a version of Rudolph Zallinger's illustration now known as *The March of Progress*, which was originally commissioned for Time-Life Books in 1965. I wanted to combine this iconic image with an image of one of our esteemed politicians. This juxtaposition appealed to me: on the one hand we have the stages of the evolutionary process, and the progression of man, developed from savages to an intelligent species, with progressive and nurturing attributes, striding forth with dignity and a sense

Useful tip concerning base colours

The amount of colours you use will determine the amount of stencils that will need to be made, but always remember that your base colour will provide you with one of those colours, so select wisely. It may, at times, be even more efficient to have your darkest tone as the base colour, and use the stencil overlays to achieve the mid tones and highlights. Using good-quality spray paints, such as the Montana Gold range, will give you very good opacity, allowing you to work on even the darkest of background colours.

These images were treated in Photoshop, but there are many other examples of image-manipulating software available that include the basic tools for grayscale conversions. To the left we see the 'Image' > 'Mode' > 'Grayscale' drop-down menus. Below we see the 'Image' > 'Adjustments' > 'Posterize' drop-down menus.

of pride in his achievements. Then, on the other hand, and ending the sequence, we have a man of importance with the responsibility of high office, who aims to capture the nation's imagination and respect by, amongst other things, goofing around in front of the camera. Boris Johnson seemed to fit the bill very well and there were many images to choose from. I actually selected two images: one where Boris is seen hanging on the end of a bungee rope whilst waving a couple of Union Jack flags, and a second image in which he appears to be gurning, and thus further enhancing the admirable qualities of such a prominent politician. I was able to superimpose the two main images and create a 'stitched' composite of Boris on my computer, and subsequently make a montage with the *March of Progress* image. This became my *March of 'Progress'*.

Once you have an image resolved, the next step is to make the necessary adjustments in preparation for converting it into a stencil. For this you will need an image-editing programme such as Photoshop, though any basic programme that has the facility to adjust the contrast and brightness will do. For the image in this example I used the 'Posterize' tool in Photoshop.

In Photoshop, select 'Image' from the menu bar and select 'Mode' from the drop-down menu. This will open up an adjacent drop-down list of commands from which you need to select 'Grayscale'. At this stage a window will open asking if you wish to discard colour information; select 'Discard', and the image will be rendered in grayscale.

When all colour from the image has been discarded, you will then need to simplify the image

If your stencil is large you may need to tape several pieces of Manila paper together. If so, use gaffer tape or duct tape, which is a fabric-backed tape with strong adhesive.

When spraying your stencils make sure that the environment is well ventilated and that you have a good-quality mask that is suitable for protection while spraying.

even further by reducing the tonal range. This can be achieved by using the 'Posterize' tool in Photoshop.

In Photoshop, select 'Image' from the menu bar and this time select 'Adjustments' from the drop-down menu. From the list of commands you will need to select 'Posterize'. Selecting this option will open up a dialogue box.

This basically allows you to control the simplicity or complexity of the tonal variation of your image. As the intended final result of this example is to look like a rough and ready piece of street art, *à la* early Bansky, we'll need to reduce the tonal variation of the grayscale image to black and white.

The slider bar in the Posterize dialogue box enables you to increase or reduce the tonal range of an image. In this case I took the slider to the extreme left until the integer in the small window read '2', thus giving me my two-tone, black-and-white image.

Always remember when using any image-editing software to save your image at every stage of the process, so you have a backup should it be required.

For the whole stencil I needed six large sheets of Manila paper which I taped together using gaffer tape. Gaffer tape is a strong, cloth-backed, adhesive tape. You will need good-quality strong tape for something of this scale or your stencil will not hold together. The stencil needs to be big enough to accommodate your printouts with enough room for a border for good measure.

For a large and complex stencil like this, the easiest method of transfer was to fix printouts to the stencil paper as described in the earlier example. At this size the file is way too big to print out in one piece, so the trick is to print out a lot of A4 or A3 sheets and piece them together. Your printouts will need to be taken from a digital image that is the exact same size as the

Step 1 Use the marquee tool in Photoshop to break down your image into workable components.

Step 2 The components are printed out onto separate sheets.

finished product so it is advisable to keep the file to a manageable size. In this example I kept the resolution at 72 dpi, and increased the size of the image to 320 × 140cm. This gave me a digital image with the exact same dimensions as the finished product and only 29mb in its digital format. This meant that I could now print out all the relevant sections knowing they would correspond perfectly with my canvas size.

To print out all the separate elements to this given scale involved using the marquee tool (cropping tool), in Photoshop. This was set to a fixed size of 27.5 × 18.5cm. As I was using A4 printouts this gave me a good, sizable image with a border of approximately 10mm all the way round. This is just a preferred way of working but there is nothing stopping you printing out at any size that suits you, with or without borders.

In this instance, as seen in the step 1 illustration, the marquee tool was used to crop each figure as many times as was required until enough sections had been selected and cropped to be pieced together to create a whole figure.

In the step 2 illustration, you can see the Dryopithecus figure is made up of only four A4 printouts, each with a slight overlap to help with alignment. Once the separate elements are taped together, spray adhesive can be applied to the reverse side and the composite image can be fixed in place on the stencil paper.

A good measure of precaution when using this method, especially on something as large as this, is to make registration marks on your stencil paper in preparation for receiving the printed-out composites of each figure. Draw out the vertical and horizontal centre lines and borders too, as these will help maintain a level across the whole span of wall or canvas, reducing any potential distortion caused by any misalignment of your elements.

Step 3 Making a composite of the separate elements, which can be fixed to your stencil material, makes a perfect guide as to where to make the necessary incisions when cutting the stencil.

Step 4 Tracing the smaller detailed second stencil. Secondary stencils can be made to accommodate the smaller details that are too intricate for the main stencil.

Once the first full figure is stuck down as in the step 3 illustration, it is useful to extend it enough so there is a reference for the distance to the next character, and so on and so forth. The method is continued in this manner until the whole image is laid out.

With the whole image fixed firmly in place onto the stencil paper, it is time to start cutting. Cutting stencils as intricate as this can be a time-consuming process and if you can get any assistance when doing this I would strongly advise you do so. Before cutting commences just check over the whole design and, if need be, simplify over-elaborate detail and any unwanted islands.

With this design a dark colour is sprayed over a light background. As such all the dark areas needed to be cut out of the stencil paper and all light areas needed to remain in place. With this particular image, even when simplified, there were still a lot of these white islands that could not be bridged and this is where a second stencil came into play.

Before starting to cut the main stencil I traced over each figure, following the general outline, and traced the small islands of highlight and shade, as can be seen in the step 4 illustration. These were

Step 5 Main stencil positioned in place. Make sure the positioning of your stencil is guided by registration marks. Once aligned you will need to fix it in place using tape or spray adhesive, or even both.

Step 6 First spray application. Apply your paint through the stencil, being careful not to paint, spray, or roll on too much paint in one go. Take your time and apply several thin coats if necessary.

Step 7 Lining up the second stencil. Secondary stencils can be applied once the first stage of paint application has dried. Once again you will need to pay attention to achieve good alignment.

Step 8 Finished Dryopithecus stencil. The finished stencil artwork can be really effective when attention is paid to the whole process, following a clearly laid out plan.

Step 9 More complex stencilled figures. Making stencil work of this nature, using the same basic principles as outlined here, can be used to make quite complex compositions.

then cut directly from the tracing paper, which was subsequently employed as a stencil for these smaller aspects. Tracing paper, with the right amount of adhesive, will work adequately as a stencil on some surfaces but not so well on others. Too much spray will leave a gummy residue on your image and too little will hinder you from adhering the stencil to the canvas or wall. Always do a test sample before committing to the stencil proper.

If you are using more than one stencil plate you will need to work out a satisfactory system of registration marks that will facilitate the exact lining up of each stencil.

For this exercise I applied the stencil to a canvas that had been stretched onto a wall in my studio. You may wish to apply your stencil straight onto an internal or external wall. Either way you will need to make sure that the surface is sound, completely dry, and free from any grease or dust. For the canvas used here I based it out with a premixed gesso – an acrylic substitute rather than the proper gesso made of rabbit skin glue and chalk – and this gave me a really nice, flat and absorbent finish that was ideal for the spray paint used. If possible avoid using base coats that have any sheen to them as this may reject the spray and cause 'cissing'. Cissing is the technical term used for when paint fails to adhere properly to a surface to which it is applied, and this will result in beading and unwanted drips.

With the stencil now cut and in place, all that is left to do is apply the spray paint as described in the earlier exercise. In the examples shown, I chose the simplest chimp-like Dryopithecus figure to illustrate the process. This may be the least complex figure in the composition, but the same principle applies throughout.

To make Boris more instantly recognizable I used several layers, allowing for more tonal information than was used for the more generic figures in the rest of the image. I was able to achieve this by putting the initial composite through Photoshop, and with

You can use the same principles described above to create stencil works that are built up in several layers, adding different tones and colours with each.

the 'Posterize' tool reduced the image to four tones as opposed to two. Once the image was printed out I was then able to take tracings and cut the relevant stencils for each of the tones.

The majority of my mural work is painted on canvas in my studio in this manner and subsequently rolled up when finished, then delivered and installed in its designated location. When stretching a canvas onto a wall it is good to get into the habit of allowing

For this exercise I took my reference image from a maquette I'd made for a series of easel paintings. This one is entitled 'Fat Bacchus #2'

As in the previous example, it is possible to reduce the photograph to a manageable amount of tones. For this piece I opted for four tones, and made a stencil for each.

an added margin all the way around. Doing this will give you some leeway should there be any discrepancies when it comes to installing your work. Your canvas can then be trimmed to the actual given space, making for a snug fit.

As with the previous stencil I used aerosols for this image. For the intricate areas I used masking film to cut out the smaller details. Note how the surrounding areas are also masked off, this time with cheap polythene. The polythene helped protect the rest of the canvas from being damaged, but it is advisable to cover anything of any value beyond the parameters of

the canvas too, just in case of any unwanted overspray.

Most of this image was produced using a combination of stencils and masking film and, as you can see in the illustration, I also hand painted some of the other details such as the backlight in the rear archway. In the final full-page image you will also see how I mixed a warm colour for the fluting of the right-hand side of the columns to suggest a warm, reflected light. This helped give a bit of character to the painting and create more form to the composition.

Stencilling is a very efficient way of working, and incorporated glazes or hand-painted embellishments with your stencils will make it a very versatile way of working too.

For the base colour of your stencil it is usually advisable to select the colour that is the most predominant in your design. In this instance that colour was black.

On something this size it is possible to transfer the image using a digital projector directly on to tracing paper, or any other stencil material, and draw and cut from the projected image.

When you have your main stencil firmly fixed in place, you can begin spraying the first application.

Always remember to mask off any areas that do not require being coated… that includes any items/areas beyond the canvas or wall parameters!

Work into the stencilled areas and hand paint any details that will enhance the finished piece. Here you can see how I painted the inner portion of the rear arch as a base for a subsequent layering of warmer colours to give it a glow.

Here you can see further additions such as the hand-painted warm glow visible through the rear arch, and the reflected warm light on the right-hand side of the fluted columns. Always be on the lookout for opportunities to mix techniques, such as stencilling and hand painted aspects as seen here; they can work to great effect.

Trompe l'oeil

Brighton Beach mural, Hotel du Vin, Brighton. Trompe l'oeil works well when there is a blurring of boundaries between what is painted and what is real. In this illustration you can see how the actual returns of the wall and the floorboards are echoed in the painting.

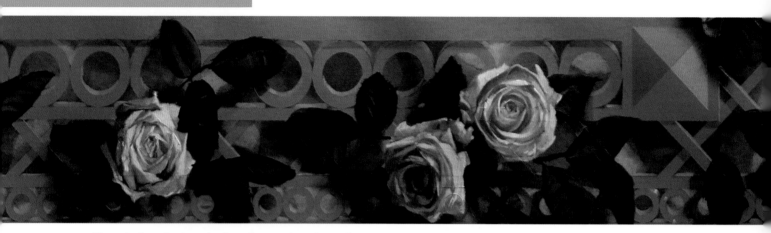

The painting of a drop shadow glaze, as though cast from the roses on to the lattice, helps create the illusion that the roses are coming away from the trellis.

It seems a little crazy trying to cram the subject of trompe l'oeil into one chapter when it could quite easily fill a whole book. But it is often a part, and sometimes a big part, of mural painting that makes it a difficult business to sidestep. I will therefore endeavour to at least give you an outline and highlight a few often-used techniques that you will find useful, whilst drawing your attention to how you can bring different elements and working methods together to create really interesting trompe l'oeil artwork.

Trompe l'oeil is a term that is used to describe a painting, or part of a painting, that is made with the intention of testing the viewer's sense of perception and translates loosely into English as 'deceives the eye'. In other words, trompe l'oeil works as an optical illusion. In decorative terms this can refer to paint effects that are created to imitate materials such as marble, stone and wood, and in its artistic context it is usually associated with the depiction of architecture, and other objects, painted in such a way as to lead the viewer into believing that these features exist within a three-dimensional space.

The practice of employing trompe l'oeil techniques as a pictorial device is not uncommon in mural work and you will find many examples. Typical scenarios will include a landscape or vista viewed through an architectural aperture such as a window, arch, or a series of classical columns. This kind of deception works because attention is drawn to both the picture plane, where the architectural aperture tends to be depicted in the foreground, and the illusion painted beyond it. It acts as a framing device and also provides a good opportunity for a mural to contain and reflect elements of the actual surrounding architecture, and this latter aspect helps blur the boundaries between what is painted and what is real. The image of the *Brighton Beach* mural, used in the opening pages of this chapter, serves as a good example of this notion of the blurring of boundaries – in it you can see how the real wall returns and floorboards are continued and echoed within the painting.

The term 'trompe l'oeil' first appeared during the Baroque period of the seventeenth and eighteenth centuries, though plenty of evidence alludes to the

artform existing way before that, and even as far back as antiquity. In his book *The Lives of the Artists*, Giorgio Vasari writes about Giotto (*c.*1267–1337) playing a trick on his master, the Florentine painter, Cimabue (*c.*1240–1302?), by painting a fly on a mural that he was working on. Further back in history there is the anecdote, as told by Pliny the Elder (AD23–79), of a painting contest held in the fifth century BC between two of the greatest artists in Athens at that time, Zeuxis and Parrhasius. According to the story, Zeuxis had painted a bowl of fruit so lifelike that the birds flew down from the trees in an attempt to eat the grapes. Naturally assuming victory was his, Zeuxis called on Parrhasius to draw back the curtain concealing his painting, only to discover that the curtain was in fact the image that Parrhasius had produced. Zeuxis had succeeded in fooling the birds, but Parrhasius had fooled not only a man but also a fellow artist!

Sadly the above examples are only anecdotal, and the complete lack of any existent evidence of the works in question only leaves us guessing as to the veracity of these tales. Fortunately, however, there are plenty of other examples of excellent trompe l'oeil from the past that can still be witnessed today. Brilliant examples that spring to mind include the *Diptych of the Annunciation*, by the Netherlandish artist, Jan van Eyck (1390–1441), in the Museo Thyssen-Bornemisza, Madrid; the beautiful sixteenth-century trompe l'oeil paintings by Paolo Veronese, in the Villa Barbaro in Maser, Italy; and, perhaps one of the most virtuosic displays of trompe l'oeil ever painted, in the church of St Ignatius of Loyola at Campus Mattias, Rome. The last, of breathtaking quality, where Andrea Pozzo (1642–1709) was commissioned to paint a domed ceiling with a cupola where none existed, is a truly stunning example of how far illusionistic painting can be taken where there is the will and, perhaps more importantly, the budget to fund such a project.

I doubt any of us will ever get to tackle anything on such a grand scale as the church of St Ignatius but, no matter how great or small the scope of your future projects may be, to equip one's self with an understanding of some basic principals of trompe l'oeil will put you in good stead for most possible scenarios. With that in mind, I think it would be instructive to start off by illustrating some elementary aspects of trompe l'oeil and then build on those, whilst introducing other aspects already touched upon in the book, such as perspective, with a view to understanding how you can develop really interesting trompe l'oeil that can be incorporated into mural designs.

Simple marble and stone effects

We will start off by looking at a couple of trompe l'oeil surface effects. There are many trompe l'oeil effects that can be achieved, and should you wish to learn more about marbling, wood graining, or any of these kinds of paint finishes there are plenty of easily accessible books, courses, and online tutorials that cover these areas. But, for now, I will demonstrate a simple yet effective method of producing a generic limestone finish, and a generic Carrara marble finish.

Choice of medium

It is possible to create most effects in either oils or acrylics, though where the effect requires the application of numerous layers I would recommend using acrylics, purely and simply because of the pragmatics of drying time. The drying time between coats of oils could mean literally taking days to finish an effect; using acrylics makes it possible to produce the same effect in one day.

As regards the glaze medium, it is possible to use a ready-made glaze such as Polyvine scumble glaze – a product I use a lot when creating effects – but on projects that require speed and efficiency I would opt for a solution of one part matte medium to one part water. Both of these glazes are quick drying, though the scumble glaze takes a longer time to cure, requiring twenty-four hours between coats.

Always aim to keep your effects simple and try not to overwork them. These trompe l'oeil finishes always work best when they appear effortless.

For these particular exercises you will need a selection of brushes including:

- 3in varnishing brush
- 2in decorating brush with synthetic bristles
- Selection of round brushes including some fine lining brushes
- Badger-bristled brush
- Stippling brush

Colours
- Titanium White
- Yellow Ochre
- Raw Sienna
- Burnt Sienna
- Raw Umber
- Ultramarine Blue
- Ivory Black

Clear glaze medium – for this you can use a premixed glaze such as Polyvine scumble glaze, or you can mix your own glaze medium using one part matte medium to one part water.

Equipment
- (Disposable) palette
- Sea sponge
- Paint kettles and/or plastic cups

Simple stone block effect

When producing trompe l'oeil effects, aim to keep your effects simple and be aware of the dangers of overworking them – in my opinion, the more simple the effect, the more successful it will be. Avoid making your effects too fussy, with overly elaborate layering and fussy detail – most effects work best when appearing effortless, with as little evidence of the hand in

their production as possible. When executed with natural-looking colours, and subtle textural effects, these effects can be quite stunning; with less consideration these effects will soon start to look artificial and forced. Take your time and aim to work with good reference: good-quality photographs and/or colour studies, notes and samples obtained from real examples.

Step 1 – Basing out, drawing up and masking off

For this exercise you will need to work on an off-white base, painted in a good-quality commercial acrylic paint – in the exercise shown I used Dulux Trade Diamond matt, and the colour was called 'Gardenia'. The colour of your base will ultimately play the part of your mortar lines, so select a colour that best matches whatever colour you wish your joints to be when the work is finished.

When the base coat has dried you can draw out your blocks using a hard leaded pencil (2H or H), and a ruler or straight edge. There is no definitive set pattern or fixed set of dimensions or proportions you should work to when drawing out your blocks – each project will have its own set of unique requirements and should be considered accordingly. Work out your blocks in proportion to the wall in question, and look at other examples of block work – either real or trompe l'oeil – to give you further guidance. Consider the width in relation to the height of your blocks, and think about how those proportions relate to the size of the wall and the rest of the architectural space in general.

With all your joint lines drawn out you can begin to mask them, using fine line masking tape – also called pinstriping tape. This is an adhesive tape that is available in a variety of widths. The tape used in this example is 3mm. Mask off all the verticals and horizontals of your mortar lines, using a scalpel blade to trim the ends of each length of tape before moving on to the next line. Continue in this fashion until all your lines are masked.

Step 2 Colour palette.

Step 3 Adding the colour.

Step 2 – Colour palette

Once all your masking tape is firmly in place, use the varnishing brush to apply a thin coat of the clear glaze medium over the entire surface and allow to dry – this is to seal the edges of the masking tape and prevent any of the subsequent colour applications from 'bleeding' underneath the tape.

The colours for this exercise should all be prepared as glazes – mixed with amounts of the glaze medium discussed earlier – and can be stored in small plastic cups or paint kettles. For this effect you will need three key-tone colours relatively close in hue and value, and one dark colour and one warm colour for the accents. Mix the colours using the white, Yellow Ochre, Raw Sienna, Burnt Sienna, Raw Umber and Ultramarine. Lay out your glaze colours on a palette, as shown in the illustration and, although they are premixed, you should partly blend them further with the other glazes before applying to the surface. This helps create better blends and subtle shifts of colour and tone in the finished work.

Step 3 – Adding the colour

Once the previous glaze application has dried, and before you add any colour, apply a second coat of clear glaze. Then, using several brushes to apply your paint mixes – one separate brush for each of the key-tones and one for each of the accent colours, to allow the different colours and tones to retain an element of their original identity and not all become the same muddied hue – paint your colours into the wet clear glaze. This step, along with the following two steps, will require efficient working methods so restrict the size of the surface area you paint – you may need to mask off areas and paint your stone blocking in sections, several blocks at a time, enabling you to tackle these steps successfully without areas drying ahead of you. Avoid over-stretching – start off painting only several blocks at a time and judge what works best for the circumstances and conditions that you are working in.

Step 4 Adding texture.

Step 5 Softening the effect.

Step 4 – Adding texture

The acrylic paints and glaze are prone to rapid drying – this is why it is advised, when working on large areas, to work section-by-section rather than trying to complete the whole surface in one hit. Once the paint has been applied, as described in the previous step, you will need to start adding texture using a dampened sea sponge. Soak the sponge in clean water and wring out before applying to the wet painted surface, gently lifting off the glaze in areas, leaving a beautiful organic texture. Try not to dab or press too hard – this works best when the sponge is employed in a gentle rolling action, varying the angle and pressure as you work over the surface. Keep the sponge clean by regularly rinsing and wringing out in the water.

Step 5 – Softening the effect

Once the sea sponge texture has been successfully applied and the paint hasn't quite dried, take a badger-bristled brush and gently brush over the surface of your work. This softens some of the edges of the marks left by the sponging technique, but not all, and it helps create a natural, organic feel to the effect. Badger-bristled brushes are excellent for this kind of work, but they are not cheap, so it is worth bearing in mind that when working with any quick-drying medium, you will need to really keep on top of cleaning the bristles on a regular basis.

Step 6 Removing the tape.

Step 6 – Removing the tape

Allow the surface to dry – at this stage it only needs to be dry to the touch, and not fully cured – and then begin removing the fine line masking tape. To gain purchase, pick at an edge or corner of the tape with a fingernail and pull. This should remove the tape without much resistance, taking a line of paint with it, and leaving a sharply defined fine line of the initial off-white base colour between each block.

Step 7 – Varnishing

The final step of the process, when all of the previous steps are completed and fully dried, is to apply a protective coat of varnish over the whole surface. For stonework effects I would recommend using a dead flat, or matte varnish – you will find that any amount of sheen to the varnish will tend to detract from the desired effect.

A variation on this theme is to paint your effect onto a subtly textured surface. If you are to opt for this method you will need to mix, apply, and manipulate a heavy-bodied paint layer between the steps 2 and 3 as illustrated above.

Step 2b – Heavy-bodied paint mix

In a clean paint kettle, mix up a compound consisting of one part Dulux Trade Diamond eggshell, one part moulding paste, and one part whiting powder. The Diamond eggshell is a commercially produced paint that is ideal for this purpose, and it can be purchased from most hardware stores. The moulding paste and whiting powder, attainable from most art shops, will together with the paint form a strong and durable base coat which can be manipulated into a stippled texture whilst wet. Apply this mix evenly over your surface, using an old decorating brush.

Step 2c – Applying the texture

Whilst the texture coat is still wet, you will need to manipulate it with a stippling brush. Work and rework the brush over the whole area, varying the angle and direction and altering your wrist action to avoid repeat patterns forming in the textured surface. Keep working in this fashion until a subtle stippled texture is achieved. This effect will not work if you have a very rough surface, with high peaks and deep troughs, so you should strive to create a texture that is more akin to coarse-grain sandpaper than to the top of a meringue. If you intend to create this effect over a large surface, it would be wise to break it down into manageable segments and build up the whole area in a piecemeal fashion. If you are too ambitious you may find that areas are drying ahead of you, before you can manipulate them. Plan your approach carefully.

Step 2d – Sanding the texture

Once the entire surface area is treated as outlined above, allow for the textured coat to completely dry (two to four hours). When dry it will have formed into a hard and durable film. This can now be sanded back, using 120-grit sandpaper and a sanding pad or block. This will take off any sharp peaks created in the previous step, whilst softening and reducing the overall effect to a really nice, subtle finish. Once this stage has been achieved you can resume the process starting from step 3 as outlined above.

Step 2b Heavy-bodied paint mix.

Step 2c Applying the mix.

Step 2d Sanding the texture.

These trompe l'oeil finishes can be very effective, simply as decoration or incorporated into a pictorial design.

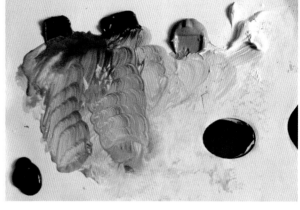

Step 1 Colour palette.

Step 2 Base colour and initial colour applications.

Simple marble effect

Slightly more involved than the previous example, though still relatively simple, this following exercise will show you how to create a generic Carrara marble effect. Carrara is generally a blue-grey marble used a lot in building décor, and is often used in trompe l'oeil work. Although a blue-grey marble, I tend to add the occasional warm colour accent to give it more character.

Step 1 – Colour palette

Mix up some clear glaze medium, as described above, and have a container of it near at hand.

In another batch of the same clear glaze, mix up some mid-grey glaze, using Ultramarine Blue, Raw Umber and a little white – this should be a thinly mixed glaze, which will be used as a key-tone, into which you can add other colours from the palette as you progress.

Prepare a palette with your colours laid out clearly, leaving enough room to introduce your grey key-tone glaze, and enough room to mix variations of the grey with the addition of the colours laid out. Mixing your colours in this fashion will help you achieve softer gradations and more naturalistic looking blending – remember that with these effects, and particularly with this kind of marble, subtlety is key.

Step 2 – Base colour and initial applications

For the base you should apply two coats of a good-quality commercial white acrylic paint – in the illustration I used Dulux Trade Diamond eggshell – allowing sufficient drying time between each application (two to four hours). Once your base is dry you can lightly sand with 240-grit sandpaper before moving on to the next stage.

For the next stage, before the introduction of any colour, apply a coat of the clear glaze medium over the entire surface using the 3in varnishing brush. Whilst this application is still wet, and using the 2in decorators' brush, start to add areas of colour, painting directly into the wet, clear glaze. The colours you add should primarily be your grey glaze, adjusted here and there with a little Yellow Ochre/Raw Umber/blue, to create subtle variations of colour and tone. The

Step 3 First phase of adding texture.

Step 4 Softening with the badger brush.

intention of this first step is to establish the broad direction of the subsequent veining – not to cover the whole surface with colour but to create the underlying patterns of the marble.

Step 3 – First phase of adding texture

Whilst the broad strokes of colour and clear glaze of the previous step are still wet, they should be softened and blended. At this stage this can be achieved with the varnishing brush – the bristles will need to be dry for the best results, so if still wet from steps 1 and 2 you should clean the brush and dry using a hairdryer. Brush gently and evenly over the whole surface – not in an attempt to blend out the directional patterns created by the broad strokes of colour added in the previous step but to modify them into softer transitions.

Before this layer dries you will need to add texture with a clean sea sponge that has been soaked in clear, cold water and wrung out. Apply the sponge lightly to the glazed surface in a manner that will lift off areas of the glaze, exposing the base colour beneath. As

with the stone-blocking exercise illustrated earlier, it is better to do this in a rolling fashion rather than in a dabbing motion. The sponge can be rolled and manipulated in a variety of directions and using varying degrees of pressure. If done correctly this will result in mark making that appears more organic and less contrived – it may take some time getting used to working the sea sponge like this, but it really is worth persevering with.

Try not to spend too long on the sponging as you will also need to carry out the next step whilst the paint and glaze are still wet enough to be manipulated.

Step 4 – Softening with the badger brush

Use the badger-bristled brush to gently brush over the whole surface before it has had a chance to completely dry – vary the direction of your brushstrokes in this part of the process, but maintain a bias in one direction that follows the main flow of the broad strokes created in step 2. The badger bristles have a wonderful and unique way of pulling the glaze, which make them ideal for marbling effects.

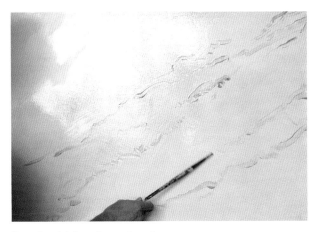

Step 5 Adding the main veins.

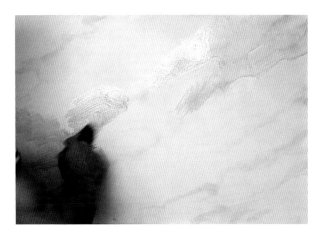

Step 6 Colour accentuation.

Step 5 – Adding the main veins

Allow for the previous coat to fully dry (one to two hours), and then apply another coat of the clear glaze mix over the whole surface using the varnishing brush. Whilst still wet you should start adding the broad veining, using a large, round brush. The colour should be obtained from the Ultramarine Blue and Raw Umber, and mixed to a thicker consistency than the glaze mix described in step 1. Avoid keeping the colour and consistency fixed – it works best when there are slight variations throughout the process. Maintain the flow and direction as established with the 2in decorators' brush in step 2 – these original marks should govern your veining/patterning throughout the whole exercise. As with a lot of veining, when painting effects, the trick is to load your brush and keep using it until the colour is completely spent. This will yield a nice variety of line in terms of both width and density. Be prepared for this aspect and have close at hand good reference images that can inform you of how marble veins look and behave.

Once again, before this coat is dry you will need to soften with the badger brush, blending the veins into the clear, wet glaze. Allow some of the dragging to remain visible, as well as the more softly blended areas, to suggest a variety of texture – a combination of soft and hard edges is as beneficial to these effects as the subtle variety of colour and tone, and density and width of line.

Step 6 – Colour accentuation

Once the previous layer has dried you may wish to accentuate some of the colours and patterns established in step 2. To do this you first need to apply a coat of clear glaze and mix your colours into it, strengthening the colours and accents in places to add depth. This application will need to be sponged and softened with the badger brush as in the previous step 3. The building up of layers in this exercise can be a subtle one. It is possible to achieve a simple marble effect with fewer stages, but unless you are really confident with getting the colours and density of your glaze mixes exact, it is better to build up with a couple of subtle layers rather than to overstate it with just one.

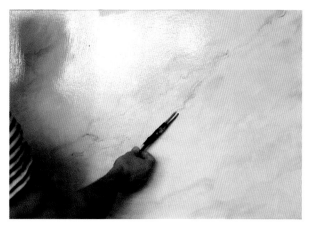

Step 7 Double brush.

Step 8 Cross veins.

Step 7 – Double brush

For the finer veining it is advised that you use a variety of different-sized brushes, working first with medium and then with smaller ones as you progress. That said, be careful not to make it too fussy. In the illustration for step 7 you can see that I am using a double-headed brush, fabricated by taping two small round brushes together – this can be held loosely like a drumstick, and moved in a variety of directions; mainly following the broad vein direction, but also in a jagged and erratic fashion to create a network of markings that can be quite effective with some of these marbling techniques.

Step 9 Ultrafine veins.

Step 8 – Cross veins

The last stages of veining should be performed using small rounds and fine lining brushes to add feint but characteristic fine veins. Work on lines mainly following the general flow and pattern, as governed by the original broad strokes of step 2, but also on some subtle veins running counter to this main direction. Always work into a surface that has been lightly coated with wet glaze – and follow up in places with the badger brush to soften the effect.

Step 9 – Ultrafine veins

With a very fine brush you can add a few thin veins, but be careful with these as the idea is to merely suggest a few and not to overplay them – always remember that too much detail with these effects is usually detrimental.

As with the stone-blocking effect, the final stage of this process is to varnish. Though unlike the stone, for marbling that has been created as a decorative effect I would advocate a satin or semi-sheen varnish. For marbling that appears within the context of a mural, I would advise that a matte or dead flat varnish be used for the whole wall or canvas.

With the addition of perspective, and light and shade glazes, these effects can be embellished to suggest a three-dimensional form.

Perspective and trompe l'oeil effects

The reasoning behind my inclusion of the above trompe l'oeil surface effects is purely and simply to highlight their versatility. They can make beautiful decorative finishes in themselves, and they can also be incorporated into pictorial designs too, giving you the option of adding an extra dimension of interest to any trompe l'oeil architecture within your murals. To do this with any degree of success, however, will require you having at least some understanding of: i) perspective; ii) the behaviour of light and shade; and iii) the nature of cast shadows (or drop-shadows). Within trompe l'oeil artwork, the use of perspective will delineate the form; the addition of light and shade will give your form substance and the cast shadow will determine the form's spatial relationship within the design.

As you develop your skills at creating effective trompe l'oeil, you will no doubt want to refine it further by introducing elements of focus; aerial perspective; and the interrelation between warm and cool colours. For now, let us concentrate on the first of the three main considerations: i) perspective.

If we look at the illustration above, you can see I have taken the stone-block sample of the previous exercise and embellished it to include trompe l'oeil architectural detail. This is just a digital mock-up but it is perfectly valid to transform your stone effect to include such details with the addition of the three considerations listed above.

The stone effect created in the previous example is seen face on. It is flat, without any sense of real depth, and will be read as such, and this is why I refer to these finishes as surface effects. In the digital composite of the niche, however, we have introduced space and depth: the perspective, particularly as used in the mortar lines, leads us to believe we are looking up at a niche that recedes into a wall and contains a classical bust; the light and shade suggests the curved scoop of the niche wall and the modulations of the bust; and the cast shadow tells us whereabouts in the niche the bust sits. All these tricks help immensely with illusionistic work, and the more attention you pay to them the better your trompe l'oeil will be. For better results still, make a physical mock-up (such as the one shown in the illustration) of the thing you have in mind and let that inform you of the light and shade and so on – when done properly this is never a waste of time and will always yield excellent results. But before we jump too far ahead of ourselves, let us now look at a few other examples where the surface effects can be put to good use.

As with the niche, it is possible to apply the rules of perspective to the stone and create a strong illusionistic sense of space and depth within the depiction of larger and more intricate architecture. Any part of your design that depicts a plane that is perpendicular, and not parallel, to our face can be accentuated with perspectival lines that recede toward a common vanishing point. If you look at the illustration of the

Making maquettes will greatly improve the quality of any trompe l'oeil work you paint. They will provide all the information required regarding the effects of perspective, light and shade.

The mortar lines of stone-blocking, when drawn to follow the laws of perspective, create powerful optical illusions.

stained-glass window, which was designed for a small mural in a private residence in the West Midlands, you can see how this was achieved using mathematical perspective. To do this properly I calculated the perspective from the optimum vantage point from which it would be seen and, in this instance, the vanishing point was taken from the height of the client's eye line.

When working on something like this, draw out your mortar lines according to the calculated vanishing point and point of sight. Once worked out and drawn up, you can then run the fine line masking tape to follow these receding lines and add the stone-block

effect as per the previous exercise. To enhance the effect further you should then look at adding transparent glazes over the effect, to suggest the highlighted and shaded areas of the window returns. Together, all these elements create really effective trompe l'oeil work.

Similarly, in the trompe l'oeil columns and marble frieze seen in the Roman mural, Hotel du Vin, York, illustrated in the previous chapter – a detail of which is reproduced here – you can see how a simple marble effect can be incorporated within a perspectival design and further enhanced with transparent glazes to suggest highlights and shade.

Glazes

Glazes for the highlight and shade can be made from the same water/matte medium combination listed above, or they can be made using a premixed acrylic scumble glaze such as the Polyvine scumble. The Polyvine scumble glaze is a relatively clean and easy medium to use. It will remain 'open' for longer than the water/matte medium version, meaning you will have a longer period of time to apply and manipulate your glazes, making it ideal for more complex blending. If your highlight and shade glazes require subtle, diffused blends or transitions you may need to mix a clear glaze and an intermediary glaze (made with one part clear glaze to one part tinted glaze), and blend those into each other to achieve a smoother gradation.

Bringing all the elements together

On a grander scale we can employ all these tricks to conjure up something that has real impact, and creates a strong sense of illusion, as in the Brighton Beach mural illustrated in the opening pages of this chapter.

Although there is not the space here to go through every aspect of this trompe l'oeil mural, you can at least see in the illustration how it all starts off with the drawing, with a heavy reliance on mathematical perspective. But it is a very simple format and you can see where my main vanishing point and horizon line are situated, indicated by the red lines. A centrally orchestrated perspective such as this should not pose too many problems, but when working out your own perspectival solutions bear in mind that it often pays to be a little more adventurous in where you position your vanishing points. Regardless, always work out your perspective first and then, during the painting stage, you can add the relevant textures, highlights and shades to all the elements depicted.

A combination of stencil work, marble effect, perspective, and light and shade glazes can pull together to create effective trompe l'oeil.

Work out any perspective that is required in your work in advance of applying any paint. Always consider the optimum vantage point from which the work will be viewed, conducting the perspective accordingly.

The floorboards in *The Judgement of Paris* mural were painted in my studio using a sample of the timber used in the flooring as a reference. When the canvas was installed, therefore, the colour and grain of the painted floorboards matched well with the newly laid floor. (Photo: Simon Herrema)

For this mural, painted for the Fragrant Nature Hotel, Munnar, in Kerala, India, I wanted to pull out all the stops. In making it, I employed practically every aspect covered in this book: colour theory, composition and perspective, photography, stencils and trompe l'oeil.

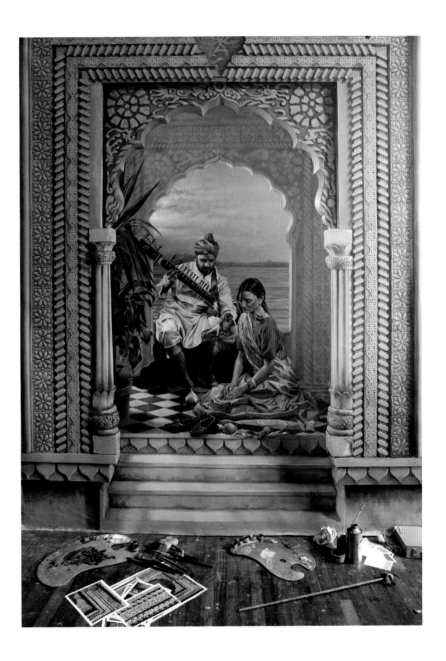

Fragrant Nature trompe l'oeil arch

So far we have looked at fairly basic ideas of trompe l'oeil but, before I bring this chapter to a close, I think it would be worthwhile spending a little time running through the process of creating something more complex – a trompe l'oeil mural containing architecture, foliage and figures. It too draws on the many aspects that we have touched upon thus far throughout the book but shows, more so than the previous examples, just how far we can push our trompe l'oeil effects with a little bit of know-how.

In creating this next piece I employed elements of colour theory, and I also had to draw on my knowledge of perspective, photography, composition, stencilling, and model making – in short, pretty much all of the aspects, methods and approaches that have already been discussed in earlier chapters. As such we needn't dwell too long on repeating stuff here, but it should be useful to illustrate how these different strands can be pulled together to make a comprehensive and effective piece of trompe l'oeil work.

Step 1 Drawing.

Step 2 Model box.

Step 1 – Drawing

As usual, the drawing comes first. Always make your ideas manifest in the form of a drawing even if it is just a very crude thumbnail sketch. This is a drawing I put together – using a combination of analogue and digital, the hand-drawn and the digitally cut and pasted – for a mural for the Fragrant Nature Hotel in Munnar, Kerala, India. The idea was to create a piece of trompe l'oeil artwork for a restaurant area of the hotel.

The drawing of the arch was loosely based on some images I had downloaded from the internet of ancient fortresses of the Mughal age of India, and onto the basic design of the façade I was able to introduce a perspectival layout of the tiled floor and background window.

I wanted to introduce a romantic aspect to the image so I included a courting couple compiled from independent internet searches – as you can see, the perspective correlation between the figures and the architecture is not quite correct here, but for the purposes of a presentation drawing it is perfectly fine.

Step 2 – Model box

In Chapter 4, I discussed how using a box to suggest a piggery would help with the rendering of the trompe l'oeil aspects of the subsequent painting. Here I have adopted the same principle. Though admittedly in this instance the maquette was pushed a little further to include the intricate architectural detail. But the basic idea is the same.

From the drawing, and the photo references I had collated, a maquette was made – I can't actually take credit for this brilliant model box: all thanks in this instance goes to my talented studio assistant, Amanda Bradshaw. Having studied stage management and set design at RADA she was way more equipped to do this than I was.

The maquette was constructed from sheets of MDF (medium density fibreboard), cardboard, modelling clay, plastic drinking straws, glue and paint. The model was made primarily for the purposes of studying how the light and shade behaved on and within the main structure, and was perfect for my needs. I

Paper mock-up of arch.

Step 3 Photo shoot.

would not expect many other people, myself – without my assistant – included, to go to such lengths as this. If you were to try this yourself you may just want to focus on the basic aspects of the main solid structure, and the basic features of façade, steps, arch and tiled interior, and leave out the elaborate architectural decorative detail. Those details and information can be sourced from the internet, and if need be, added in the painting stage of the production.

Lighting is very important with mural painting, and even more so in trompe l'oeil work. When taking reference photos of your props or people it is imperative that you maintain consistency of light. When photographing the model box I rigged up some rudimentary lighting, using natural light for the exterior and a small angle-poise table lamp for the warm light of the interior. This cool/warm lighting juxtaposition was then replicated in the subsequent studio photo shoot with the models.

Step 3 – Photo shoot

For the photo shoot I put together a crude arch structure made from lining paper and gaffer tape – this served two purposes: to separate the warm light of the interior from the cool light of the exterior; and to give me an idea of the proportions and sense of scale between the arch, cast and props. This always proves useful when creating the later composite and when scaling the drawing on your canvas.

The models I used during the photo shoot are friends of mine who were happy to come along, get dressed up for an hour or so and pose in front of the camera. And they were perfect. With everything in place, and with lighting that was sympathetic to that used for the maquette photograph, I was then able to obtain the desired photo references for my painting. Using cameras and arranging photo shoots are discussed in Chapters 4 and 8.

Step 4 Digital composite.

Step 5 Blank canvas.

Step 4 – Digital composite

The next step of the process is to combine the models with the model box and the step 4 illustration shows how I was able to make a collage of the photographed figures and the maquette. This was achieved with a basic cut-and-paste job using Photoshop.

It is of vital importance that you monitor your camera settings during the photography stages so that both the model box and your figures in the photo shoot correspond. The slightest deviation will always show in your composites if you are not careful, so be sure to pay attention when taking your shots.

Now that you have a composite with all the elements of the design in place, it is possible to project straight onto the canvas and begin drawing out the image in full. If you approach this in the correct fashion, with all your proportions and perspective working in concert, you will be able to perform this task without having to work out any of the perspective on the canvas.

Step 5 – Blank canvas

As discussed in greater detail in Chapter 1, most of my work is carried out on canvas stretched onto one of my studio walls and, on completion, it is rolled up, transported, and installed in its new home.

Ordinarily I tend to colour my ground before any drawing or painting takes place – this is discussed in greater detail in the next chapter – and as you can see here, I often opt for a neutral mid-tone colour that is not too far removed from the colour of artists' linen.

Step 6 Drawing out.

Step 6 – Drawing out

As mentioned earlier, if planned correctly, you will be able to project and draw out your composition directly from the digital composite like this, without any further workings out of the perspective, meaning that the hard work put in during the preparatory stages results in a lot less work at this stage. That said, there might be parts of the composition that distort in the projection and need to be corrected. In the illustration you will see that I'm using a length of string, taped to the vanishing point in the composition, in order to re-establish the important perspective lines of the steps and the chequered tiles – this is a very basic method, but one that nonetheless works very well.

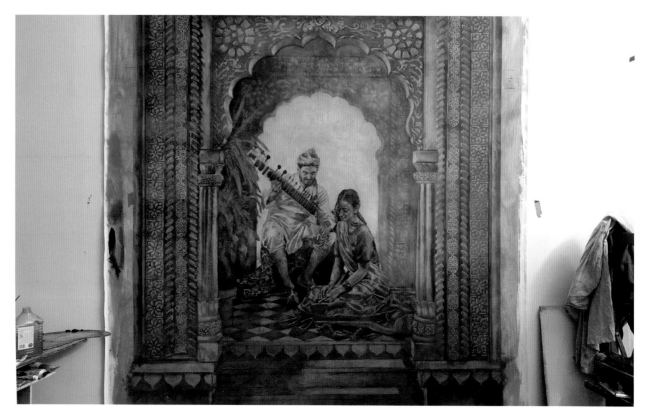

Step 7 Blocking in.

Step 7 – Blocking in

It is useful to get a lot of information onto your canvas as soon as possible. Once the image has been drawn out and fixed, begin by blocking in all the main areas of colour and tone in your design. This will give you a good idea of the overall composition and will make it easier for you to judge any strokes of colour added in the later stage of painting, as it will already have colour and tonal values surrounding it.

To run through each part of the painting process of a project this complex would, understandably, take up a lot of time and space, but as we are currently focusing on trompe l'oeil, a more detailed discussion of the trompe l'oeil aspects of this canvas will follow.

Step 8 Finishing up in the studio: At this stage the work is well underway but the drop shadow glazes still need to be applied to the architecture.

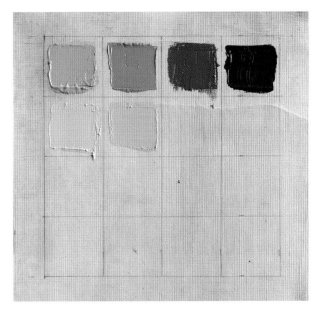

It is adviseable to premix your colours before tackling something of this nature as it will maintain the consistency of colour throughout, and it will save a lot of headaches caused by having to mix and remix the colours as you proceed. Note how I have mixed both a warm and a cool highlight – one for the main cool highlight, and one for the warm reflected light. This combination works very well with trompe l'oeil artwork.

Step 1 Stencil.

Trompe l'oeil architectural details

Step 1 – Stencil

For the fine and decorative aspects of the carved architecture on this canvas, I used a series of stencils. For the purpose of illustrating the process, I have just focused on the round floret detail. These stencils were all cut by hand – considering the relatively small scale of this project, and the nature of the stencils themselves, it was considered more efficient to opt for the hand-cut approach using Manila paper, as discussed in Chapter 5, rather than having vinyl stencils cut on a machine. When cutting stencils like this, where there is a repeat pattern, it is best to cut them in series rather than as individual stencils so as to help maintain better alignment.

Step 2 Stencilled canvas.

Step 3 Progressive stages of the painting process.

Step 2 – Stencilled canvas

The base colour on the canvas for these areas should be slightly darker in colour to that which will be forced through the stencil. This allows the stencil shape to be clearly delineated and, as the darker areas represent the recesses of the carving, which would be darker anyway, you are already on your way to creating the suggestion of form.

Following the same stencilling procedures as outlined in Chapter 5, the next step of the process here is to align the stencils and apply the paint using a stippling brush. When doing this, be careful to reduce the texture of your stipple by a repeated stippling action, progressively reducing the pressure of the brush. Care should also be taken to wipe clean both sides of the stencil between each use.

Step 3 – Progressive stages of the painting process

In the image for step 3, each square and floret as you move down the image illustrates a progressive step of the painting process, creating the basic form of the carved florets. Once the stencilled coat is dry the next stages of the process, running from top to bottom, are as follows:

- The top square – square 1 – this shows the dark colour applied to the shadow sides of the floret; the main light source for this was a cool, natural light spilling in from right to left, the references for which were obtained from the photos of the model box.
- The second square down – square 2 – shows the dark mid-tone, painted wet-into-wet with the previous darker colour.
- The third square down – square 3 – shows

Step 4 Warm and cool highlights.

Step 5 Shadow glaze.

the key-tone, blended wet-into-wet with the previous applications.

- The fourth square down – square 4 – shows the light mid-tone painted to suggest the main highlight areas. A darker outline was also added to the recess areas to help redefine the floret shape and create more depth to the bas-relief form.

Step 4 – Highlights

The next stage is to add the main highlights. These are just little glints that really lift and accentuate the sense of form. For extra fullness, I added a cool main highlight falling right to left, but also a warm reflected light picking up a source coming from left to right. This combination of cool and warm can work wonders with trompe l'oeil work – but not so much when treated in a heavy-handed fashion, so take your time and judge your colours carefully.

Step 5 – Shadow glaze

In this illustration you can see how a shade glaze has been added on the right side of the image – acting as both the shade and cast shadow of the vertical, half-round architectural detail. This is such a simple effect that takes only minutes to apply and yet transforms the artwork, immediately giving it the illusion of depth. Where possible you should always make your highlight and shade glazes using transparent or semi-transparent pigments. For this shade I used Ultramarine Blue, Rose Madder and a little Cadmium Yellow pale. The main constituents (the Ultramarine and Rose Madder) are transparent, and the yellow, used only fractionally to tone down the chroma of the glaze, is opaque.

This trompe l'oeil clock face was produced using moulding-paste mixed with metallic paint to give it texture. The mix was then used in conjunction with stencils and a cheap engraving tool to create the intricate patterning. Opaque paints and transparent glazes were later added to achieve shadows and highlights and the illusion of the cavities. A further glaze was applied and manipulated to give the clock face an antiqued appearance.

Step 6 Finished section.

Step 6 – Finished section

Here you can see a larger section complete with highlights, shades and drop shadows. This works well and seems to have a lot of form. What also really helps here is the play of warm against cool colouring, and the shift in focus from foreground to background. These are the kind of refined tricks that you can bring into play when you become more confident in creating trompe l'oeil, with the basic three elements of perspective, light and shade, and cast shadows.

Producing work like this takes a lot of time, as does learning the tricks and techniques involved. Patience is often required. But the beauty of it is that with each small step of progress comes the reward of seeing the results of that progress along the path of your journey. Never lose sight of what you are aiming for, and be reassured by the knowledge that you can only get better and you will never stop learning.

I'd like to end this chapter with a couple of examples of some of my trompe l'oeil projects that I think have worked well, not least because I have pushed the envelope in mixing up disciplines combining stencilling with freehand; acrylics with oils; and metallic-paints, moulding-paste and glaze manipulations. Don't restrict yourself; combine your methods of working and see how far you can push the levels of trompe l'oeil achieved!

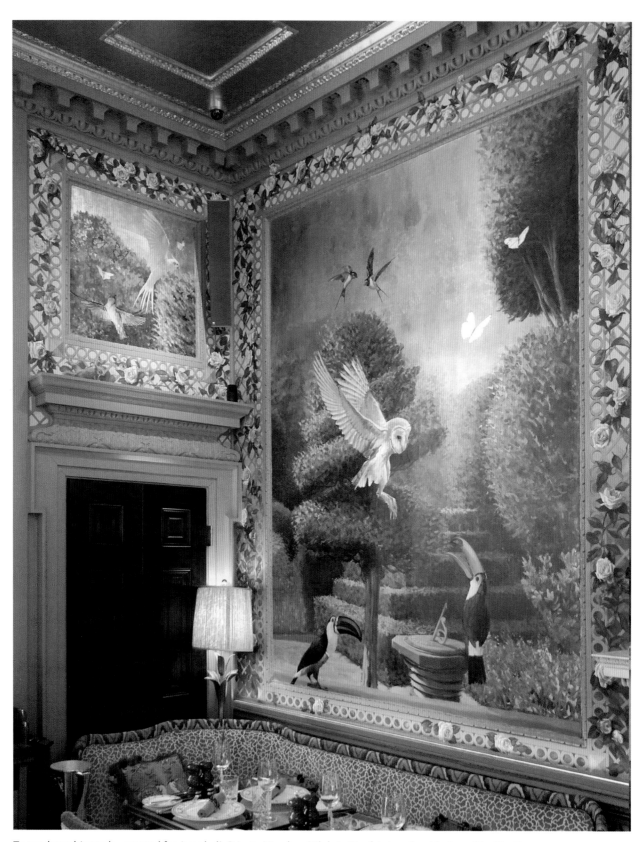

To produce this work – created for Annabel's Private Members' Club in Mayfair, London (designed by Martin Brudnizki Design Studio) – I rigged up a section of lattice, purchased from a local hardware store, and positioned and lit roses from which I was able to take photos to use as my reference material.

CHAPTER 7

Landscape

Detail from my mural entitled *Pilot Cutter on the River Thames*, painted for The Pilot, in Chiswick, London. It pays to have a clear idea at the outset of what you want from your landscape. For this image, the old-fashioned vessel was part of the brief I was given, but I wanted to set it at twilight to give me the monochromatic cool tones, accented by the colours of the setting sun. (Photo: Danny Boggi)

Landscape

The composite seen here of the Lake Palace, Udaipur, in India, albeit more sophisticated in its appearance, is just a digital version of the manual composites used in previous chapters using layers of tracing paper.

Most of the mural work I have produced to date has been concerned with depicting groups of people situated in some kind of interior and, although several have incorporated an element of landscape within them, I have painted few that have dealt with landscape as the primary focus. That said, I have always enjoyed painting landscapes and it is certainly a subject that is worth consideration here.

Compared to painters of the past, in terms of the technology we have at our disposal and the wide range of materials and equipment that are so readily available, we should consider ourselves lucky when it comes to planning and painting landscapes. Prior to the mid-nineteenth century, the Old Masters would have ordinarily painted their landscapes back in the studio working from colour studies, sketches, and notes made earlier on location. Although these sketches and colour studies would be rendered faithfully, working in this manner could mean losing some of the freshness that is achieved when painting from direct experience.

In the mid-nineteenth century, with the advent of the collapsible paint tube, which made paints infinitely more portable, artists were increasingly able to make finished paintings of nature from nature, recording the effects of light and shade from direct experience. It is well known that the Impressionists made full use of the easy-to-carry materials and equipment. They also made full use of the scientific studies of colour perception that were being explored at that time. And, equipped as such, they were able to go out into the field and transform the traditional attitudes and approaches to painting landscape.

In making landscapes today we have the option of working in either fashion. On the other hand we could, theoretically, just simply go out and take photographs of our chosen motif and work from those. I say theoretically because, unfortunately, it is not quite as straightforward as it may sound: photography has its limitations when used for this purpose, such as the camera's limited view and its interpretation of colour, line and light. The camera translates what it 'sees' through a mechanical process that is restricted

Landscape and Merchants, Claude Lorraine, 1629, oil on canvas (image courtesy of the National Gallery of Art, Washington). Works that are created in the studio from studies and notes or from the imagination work well but often have an otherworldly feel to them.

Ile de France, Camille Pissarro, 1873 (image courtesy of the National Gallery of Art, Washington). Impressionist paintings are usually fresh and full of life; capturing the effects of light and benefitting from having been produced from first-hand experience.

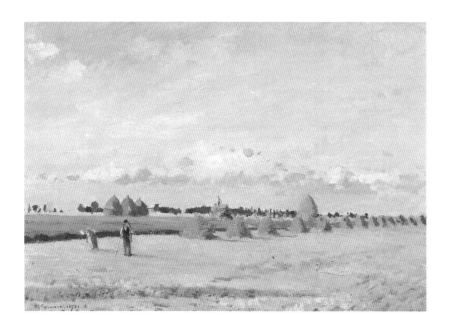

Using a wide-angled lens can result in some very dramatic landscape photographs. Unfortunately they don't always translate very well into paintings, especially large mural-sized paintings, as there is usually too much perspectival distortion.

One approach to overcoming the limitation of a camera's one-eyed way of seeing is to make composite images from a variety views. In this example you can see a simple composite image creating a narrow panorama.

Here we see another simple composite image. Using several photographs and stitching them together can create impressive panoramas, but this will only work to a degree before everything starts to look forced.

Photomontage of the Swing Bridge, Tyneside. Here you can see a more complex version of a photo stitch, which was used in my Tyneside evening mural; very similar to the Cubist photography propounded by David Hockney where objects and landscapes are analysed from many viewpoints and then stitched together. When transposed into a painting these need to be modified a fair amount to be readable in a more conventional way. Although a lot of compromises need to be made with this method, it can work well in creating a sense of size, scale and space in a large mural where a wide-angle lens image performs less well.

to a one-eyed way of seeing, and as such it struggles to interpret space and depth, as we perceive them in real life. Photography also has problems understanding and translating dark shadows and bright highlights, capturing very little or none of the subtle nuances of colour that can be detected by the human eye. So if your photography skills are not quite up to speed it is not difficult to end up with images that suffer from over-exaggerated perspective and distortions of colour and light.

There are arguments against the use of a camera when making paintings but, whilst I agree that there is much validity in this purist approach when applied to making easel paintings, when designing and painting murals we have to be realistic and be governed by pragmatism rather than ideology. As a mural artist your camera will be, a lot of the time, your best friend; you just need to be aware of its limitations and how best to overcome them. Although we can make studies from nature, as mural artists we don't really have the luxury of being able to paint the whole image en plein air, from nature, in front of the actual motif, so some compromises will always need to be made. In this day and age, however, with the knowledge we can glean from the Old Masters and the lessons taught us by the Impressionists, it is not impossible to take these insights and make a decent landscape mural by applying them to our practice when working from photographs and other references.

The two murals I have decided to use as examples here centre on the same subject matter: the River Thames. They are both viewed from pretty much the same vantage point, though one of them looks in a westerly direction toward Kew Bridge, and the other is looking east toward Chiswick. Although they bear many similarities I figured they both justify being discussed here from a practical point of view as they differ in both their construction and in their execution.

Even the most basic of studies can prove useful. It's good to try out some small studies just to see how certain colour relationships will work out. On these small A5 sheets of acrylic paper I was testing simple sky tones and colour relationships on a coloured ground in preparation for *Pilot Cutter on the River Thames*.

With the first example we will look at how to use a landscape as a backdrop, or a framework, onto which we can hang other elements drafted in from another source and made to work as a coherent composition. Whereas this example used a landscape composition that was almost given, in that it was largely acquired from one photograph, the second example demonstrates how it is possible to construct a coherent landscape from a composite of different views using several photographs.

Getting started

As with any project you embark upon, one of the first considerations you will be faced with are the proportions within which you need to plan your mural and how your image might work within those proportions. Another consideration of importance, early on in the process, is establishing the height the horizon line will need to be. The height of the horizon in a composition – bearing in mind that, when looking at a vista, the horizon line is always consonant with one's eye level – will govern how others subsequently view it. This is an important detail if you want your vista to have any degree of credibility to it. Consider whether your mural will ultimately be viewed primarily from a standing position or from a seated position. The latter may be the case if the mural is commissioned for a restaurant or dining room. You should then plan the height of the horizon line accordingly, bringing it in line with the relevant eye level. This should also be borne in mind when taking your photographical references. In short, there is no point in taking your reference photos from a high vantage point if your painted image is to be viewed from a seated position or vice versa.

Acquiring good reference material

Taking photographs will obviously require a visit to the relevant location, and this will always take time and planning. You might, on the other hand, prefer to dispense with the idea of going on location to take photographs, or make sketches and colour studies. Instead you may wish to search the internet or elsewhere for suitable imagery to inform your mural. That is obviously an option and, for a subject like the Thames, there is a plethora of images that can be sourced in books, on line, and in film. That said, if you choose this way of working you will soon realize that it is practically impossible to get an image in this fashion that will satisfy all your requirements for the painted composition, with the perspective you have in mind or the right vista or angle of view that suits the image you hope to paint. In such circumstances there is no substitute for first-hand research and you may well find that, depending on time and budget, photography is the most pragmatic option. Living in London made it easy for me to make several trips to the Thames and find decent locations. Regardless of the proximity of the location, however, I would suggest that where and whenever possible, you travel to get your references first hand. Needless to say, accounting for this aspect when calculating the cost of the commission is important.

When planning a location shoot, you should be prepared to spend a good amount of time on reconnaissance walks, finding the best vantage points for the painting you have in mind. If you want dramatic lighting in your image you may wish to consider taking your photographs during what some photographers call the 'golden hour' – a period of each day that occurs for approximately forty-five minutes or so at dawn and dusk, according to the relevant season and latitude. If so, be prepared to get up very early in the morning if you want that dramatic shot of the sunrise. For these examples I used both: the westward-looking painting, toward Kew Bridge, is set at twilight as the sun is setting; and in the latter composition, looking east toward Kew railway bridge and Chiswick, the sun is just coming up. For the latter it was necessary to get up early enough to be in place, set up and ready to document the glorious change of colours as the sun started rising. It was very early, very dark – at least to start off with – and, as the photographs were taken on Christmas morning and Boxing Day, it was very cold. But it was also well worth the effort.

In preparation for a mural like the ones discussed here you may even need to make several visits to your chosen location. I made half a dozen trips down to the Thames and I shot hundreds of photographs for each composition. A lot of the photographs were aimed at capturing an overall vista, but there were also many detail shots taken too. Take as many photographs as

Backing up your reference material

When working in this manner it is crucial that you keep a backup of all your reference photographs. As an aside: you should get into the habit of backing up all your photographs, whether they are your reference photographs or the documentation of your finished drawings, paintings and murals. To lose a record of any of these, at any stage, can prove to be a costly lesson.

you think you may need, and then take a few more for good measure. Don't expect to get your ideal shot first time around, and don't be disappointed when you don't. It pays to persevere.

At high tide, along this particular stretch of the Thames, unless you have access to a boat or landing stage, it is only possible to take images from the level of the roadside. I needed a low tide so I could get down onto the riverbed as low as possible for the kind of image that I had in mind, so it was necessary for me to ascertain the dates when the low tide and sunrise coincided. This information is easily acquired online, and if you are ever to tackle something similar to this it is essential that you check out in advance the weather forecast and tidal times – and regardless of whether you plan on taking your sketchbook or your camera, safety must always come first.

Whatever light or atmosphere you plan to use in your mural you must aim to work every step of the way with those conditions in mind. I wanted my landscapes to have dramatic lighting, with the colours of a sunrise or sunset providing a burst of warmth to an otherwise cool and monochromatic palette. This is why it was necessary for me to take my reference photographs during the golden hour of morning and evening, as it gave me the tonal range I was looking for. Put simply, the reference material you acquire and use needs to be in concert with the image you intend to make. It is not possible to force your desired colour and tonal arrangement onto a landscape image

taken from any other time of day or season, and hope to achieve a coherent and natural-looking painting. Don't waste your time trying to paint a dark picture using references of a subject that is not dark – the chances are that it will just end up looking wrong. Forced colour and tonal relations will always stand out as being wrong if naturalism is something that you are striving for.

Composing the landscape image

Superimposing extraneous elements

Once you have collated all the reference material for each aspect of your design you can start building the composition. In the examples shown here there are two variations of how to achieve this. With the first example, *Pilot Cutter on the Thames*, we start with a basic landscape taken from one photograph. The photograph required a little editing when being transferred to the canvas, not least in the removal of some of the high-rise buildings in the far distance, but on the whole it contained everything I needed for the composition. The only thing left to be added was the pilot cutter of the title – pilot cutters were used in the olden days to assist in the safe navigation of the large trading ships along the Thames. To incorporate something like this into a landscape is a relatively easy operation once you have the basic layout of your design mapped out. This can be done freehand or on a computer but in this instance, with only one element being drafted in, I considered it easy enough to work it out by eye, directly onto the canvas using an overhead projector.

This kind of addition requires no more than sourcing a suitable-looking image of the object you wish to include, making sure that the lighting and perspective are somewhere within the same register as your background reference. You then need to make a tracing of the image, which you can project directly onto the mural.

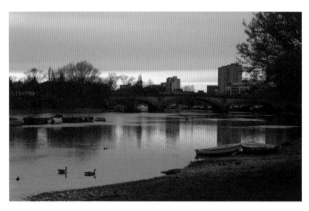

Here we can see the photograph that served as my main reference for *Pilot Cutter on the River Thames*. Note how several adjustments were made between the photograph and the final image. As well as the obvious addition of the pilot cutter, I also (amongst other things) enriched the colour scheme and eliminated some of the high-rise flats in the distance.

Tracing out elements on acetate and then using them with an overhead projector is a very efficient way of introducing extraneous features into your composition.

To do this you will need an appropriately sized printout of the image in question and, using a fine-tipped marker pen you can trace the image onto a sheet of acetate. It is advisable to use a permanent marker so your lines will not be easily erased from the tracing. The acetate drawing will provide you with a clearly defined outline of your image, which can then be used with the projector, scaling and positioning the image directly onto the wall or canvas. Once the composition is drawn out, it can be painted into the rest of the image.

The above explanation describes a simple method of arriving at a composition, but it would be misleading to imply that all compositions are arrived at so easily. Before we move on to the painting stage, therefore, it would be instructive to consider a more complex method of building a landscape composite.

Landscape composite

The problem faced in this example is one that you will encounter frequently with projects of this nature: how to rearrange and incorporate several elements or views into one coherent composition, without distorting the facts beyond recognition. In this case I wanted to capture a section of the Thames that included the Victorian Kew Railway Bridge, Oliver's Island, the Moorings, and the crack willow tree leaning in from the Strand on the Green. I couldn't get all of these aspects within one camera shot without photographing from a distance with a wide-angled lens, and without seriously compromising the overall composition. Taken as such, any photograph would result in reducing at least one of the elements to a barely visible speck on the horizon. So how is it possible to resolve this kind of problem and still create a dynamic and recognizable image? One way is to take reference images of all the relevant aspects you hope to include, with a view to piecing them together in a coherent fashion later on.

With the relevant photographs taken, you will have all the basic constituents for your image, and you can now start to arrange the composition. This phase can be carried out using computer software

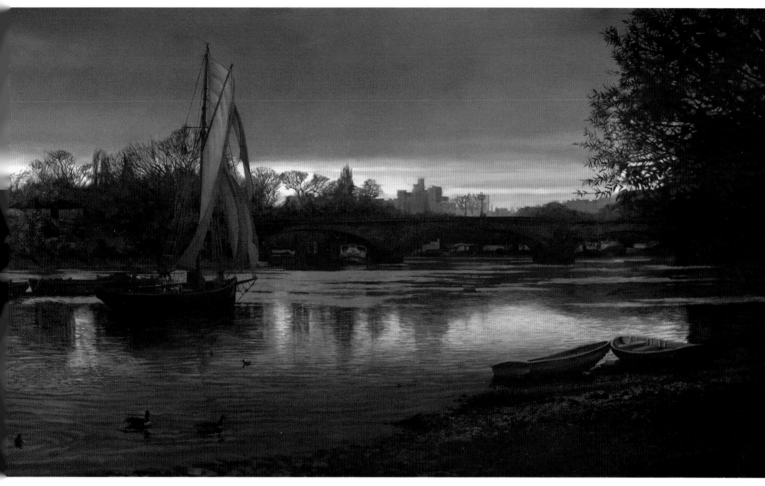

Here you can see the whole image, with the pilot cutter painted into the background forming a coherent composition. To do this successfully you must pay attention to the perspective and light source in all the elements being used and make sure there is at least some level of consonance between them. (Photo: Danny Boggi)

such as Photoshop, or you can compose all your elements together using tracing overlays as shown in the diagram. A fair amount of artistic license can be used here, within reason, without compromising the true nature of the scene. It should be noted that regardless of how well you have taken your reference images the separate views will never fit together perfectly with each other. But as you can see from the illustration it is possible to create a believable composition from disparate views and, with just a few tweaks and adjustments, the whole configuration can be rendered fairly consistent.

When building your composition and setting out to create your landscape mural, you should keep these kinds of questions in mind: what is it you wish

Continuity when taking your reference photographs

When taking photographs for this second method of working you will need to consider how the whole sequence of images are taken and aim to maintain consistency throughout in terms of height of the horizon line, view point, camera angle and sight-line. And you must always maintain, as best you can, consistency of light.

Tracings of basic constituents of Thames 2 #1, #2 and #3]
Having each element traced onto separate pieces of tracing
paper will allow you to piece them together and adjust until
a comprehensive image is formed. The elements won't fit
together perfectly but you should be able to correct any
shortfalls enough to create a coherent composite.

to express with your landscape? Which parts do you
want to emphasize? What is your motif, and why? Is it
the colour contrast or harmony? Is it tonal variation or
similarity? Is it the sweep of a road, track or river; the
rise and fall of hillsides; is it the horizontality of a flat
plain; or is it a dramatic sense of depth and scale? Look
carefully at your references, or any studies and notes
you may have been able to make, and decide which are
the most expressive aspects of your landscape. For me,
in both these examples, especially in the latter one,
it was the curve of the river, the light and the atmos-
phere. A verbatim copy taken from the photographs
would not have served my mural well and therefore I
had to employ a little artistic license, adjusting certain
features here and there. With your own compositions
you should work out the general rhythm and move-
ments of these lines and try them out in preliminary
works to see how successful they appear. Get your
main characteristics down first and then draw in
everything else, making note of the salient points of
your composition and deciding on what needs to be
dominant and what doesn't; which elements need to
be detailed and which elements needn't be.

Background, middle distance and foreground

Work out and understand the background, middle
distance and foreground detail. This does not mean
that every last detail needs describing, it just means
understanding the structure of your composition. It
doesn't necessarily mean the foreground has to be the
most detailed either. You may choose to have your
focus in the middle distance but either way, under-
stand how space and depth can be emphasized by
using this division of your depth of field and the
scale-ratios within them.

When tackling landscape murals, it is useful to
know how to create a sense of depth and scale in your
composition. Scale isn't just about the size of the wall
or canvas that you paint your mural on, it is also about
the relationship between objects within it, and it is

See how the composition appears quite flat, with no detail in the middle distance or foreground.

Here you can see how the composition is improved by adding more detail in front of the background landmass.

Adding detail to the middle distance, such as the boat in this example, will automatically create an engaging relationship between the viewer and the background details, adding a sense of space and depth to your compositions. In this instance it also creates a suggestion of narrative too.

By adding the foreground petals on the water's surface, the eye is drawn into the image and led through the composition, creating a strong sense of space and depth. The roses in the top corners bring the picture plane to our attention and help frame the image, creating yet more depth and context.

Here you can see how I painted the background hills in paler, greyer colours than the details nearer to us. This is what is referred to as aerial perspective and it is a very effective pictorial device when suggesting depth in a painting.

useful to know how these scale ratios can be used to draw the eye in and lead it through the composition. As the artist, you should think about ways of composing your images in a way that can influence the viewer's eye as it reads the image.

So think about these main areas of your landscape image: background, middle distance, and foreground. If you have objects positioned to suggest these main areas, and scaled in adequate proportion, you can create really strong illusions of depth. Look at the four diagrams shown on the previous page and see how the first landscape compares with the second, third and fourth. The illustrations increasingly include suggestions of middle distance and foreground. The difference these aspects immediately add, in terms of conjuring up a sense of scale and distance to the image, can clearly be seen.

Now, if you consider both murals depicting the Thames, you will see how I have used the principles as outlined above. In the first image I have the muddy bank of the river, the moored rowboats, the tree, and the coots taking up the part of the composition that designates the foreground. In the background you have the distant foliage and the architecture. The

bridge and the pilot cutter inhabit those areas we describe as the middle distance. In the second painting this is even more pronounced, with the silhouetted crack willow tree, along with the rowing boat and the young coots dominating the foreground. The use of line describing the water's edge is also put to use in this arrangement in that it leads the eye all the way to the distant view of Kew Railway Bridge and beyond. Note how these distant objects are painted with less detail and in cooler, paler colours to emphasize the aerial perspective.

Linear and aerial perspective

There are few straight lines in landscapes, and yet linear perspective still comes into play – as explained above in the use of line describing the water's edge, for example – and can be a very useful part of the composition if you wish to achieve a sense of depth. Aerial perspective is an important aspect of landscape painting too and can be used to great effect. Aerial perspective refers to the effects that atmosphere has on objects as they appear in the distance. The further the object the less saturated its colour will appear, and less visible its detail. Linear and aerial perspective is discussed in more detail in Chapter 3.

Making tonal drawings and colour studies prior to painting a mural is a healthy habit to adopt. These will give you a good indication as to the composition's strengths and weakness at a stage when it is easy to make any necessary adjustments.

Tonal drawings and colour studies

Once the general layout of the design has been established it is useful to make a tonal drawing, or a basic colour study, to see how the composition holds. This is not absolutely necessary but it does help determine the strengths and weaknesses of the composite before committing the image to your wall or canvas.

At this stage it is much easier for you to make decisions on which aspects work and which need to be adjusted or jettisoned – much easier than to change the course of direction halfway through painting the mural. Making the colour study, for me, was a worthwhile exercise as I was able to gauge more precisely the colour palette for the finished painting.

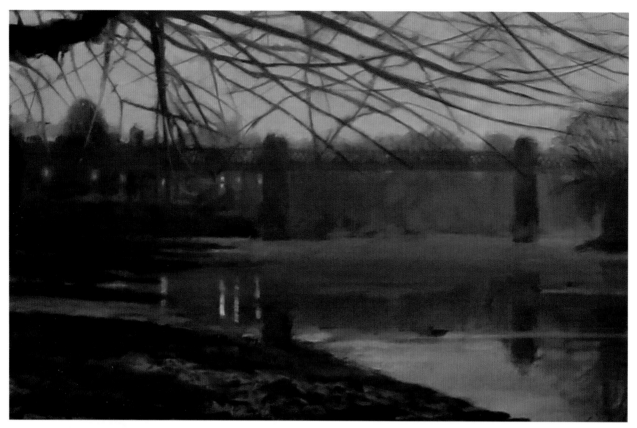

Note in this detail how little flecks of King's Blue and Naples Yellow add a charming accent to the monochromatic surroundings.

The painting stage

There is much to think about when making murals, as there is in making artwork in general, and much has been discussed here before arriving at the painting phase of the process. I think this is quite indicative of how much preparatory work should go into making murals. If you are to take only one thing away with you having read this book, it should be the importance that needs to be bestowed on these preliminary stages of mural work.

Around the time of being commissioned to paint the second example discussed here, I had been looking a lot at the work of John Atkinson Grimshaw and James Abbot McNeill Whistler, which ultimately influenced my course of direction in the painting. It really pays to look at the work of other artists and personally I think you can never do this enough. It can be very instructional to look and see how other artists have tackled and achieved similar issues. And when I say study the works of these great artists I mean you should, when and where possible, study them firsthand. Of course, it helps to see the works of others in reproduction and there is no harm in that, but there is no real substitute for experiencing artwork first-hand for a true sense of colour and paint application. No printed page or digital screen will match the colour, light and texture achieved by the actual pigments and the methods applied.

Limited palettes

Similar to the *The Pilot Cutter*, my intention for *Early Morning, Low Tide on the Thames* was to paint a fairly monochromatic canvas, primarily in cool colours, with a burst of warmth coming from the colours cast by the rising sun.

For this second mural, the underpainting was carried out using Raw Umber, and the overpainting was produced with a restricted palette as described in Chapter 2, mainly consisting of Cadmium Yellow pale, Cadmium Orange, Rose Madder and French Ultramarine, plus a little Flake White. To create the dark darks in the foreground I used Burnt Umber and Ultramarine, and for the streetlamps and reflected light in the distance I employed tiny flecks of Old Holland Naples Yellow deep, and Michael Harding King's Blue. For the best part of the canvas I relied on the restricted palette of the first four colours listed above, which is to all intents and purposes a variation on the artists' spectrum primaries; red, yellow and blue. A limited palette, or restricted palette, refers to a narrower range of colours than is usually considered the norm, and tends to yield more unified and harmonious effects. It really is amazing to discover the vast range of colours you can achieve with so few pigments at your disposal. I really recommend trying out restricted palettes so you can experience first hand how they can affect the overall harmony and balance within your compositions.

With this method of painting, where a limited number of pigments are used to create all the colours of the composition, each colour you mix can be seen as a 'distant cousin' to the next, in that they are in some way related even if only by a fraction. In using the same four basic ingredients throughout, when I added the warmer colours of the sunrise, the yellow and Cadmium Orange are seen as complementary to the violets and blues of the shaded areas, but the whole spectrum in-between contains varying degrees of all these colours. As such the whole composition automatically harmonizes.

Greys
Lazy mixing habits can be shaken up when using a limited palette, as it will help refine your sensibilities and you'll be surprised at the results that can be achieved. You can mix a range of interesting greys with this palette, using the complementary colours of Cadmium Orange and French Ultramarine, for example – and when I say 'interesting greys' I mean beautiful, sensitive greys that contain colour – not the dull, lifeless grey that is achieved mixing black with white. In using Cadmium Orange and French Ultramarine, I was able to draw out the colour from the greys made from this combination, pushing the mix more toward the warmer end of the spectrum using more Cadmium Orange, or to the cooler end of the spectrum using more Ultramarine and/or Rose Madder. Subtle yet very effective passages of painting can be achieved in this fashion.

Grey is an interesting colour, and is considered by many painters to be an artist's best friend. It should be remembered that there is no single grey colour. Ask most people to mix a grey and they will tend to make it from black and white. But once the fundamentals of colour theory are understood, and more is learned about the behaviour and versatility of colour, you will soon realize that there is a lot more to grey than initially thought. To the careful observer, grey comes in many subtle variations and you can make some really beautiful and appealing greys using complementary colours – blues and oranges, for example, or reds/greens, and violets/yellows. Mix lots of pigments together and you will achieve a muddy and turgid mid-grey, but keep your mixes simple, as with the Ultramarine and Cadmium Orange mentioned above, for example, with some white, and you will produce a range of greys that can be warm or cool depending on the ratio of orange to blue and vice versa. These colours can create beautiful effects in your work. The potential variety achievable from such minimal resources is truly astounding, and please don't just take my word for it, play around with mixing greys from complementary colours and see for yourself what can be achieved with a little perseverance and careful observation. Just refrain from using black!

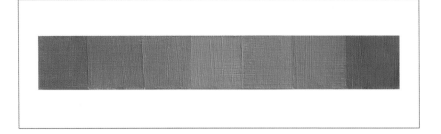

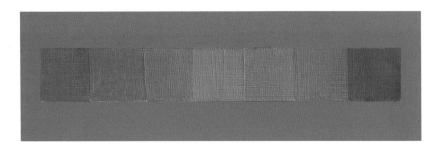

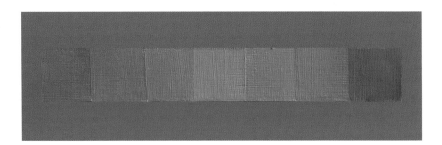

Here I have included a grey scale made from Cadmium Orange, Ultramarine Blue and Titanium White. I started off with a neutral mid-grey in the centre and worked toward the left, adding more orange and toward the right adding more Ultramarine. I've placed the same scale on different coloured backgrounds to show how the relatively neutral colours can appear differently depending on the adjacent tone and colour. Note for example how the orange aspect seems more potent when placed on the blue-grey background and vice versa.

This shot of my studio illustrates how the canvases are stretched directly onto the wall. On the canvas nearest to us you will notice that the landscape has been very loosely drawn out, using a digital projector, charcoal and thin washes of Raw Umber. (Photo: Danny Boggi)

Drawing out and blocking in

With your composition and colour palette sorted, the next step of the process is to draw out your mural, and any of the methods discussed in Chapter 4 can be used for this purpose. I used a digital projector to quickly mark out the basic outlines. With that done, you can then use a thin wash of Raw Umber to suggest the main areas of tonal variation. Raw Umber is a good colour for this process on a dark landscape image, as it is relatively neutral and balances well with the warm, mid-grey coloured ground. This technique is known as 'rubbing-in' and is discussed in more detail in the following chapter. When you have established the overall composition and general areas of tone and allowed them to dry, you can begin blocking in the local colour, using your photographs and/or sketches and colour studies as reference, painting broadly and loosely, approximating the colours to match each relevant area. Keep checking the overall composition as you work and don't get too absorbed in the small detail

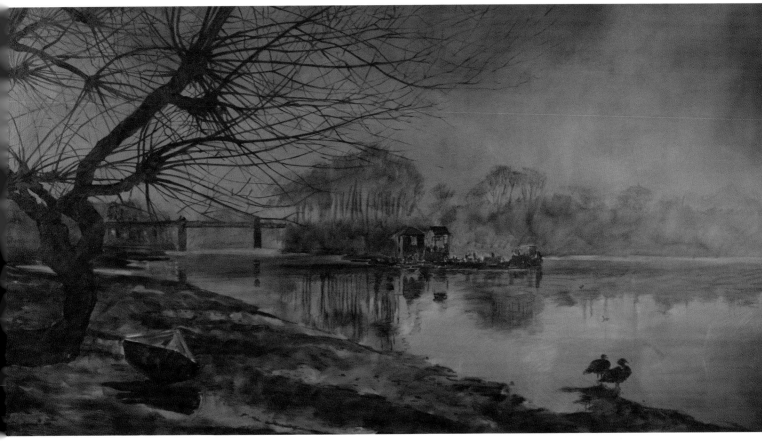

Once the landscape has been drawn out and fixed, a loose working of a Raw Umber mix thinned with white spirit or turpentine can be used to adumbrate the main tonal areas of the composition. Note how much information this simple veil of colour suggests, making it easier to assess the composition as a whole from very early on in the process.

at the cost of losing sight of the bigger picture. Judging your work as a whole throughout any stage of the production of a mural is vital. It is not advisable to work on a composition treating each area as a separate entity until you know the composition is sound.

Pitch

Get into the habit of thinking about the overall composition and get into the habit of thinking about the overall pitch of your painting too, as this will help create atmosphere. Is it a bright sunny day or a cold winter's morning for example? Do you want the image light or dark, clear and distinct, or made atmospheric in a hazy or soft-focus kind of way? The pitch or key of a painting should be considered in all works, but perhaps even more so in landscape. The overall balance and distribution of light and weight,

tone and colour, and line and mass, are vital if you want to create a harmonious composition with a credible atmosphere.

Harmony

Remember too that harmony isn't just about colour relationships; it is also about the harmonious relationships in nature such as the interdependence of dark and light, and vice versa. It is about the correlation between a hard and soft edge, a coarse or fine texture, or an opaque and translucent surface and all the areas in-between. Harmony is also about how the lines in your image relate to each other, transitioning from straight to curved, thick to thin, and rough to smooth. All these relationships, when used with consideration, will be extremely effective in adding interest and harmony to your composition.

In the two images here, originally created as samples for a huge mural project I was commissioned to paint for Annabel's Private Members' Club in Mayfair (designed by Martin Brudnizki Studio), you can see how each painting was made to depict a different season: the first one as autumn and the second one as spring.

Detail

Ask yourself about the relation of things in your chosen scene, and bear those thoughts in mind when depicting them in your mural. Remain truthful to what you originally observed in front of your chosen landscape; to what provided the inspiration; but that does not mean you have to translate every detail literally. For example, the crack willow tree in both paintings discussed in this chapter is not a verbatim translation of branch for branch, and twig for twig. It is an assimilation of the character of the tree, which aims to capture the general flow of branch growth, the distribution of weight and characteristic spring of the branches, and the general nature of leaf growth and cluster. For any foliage in the background, only a vague impression needs to be given. If loose, scumbled brush marks can make you think of distant foliage then why not use that same technique to suggest your trees in the background of your painting? If you paint all your leaves and branches in detail it will look very odd. That is not how we see, or how we experience these things in real life. The eye sees and the brain translates, and the brain is always filling in the blank spaces to make sense of what the eye sees – this is why we have a tendency to 'see' faces in clouds, or figures in flickering flames. For the best part, when looking at a landscape we perceive impressions, especially of the distant foliage. It is only when we focus or zoom in that we see the detail. If we tried to focus on everything at once it would be impossible, and that is why overly detailed work always looks odd and unnatural.

When painting landscape murals always bear in mind that the colour, light and atmosphere will be enough to provide the beauty you are after. The conjuring up of a sense of time or season will capture the magic, not the amount of detail or fact you include. This does not necessarily mean that less detail is less work, and therefore easy. It is quite difficult in fact to simplify a painting in a way where an economy of marks will appear to render sufficient detail. For this you will require a lot of concentration in both the analysis of your subject and the application of your mark making. To elaborate further, this doesn't mean every brushstroke has to be slow and intensely laborious, it just means your colour mixing and brush handling need to be considered throughout.

For an example of an economical use of marks you could do a lot worse than look at Jean-Baptiste-Camille Corot's *The Four Times of Day* in the National Gallery in London, to see how an accomplished artist can paint so loosely, and with such brevity, and yet express so much.

Painting skies and water

Light and luminosity will always add atmosphere to your landscape murals, so much attention should be given to how the scene is illuminated. Look carefully and try to get an understanding of how the light filters through the whole scene and aim to translate, for example, the subtle shifts of light as it falls away from the main source. Some great works are made with very subdued lighting, and they succeed because, although relatively dark, they manage to achieve a credible glow to them. The works of the aforementioned Atkinson Grimshaw and Whistler are a case in point. One way of achieving light, brilliancy and life in your paintings is by careful placement of your colour mixes, and the juxtaposition of complementaries. Placing a colour next to, or nearby, its complementary will increase the appearance of the colour's strength. This can be used to great effect when using cool shadows with warm light or vice versa. For example, you can see in the *Low Tide, Early Morning* painting how the orange/yellow hues of the sunrise play against the blue/violets of the rest of the composition, emphasizing the light and atmosphere.

Even though the colours are premixed, it is good to mix further on the palette as this helps to achieve subtle blends and softer transitions of colour.

This image shows the range of premixed colours I used to paint the sky in the *Early Morning, Low Tide on the Thames* painting. Note how the colours are mixed on top of a palette that is similar in colour and tone to the ground colour of the canvas. Note too that the colours mixed contain both warm and cool variants.

Painting clouds

If you need to paint clouds be careful; they are not so easy to paint well. Achieving the correct mass, direction and texture, in accordance with a specific atmosphere is not a simple process. A little knowledge of cloud formation and their relation to the atmosphere will be useful – just settling for generic cloud shapes will rarely cut it.

In landscape painting the sky would ordinarily be expected to be the brightest part of the composition, and it stands to reason that a lot of attention should be paid to how it is painted, bearing in mind the colours used and how they permeate and relate to the other areas of the painting. Paint your skies loosely, using large, flat brushes to lay in the colour. I tend to mix a range of colours in advance and work wet-into-wet, mixing these colours further on the palette before applying them to the canvas or wall. In the illustration you can see the range of colours that were premixed for this purpose. This will help you achieve subtle shifts of colour in your painting. The trick here is to maintain a lively blending of the colours as you work, and to steer clear of rendering the sky as one flat and lifeless tone. Use a variety of colours, both warm and cool, though don't mix too

many, and don't create a whole array of vastly different hues. Aim for around half a dozen colours within a narrow and subtle spectrum, and have a couple of accent colours too. Painting your skies with one flat colour will work to a point but will, more often than not, result in a soulless appearance.

When painting water, adopt a similar approach to painting skies: premix a range of colours and work wet-into-wet. An additional consideration when tackling the appearance of water is to employ direction to your brushstrokes that is sympathetic to the waves and ripples of the water in your scene. Without being too literal and translating each wave or ripple, it is possible to incorporate a suggestion of perspective into these strokes, making them smaller as they recede into the background.

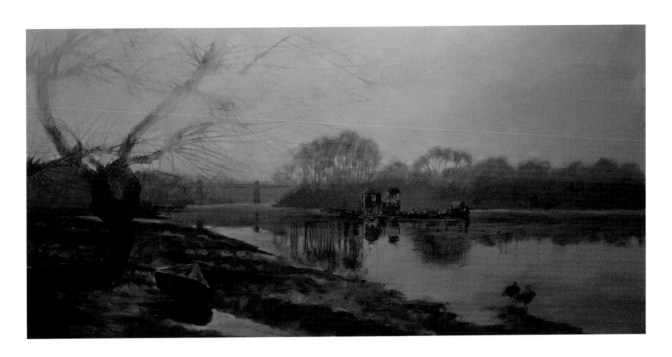

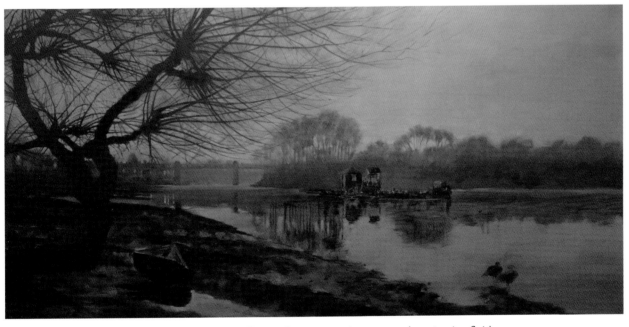

With large-scale murals it is not possible to paint all your elements wet-into-wet and create nice, fluid, painterly edges. Instead you may, for example, have to paint branches over your sky once it has dried and then cut back in with the sky colours. Focus on the negative shapes between the branches when doing this, and where the edges meet vary the quality of those edges, creating some well-defined lines, breaking some of them up in places and softening them in others. This will help prevent your details looking hard-edged and stuck on.

Treatment of edges

Where it is possible with easel painting to paint both your sky and landscape wet-into-wet, thus providing perfect conditions for painterly handling of the medium and achieving softer edges, this is not something that is usually achievable on a large-scale mural. One way around this problem is to paint the sky first, allow to dry, and then paint the landscape elements over it, varying the density of the paint and the brushstrokes so as to give the appearance that the elements are integrated within the space of your landscape and not just 'stuck on' like a separate layer. If all your edges are hard and well defined, all your features within the painting will have the appearance of being separate layers stuck onto the background. Where necessary you can cut back into the landscape, foliage and architecture: use the sky colours and focus on defining the negative spaces between the landmasses, trees, branches, twigs and so on, whilst aiming to achieve a variety of hard, soft and broken edges to them. If all your edges are treated in the same manner the painting will suffer. If all your edges are too soft the features may appear ill defined, too lost or out of focus. The trick is to maintain a good variety of edge that will help achieve more form and render the features as though existing in real, atmospheric space. To depict the finer branches and twigs you can apply thin mixes of colour, almost dry brushing in areas to leave no more than a trace.

Bear in mind the considerations made in this chapter and you will see immediate improvements in your work. As with all subjects in painting, however, there is a great deal to think about when creating landscapes, and sadly there are few short cuts, but with practice a lot of these aspects will become second nature.

Early Morning, Low Tide on the Thames. The considerations discussed above, when applied to your own work, will help you create landscapes of good quality.

Multi-figure compositions

This is a detail of a mural, *The Judgement of Paris*, painted for the Vineyard Hotel, Stockcross, that measures 6m in length by 3m in height. To create a multi-figure painting on this scale requires a lot of planning and attention to detail. (Photo: Simon Herrema)

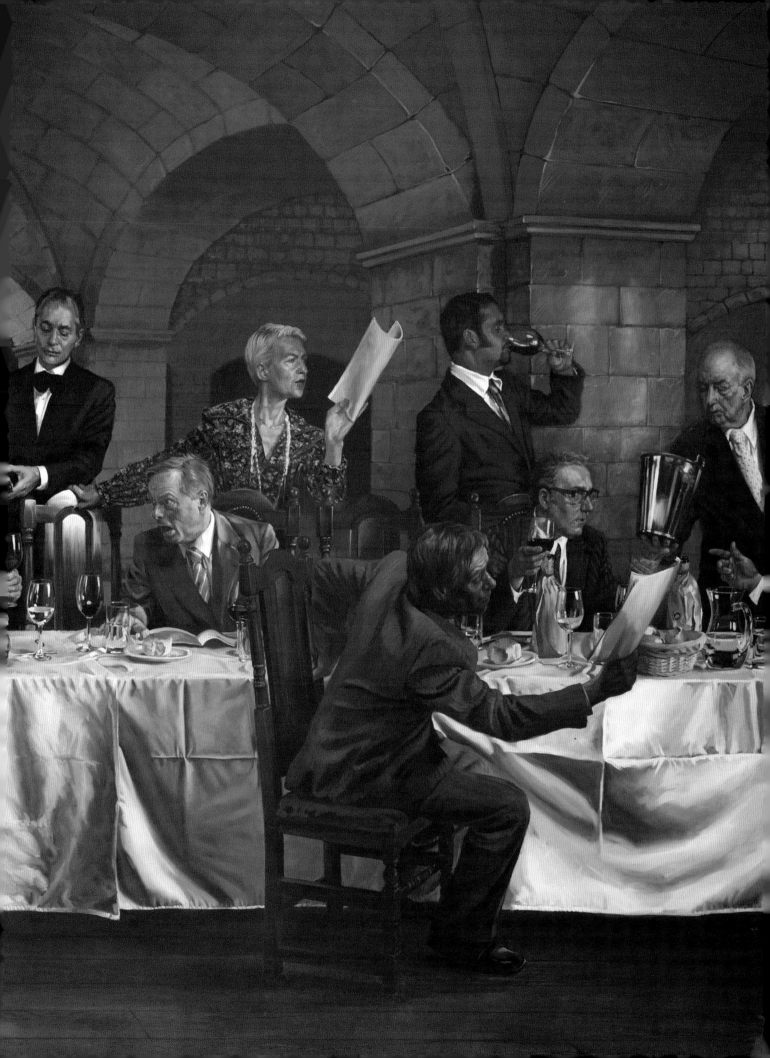

Multi-figure compositions

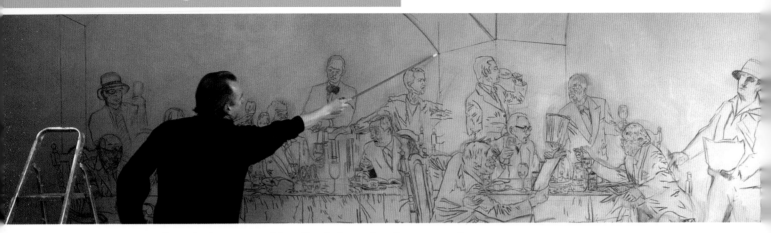

Using charcoal attached to a piece of dowelling helps to view the curves and perspective from a distance. This enables you to make a better judgement about the quality of your drawing as you are making it.

oosely related to the genre of painting known as the Conversation Piece, in that they portray groups of people, characters or types interacting with each other in an informal setting, the murals discussed in this chapter deal with multi-figure compositions. Here I want to illustrate ways of making such a painting: taking a look at the technical issues involved in the preliminary stages; showing you how to prepare the groundwork when building up a composition of this nature; and how best to equip yourself with the reference material that will ultimately inform the painting process. I will also take the opportunity to describe different aspects of the painting process from the underpainting to the finishing touches. The two murals considered here include a large narrative piece called *The Judgement of Paris* and a family portrait based on Caravaggio's *Calling of St Matthew*. The former will serve to illustrate how to put together the building blocks of a composition and acquire good-quality photographic references for the painting process, and the second will be used to highlight the painting methods employed.

The first, *The Judgement of Paris*, is a good example to start us off here as it gives me the opportunity to explain what will be expected of you should you be commissioned to design and paint something with historical significance. Needless to say, this kind of commission requires a different approach to a generic landscape or a group portrait such as the following example, and will make more demands of you in terms of your research and preparation.

If ever you are commissioned to depict a story like this that still continues to generate a lot of passion, it is difficult not to get caught up in such enthusiasm and you will want to throw yourself, heart and soul, into the project. Do so. Absorb all the facts, get an understanding of how the events of the story unfold and let your imagination be fired up. When this happens early on in the process it is a very good indicator that you are onto a winner. Regardless of the subject matter you should in any case aim to embrace it, immerse yourself, and develop a passion for it. Be prepared to do your homework and be rigorous when doing it too – research for any narrative that requires being

This mural was commissioned by Sir Peter Michael for his hotel – The Vineyard in Stockcross, Newbury – and needed to depict an actual event that took place in France on the 24 May 1976: a blind wine tasting competition organized by the renowned English wine connoisseur, Steven Spurrier. The competition was between French and Californian wines, the latter at that time being relatively unknown to the world of wines. The French sommeliers who took part in the contest were confident that the long-established superiority of French wine would assure them victory without difficulty, but much to their chagrin, and much to the making of a good story, on the day of contest, the underdogs won. The Californian wines were successful in each category, causing absolute outrage amongst the French and creating a huge scandal in the history of the wine world, putting New World wines fairly and squarely on the map.

'The Paris Tasting woke up the wine world in 1976 and it is still much talked about today. It will probably be on my gravestone.' – Steven Spurrier

'That day in Paris shocked the world and inspired winemakers from around the world to make better wines.' – George Taber

'Wine is the civilized man's social media, inside each bottle are many new friends.' – Sir Peter Michael

Spurrier) was also viewed and I was lucky enough to have many a conversation with Sir Peter Michael who, amongst numerous other things, is a connoisseur and maker of exceptional wine. There are various ways of carrying out your research but, whatever form it takes, be sure to make it a big part of the preliminary stages of a commission of this nature.

The preliminary sketches and presentation drawing

As with most projects, with your research underway, you start the process with small thumbnail sketches, aiming to get a basic understanding of the layout and how the narrative may play out in pictorial terms. You will also need to consider how the narrative will be read and interpreted by others. It is important to give the story some clarity, but don't lose sight of the fact that you are making a painting and not just an illustration. All the considerations that contribute to making a fine art easel painting – composition, rhythm, distribution of weight, light and shade, amongst other things – should also be considered here. Above all, your intuition and creative spirit should be allowed enough room to play their part too.

depicted with a fair degree of historical accuracy will always need to be thorough.

Go online and see what you can find out about the subject. Are there any topical books that can be read, or films that can be viewed, or anyone you can speak with about the topic? For *The Judgement of Paris* I was able to glean a fair amount of information online, and I bought and read a book on the subject by George Taber (*Judgment of Paris*, published by Scribner). Taber was the only journalist at the event, and was the man who cleverly coined the title for his article in *Time* magazine. A film called *Bottle Shock* (directed by Randall Miller, and starring Alan Rickman as Steven

The function of a thumbnail sketch is to document ideas rather than detail. Aim to maintain a fresh and spontaneous approach to your initial sketches.

Rough and ready cut and paste jobs on computer software can be an efficient way of rapidly cobbling together random elements to create a composition. You can then persevere with those that show promise or dismiss those that don't. The focus here is on acquiring specific body shapes and gestures; it is not about the specificity of dress or incidental detail.

The purpose of a presentation drawing is to give a clear idea to the client of your intentions in terms of composition and narrative. These will occasionally need to be in colour or accompanied by a colour palette or mood board.

Each character in this section was drawn from a different source but they have successfully been stitched together to make a coherent narrative.

Once you have a basic layout established you should get underway by adding weight to your ideas and start to assemble the reference material that will augment the design and add detail to the features and characters.

I tend to spend a fair amount of time just rifling through my art books, sketchbooks, and searching the internet for relevant pictures to inspire and develop my initial thoughts. In this case, I trawled through Google images of people at wine tastings, dinner parties and random photos of people making merry and generally getting inebriated. The latter, I imagine, is greatly frowned upon at wine tastings but I wanted to inject an element of humour into my painting. Wherever you obtain your references from at this stage, be prepared to adapt them as it's unlikely you will find that perfect something or someone in the exact pose, with the right lighting and correct perspective required for your composition. It is important to remember that these initial forages are just to find points of reference for your presentation drawing. All the fine-tuning regarding gestures and poses and the exact lighting you require will be achieved when you have models in front of you. Better ideas will invariably suggest themselves when you have real live models posing and interrelating on set during the photo shoot.

To give you an idea of how I arrived at my composition, using elements drafted in from random sources and forged into a coherent narrative, let us look at the left side, as seen in the illustration (opposite, bottom). Reading from left to right:

1. The first figure on the left is loosely based on a 1925 *Saturday Evening Post* illustration by Norman Rockwell; I used this character to depict Raymond Oliver, one of the French sommeliers judging the event, who would eventually be painted in the act of uncovering the winning bottle of Chateau Montelena and discovering that the Californian wine had won the competition. As seen in the final painting, this character is more animated and pivotal to the narrative with his expression of utter shock and horror amplified to the nth degree.

2. The second figure is a likeness of the client, Sir Peter Michael, taken from a given photograph.

3. The character third from left resembles Patricia Gallagher, another sommelier at the actual wine-tasting event. To portray this figure I appropriated the image from a John Singer Sargent painting, *Madame Gautreau Drinking a Toast* (1882–83), and whilst she has our attention I would like to illustrate how she developed from the original image to how she appears in my painting.

A charcoal drawing taken from Sargent's painting illustrates how the original pose was flipped horizontally to suit the direction the character faces in my composition, and was then given a makeover, adding a retro look from the 1970s.

Charcoal drawing copied from John Singer Sargent's painting *Madame Gautreau Drinking a Toast*.

The original pose in the Sargent painting has here been reversed to suit the orientation of my presentation drawing.

In the presentation drawing, the Madame Gautreau character was further enhanced with 1970s-style clothing to fit the bill.

Use your presentation drawing to inform the poses adopted by the models and pay attention to the details of each character and how they interact with each other.

Always aim to dress the set and your models as best you can for the photo shoot. If however something is lacking it can be added during the painting part of the process. Here you can see how Jess was given a 1970s-style haircut to add emphasis to the period. (Photo: Simon Herrema)

During the photo shoot I was able to dress the corresponding model, Jess, in 1970s-style clothing and had her adopt a similar pose. Later, in the painting process, I added a 1970s hairstyle for good measure.

4. This next figure, fourth from left, I sketched from my imagination.
5. Next along is a representation of Michel Dovaz, another participating sommelier at the actual event, taken from a Google search of wine-tasting images.

6. The last figure, Odette Khan, was based on a photograph of her that I had managed to acquire from the actual event, which required very little adjustment and slotted into the composition very easily.

I decided to include the above summary to give you an idea of how randomly the net can be cast when trawling for initial reference material in preparation for a presentation drawing. Although usually rewarding, this can be a time-consuming process so care needs to be taken not to spend too long on this

Occasionally it will be necessary to produce a revised presentation drawing so don't spend too much time on this stage of the production. I was able to take tracings of my main characters from drawing #1 and just redraw the background to make the required adjustments needed here.

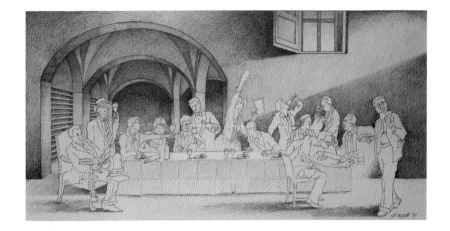

The second presentation still didn't quite cut it in terms of the background and a vaulted wine cellar was suggested. Here you can see a rough sketch taken from one of my sketchbooks, illustrating the first draft. It's a good idea to work out your ideas on a small scale before committing to the larger painting or drawing.

Note how the perspective has been worked out with the main vanishing point in the left half of the composition. This was to draw attention to the side of the table where the winning bottle is being unveiled and the shock and horror has set in. Look out for opportunities like this, were you can use the composition and perspective to influence how the narrative is interpreted.

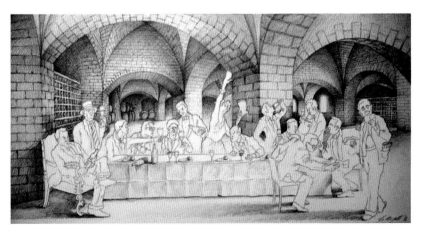

aspect. An alternative option, if you feel comfortable enough doing so, is to sketch all or some of your characters freehand from imagination. Whatever the case always bear in mind that the main objective of the presentation drawing is to get across to the client a strong and clear idea of the narrative and a general feel of the composition. It does not need to be a highly finished piece of artwork, or a full colour rendering of the proposed painting either. Depending on the client's expectations, all that may be required is a

Make use of what you can to act as props and costumes. The hire of these items is not cheap and it will soon add up. Improvise where you can; it will save you money.

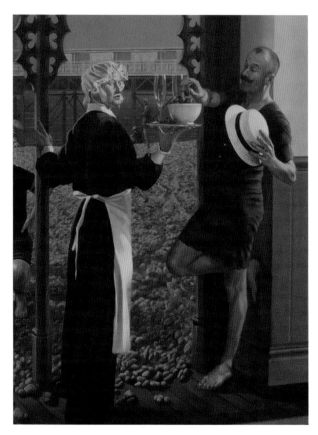

Anything that is not quite right in the photo shoot can, within reason, be adjusted in the painting phase. A cut-down and hand-painted onesie (seen in the illustration on the left) served perfectly well as an Edwardian swimsuit in the finished painting.

monochrome drawing or perhaps a drawing accompanied by a mood board, as discussed in Chapter 4, supplemented with an idea of the intended colour palette. In my experience, each client differs in terms of how much they need to see at this stage of the process. Some clients will be able to visualize from a simple sketch, yet some will want to see colour studies and close-up details, so it pays to adopt a degree of flexibility and not to put too much time and effort into the one presentation piece… just in case you are asked to make changes or provide other variations.

The photo shoot

In my experience using my own photography as reference material for my murals is usually by far the best and most efficient way forward. In doing this you can obtain great reference for pretty much anything you will need, and for something as complex as a multi-figure composition good reference material is essential. This is especially the case in relation to any period-specific narratives where the use of costumes and props is required.

Costumes, props and models

I occasionally hire my costumes and props from the National Theatre and fancy dress shops, but this can put a huge strain on the budget. Often you will find that you just don't have the time, the budget, or the resources to acquire all the exact costumes and props needed for the ideal photo shoot, so get used to the idea of making do with what is at hand. Learn how to fabricate stuff and, rather than be put off by this, give rein to your creative skills; it can be great fun to improvise in the time of need.

Remember too that the camera *can* lie, so don't be afraid to fake things if necessary: if a prop or costume is refusing to stay in its position, clamp it, pin it, tape it, or get someone to hold it in place. If you don't have the exact prop you need, use something in its place that is roughly the same size or shape; the real thing can be painted in later. As long as everything looks good through the lens it's OK – anything outside of that field of vision is irrelevant. There could be assistants holding up props, keeping the back of someone's dress pinned together, or desperately trying to prevent the scenery from collapsing; it doesn't matter. Just fabricate what needs to be fabricated and adjust the finer points in the painting stage of the production.

Lights, camera and action

For any photography you plan to take, you will need to think about the lighting. And whatever form of lighting you use will need to be consistent throughout. If you are using indoor artificial lighting you will more than likely need to black out any external light sources from windows or doors. This can be achieved by using blackout cloth, curtains or blinds, which will help you to control the lighting conditions more effectively. If you don't have access to any lights you may wish to use daylight, but remember that natural lighting conditions will be continually changing, and if the photo session is to take a couple of hours or more you will end up with a discrepancy between your first and last batch of images. This is not impossible to correct to some degree by digital manipulation or during the painting process, but it does mean adding to the project a difficulty that could have easily been avoided. If you can get all the conditions correct and working for you at this stage, do so.

In advance of any photography session, make sure you know your composition well, and familiarize yourself with the kind of poses, groupings and interactions that are needed for the narrative – your models will be looking to you for some direction. Some fortuitous poses or interactions will no doubt suggest themselves

The illustrations above are from the photo shoot for *The Judgement of Paris*. I've included these here in black and white to give them a dated appearance and to give you an idea of how well these photo sessions can turn out with enough planning. To me they look fairly authentic and not a million miles away from photographs I downloaded of the historical event. This led me to believe that, even at this stage, we were on to a winner. Whatever your subject, aim for an authentic feel as best you can. (Photos: John Biggins)

Interior lighting and theatricality

Interior artificial lighting can be used to great influence, adding dramatic *chiaroscuro* to your work – 'chiaroscuro' is the term given to the effects of strongly contrasting light and shade. This aspect I like as it suits the theatrical nature of my work, but it may not suit your own paintings. I tend to work with a pair of inexpensive Interfit studio lights that have soft-box attachments, giving me the option to create more diffuse lighting, and making them versatile enough for most situations.

during the photographing process, and these may well be improvements on the original idea, but don't leave it all down to chance; you will not have the time.

Work out the desired distances from the camera to the area of activity that you are hoping to capture, and think about the camera settings that will give you the best results. If you don't know enough about optics and taking photographs, you should take the time to learn at least the fundamentals of good camera practice. For now, a basic checklist may prove useful for any shoots you may be about to orchestrate, and following these basic considerations will put you in good stead:

1. Make sure your lighting is set up properly in a way that best suits your subject and will be consistent throughout the shoot.
2. Use a tripod and make sure that your camera is set at a height and distance that corresponds with the horizon and general perspective of your design.
3. Avoid using a wide-angled lens. A focal length of 42–50mm on a full-frame DSLR or 35mm film SLR, or the equivalent, will give you the best results, though you may struggle to get everything in if photographing in a small space. In such circumstances you will need to adjust the focal length, and compromises will

need to be made. Whatever the case, aim to be observant and avoid distortion in your images.

4. Check your white balance setting – auto white balance will be OK to a point, but for better results you will need to set the white balance to suit the lighting you are using – sunlight, overcast sky, shade or artificial lighting for example.
5. If the lighting is low you may wish to increase the ISO setting on your camera but be careful as that will also increase the danger of having digital noise in your images – digital noise is the name given to the grainy distortion that can be seen in poorly lit photographs.
6. If you have access to a manual or semi-automatic camera, play around with different settings for the aperture and shutter speed to see how possible it is to achieve a rich and painterly quality to your images when lit and photographed correctly. In low lighting, a slow shutter speed on my camera with a tripod and a cable release tends to work well for me for most studio shoots.
7. A digital camera set to automatic, with auto-focus, will take photos without you having to pay too much attention to the technical aspects. No doubt some of the photographs taken in this fashion will be reasonable, but remember that much better results are achieved when you can control the different elements manually.
8. Use a cable release (also known as a remote shutter release) to minimize camera shake.

Continuity

Use the presentation drawing to guide you when setting up your props and positioning your models and, when everything is good to go, take a few shots of the overview for general continuity purposes, so you always have a reference to revert back to. The overview photograph can be done on another camera, if you

You can see here how easily all my short-listed elements from the photo shoot could be cut out and pasted together to make a really coherent composition. Keep an eye on the continuity when taking your photographs and it will greatly benefit the end product.

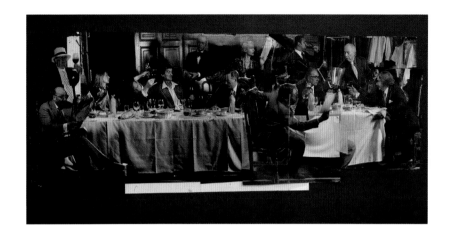

have one to hand, or even the camera on your smartphone and used as a reference when you resume the scene after any breaks in the shoot. It is also strongly advised to allow for breaks. This will give the cast ample time to stretch their legs, and for you to quickly review your images and check on progress as you go.

Keep checking for continuity: costumes, poses, light. If the theme of your mural is an historical period piece then you also need to check for things like watches, and the style of any jewellery or glasses. If you plan on taking several independent images that will eventually be stitched together in some form of montage then you also really need to be aware of how problematic making photomontages can become when continuity of the lens setting or camera angle has been neglected. Independently your photographs may look great, but any distortions will really show up when you try to bring all these elements together into a grouped composite.

With a photo shoot as complex as *The Judgement of Paris* you can easily clock up hundreds and hundreds of images, so make sure you have enough battery life in your camera (and a spare battery just in case), and enough space on your photo card.

There is a lot to think about when orchestrating a photo shoot for a complex composition like this, but the beauty of working in this manner is that it gives you excellent references: not only for the shape and texture of things but also for the overall lighting conditions; genuine cast shadows; and any incidental reflected light between interacting figures and objects.

Editing

After the shoot, scan through all the images and make a shortlist of all the best shots of each element, and from that make a more refined shortlist until you are left with only a handful of options for each character. Look for the best qualities in each image: focus, good contrast, absence of unwanted colour-cast, and continuity of lighting for example. You can then use this refined shortlist to inform the painting of each of the characters in your narrative. In the illustration above you can see how I was able to make a composite image from a selection of each character from the final shortlist. This is not a necessary part of the process but it shows how well your images can be brought together in a composite when taken with due care and attention.

Working to this level of specificity obviously requires a lot of work and a realistic budget, but the hard work put in at this stage pays off in the long run. Be sure to plan ahead and calculate these considerations at the outset of the project: determine what you want from it, and what is ultimately achievable, and account for it. Always tailor the work to the budget that you are working with, and always cut the cloth accordingly. Put simply, a photo shoot is well worth persevering with, and I strongly suggest you do it wherever and whenever possible, but you will need to be realistic as regards time and money.

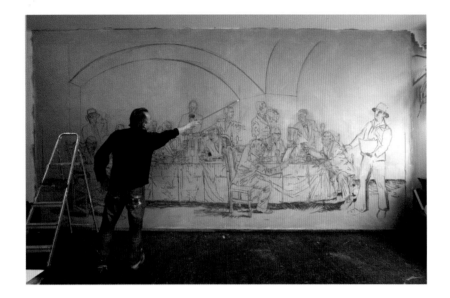

I've included a couple of images of the work in progress to give you an idea of how things look in the studio during the making of one of these murals. Here you can see the drawing being carried out with the use of a bit of charcoal on the end of a length of dowelling. Drawing out in this fashion helps to achieve the curves of the architecture, but it also allows you to be able to draw whilst standing at a distance from the canvas, enabling you to get an overview of the composition and perspective as you work.

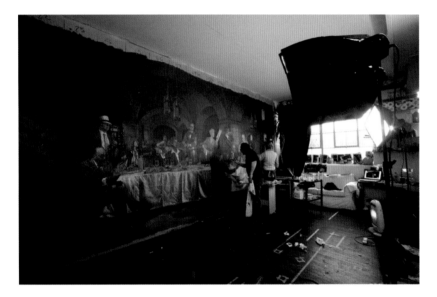

In this second image of the work in progress you can see me being assisted by Sydna Younson, a great artist who has helped me on many projects. Something this large would take forever if you tried to tackle this single handedly. You will often require assistance and it helps to know other artists with mural experience.

Drawing up and painting your mural

By this stage your composition should be looking quite strong and coherent; you can now start thinking about transferring your composition, and putting paint onto the wall or canvas. Any of the methods of gridding, squaring up or projection as discussed in Chapter 4 can be employed to draw out your composition, but with an image of this scale and complexity, projecting the whole image onto the blank surface will be the most efficient route to take.

Painting processes

Leaving *The Judgement of Paris* at the drawn out stage, and directing our focus onto the second example of this chapter, I can now give you an idea of some of the painting processes used.

There are similarities with both this second painting and the previous example: they both use a strong sense of light and shade; they both contain figures grouped around a table in a variety of poses, gestures and expressions; and they both include the element of characters in costume. A big difference, however, is that the former is a design of my own invention and the latter is pretty much a wholesale appropriation

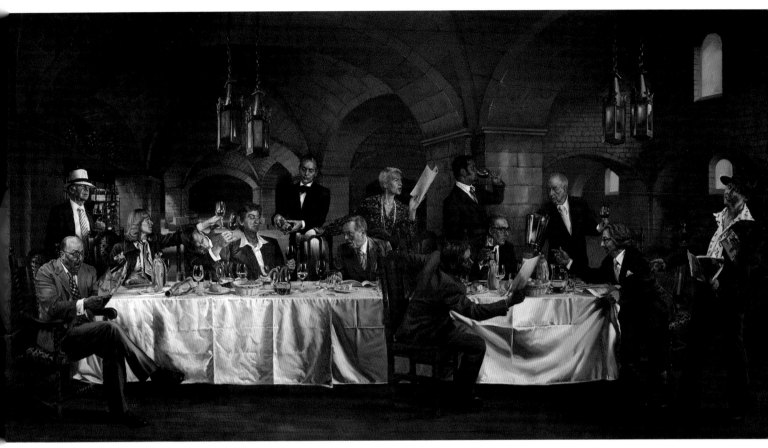

Here you can see the whole canvas completed. Always document your work with good-quality images as they will come in useful for your own record, your own website and IG account, and also to show prospective clients. (Photo: Simon Herrema)

of the original Caravaggio painting in the Contarelli Chapel, in the church of the French congregation, San Luigi dei Francesi in Rome. This understandably reduced the amount of work required in the design part of the process, but the staging and shooting of the photography session and the drawing out and painting process were the same. And it is to the painting processes that we now turn our attention.

Coloured ground

Before starting any of your paintings you should consider the nature of the intended image, and the key or pitch of the finished work. You should then plan your approach and proceed accordingly. The first step is to apply a suitable ground colour to the wall or canvas. I tend to use a neutral, mid-greyish colour that has a bias toward Raw Umber and has a

resemblance to the colour of artists' linen, but you may wish to use a completely different colour depending on your tastes or on your subject matter. For example, you could opt for a warm colour if you are to paint a scene that is illuminated by a summer's afternoon sunlight, or a cooler, bluish colour if the image is to be a night scene. For something dark and theatrical, as the painting discussed here, the grey/umber was perfect. A bonus of working on a ground colour this dark is that it essentially provides you with a mid-tone to work upon, and means that any painting done on top of it can be handled more loosely without fear of any white ground grinning through the brushstrokes.

Drawing out

The next step of the process is to transfer the design onto the prepared surface, marking out the image

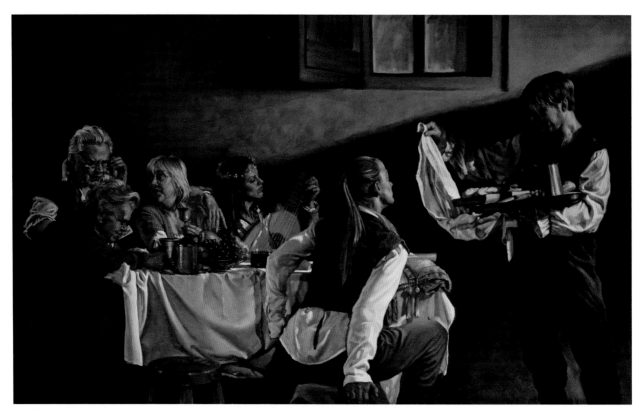

Using well-known images to inform your own compositions can be fun, but make sure that you are painting an interpretation of the original and not aiming to make a copy. (Photo: Danny Boggi)

using charcoal. Draw out the whole of your image, but don't worry about including too much detail, you just need the basic information. When you have finished marking out your image, take a piece of cotton cloth or soft rag, and gently flog the drawing by flicking the cloth against the surface of your work to remove any heavy residue of charcoal. This will leave a visible but faint trace of charcoal that will not corrupt any colour that is placed on top of it. Be careful not to flick your rag too enthusiastically or it will render your guidelines too faint to work from.

With that done, fix the drawing with a light spray of fixative. Some artists use hairspray for this practice but I always opt for the fixative spray. Some hairsprays may well contain similar ingredients but the concentration and even dispersion from the art spray fixative is usually preferable. The latter is also free from added conditioning ingredients and fragrance. Before spraying, make sure the room is well ventilated.

Rubbing-in and blocking-out

With the image drawn out and fixed, paint can now be introduced to the canvas, beginning with the 'rubbing-in' stage – a technique sometimes referred to as *frotté*. This involves scrubbing in a thin layer of colour, diluted with thinner; this process can be carried out by either using a relatively full palette, as in the Indian arch image illustrated in Chapter 6, or monochromatically as in the example shown here. In this case the mix was made primarily with Raw Umber, and modified in places with the addition of a little Ivory Black, thinned with a small amount of turpentine substitute. Apply the thin mix using a big brush and lay in your colour loosely and rapidly, suggesting the main areas of the design; working up the whole image and establishing the tonal values of the composition. As you can see in the illustration, the result is a monochromatic version of the intended painting. Paint in the broad areas of shadow and use a rag to rub back into the paint to achieve a variety of tonal

Draw out the basic shapes and areas of light and dark but keep your lines simple and not too fussy.

This is a great way of getting a lot of information down onto your wall or canvas in a very short space of time. It also encourages a looser handling of the paint, which is a good thing with these large images.

differences. More pressure applied to the rag will expose more of the canvas, and thus the lighter the tone will appear. Leave the canvas bare in those places that are to indicate highlights. Using this method over the whole painting allows you to establish a tonal composition into which you can then paint the deeper shadows of the image using the Raw Umber with the addition of more Ivory Black – this stage requires only a suggestion, so be careful not to be too heavy handed!

Once the rubbed-in underpainting is dry you can focus on individual elements and begin the second phase of painting, adding and strengthening colours and modifying tones and accents where necessary. And it is here that we will therefore look at a couple of details of the composition to understand the painting processes used to build up individual areas.

Working with an underpainting to establish tonal compositions is a great way of working as it provides you with a lot of information in a very short space of time, with all your relative values in place, against which you can judge your subsequent brushstrokes. For the rendering of certain details it is possible to work over the underpainting using nothing more than a coloured key-tone glaze into which you can then paint, wet-into-wet, the relative darks and the highlights – this method was used to paint the dark coloured fabrics in this painting, and is illustrated in more detail below.

Step 1

Step 2

Step 3

Painting with transparent glazes

Step 1 When drawing up, mark out the general shape of things and delineate the main areas of shadow and light. Keep these simple and don't overcomplicate the canvas with too many lines.

Step 2 The next step is to lay-in your monochromatic glaze and rub out the lighter areas with a rag as detailed above. You now have all your relative tones worked out.

Step 3 Mix a coloured glaze using the relevant pigments to achieve a general key-tone and a glaze medium – for the glaze medium I used one part linseed oil and one part turpentine to one part 'Liquin' – and lay in the tinted glaze, over the tonal layer. (Liquin is a medium that can be added to oil paints to speed up the drying rate. It is a useful medium but has its

Step 4

Step 5

limitations and can cause cracking in the paint film if too much is used.) In the example shown you can see how this was done, blocking in the red, green and purple fabrics. When applying colour in this fashion, the glazes work best when they are made with transparent or semi-transparent pigments. They should be thin enough so as to be able to see the tonal relations of the underpainting, but strong enough to assert themselves as a colour.

Step 4 With the key colours in place you can then paint, wet-into-wet, the darker darks and the lighter lights. Adding these tonal extremities, which should be made slightly thicker with less glaze medium and more pigment, will help strengthen the suggestion of form.

Step 5 Once the above method has been carried out you can then add any warm or cool accents of reflected light that can be detected in the shaded areas – notice how on the man's tunic I have added a cool backlight on the left-hand side.

This is a very quick way of working and can be incredibly efficient when painting certain areas, but it will not work for all the areas in your painting. The white fabrics in this painting, for instance, required a more opaque handling of the paint, and therefore required more work. I will discuss the white fabrics a little later on, but for now let us consider the flesh tones within this section of the canvas.

Mixing batches of colour in advance can really help ease the difficulties of painting. If your colours are mixed beforehand, relatively faithfully, it gives you one less thing to think about when you start the painting process.

Flesh tones

When working on complex details, like the flesh tones in portraiture, and especially when several figures are to be painted in the same scene, it is often useful to mix up a batch of colours in advance and have them laid out on your palette. These should provide you with the general colours for blocking in the main shapes and can be adjusted and fine-tuned as you progress. When mixing the flesh tones you will need to study the area you are about to paint and simplify it, breaking it down into broad planes and simple facets. Use these simplified planes of colour and tone to inform your colour mixes.

As the tonal values have already been established in the previous layer you really need to be thinking about colour here, and be thinking about cool and warm mixes too. Just as could be seen in the cool reflected light on the left side of the man's tunic, there will also be a cool reflected light here on similarly angled planes – note, for example, the man's hair and temple on the left-hand side of his head. Take your time and look carefully for these subtle reflected lights as they really help create the illusion of form.

I tend to mix most of my flesh tones using Flake White, Yellow Ochre, Vermillion (hue) and Ivory Black. Again this is just a variation of the basic red, yellow and blue of the artists' spectrum. The Ivory Black in this instance is the blue substitute – see how it is possible to make greens mixing the Ivory Black with the Yellow Ochre, and note how the Ivory Black, mixed with Vermillion and Flake White, will produce purple. Using these colours to mix your flesh tones may take some practice, but it really is worth persevering with. Other colours can be introduced to this palette such a Rose Madder, to achieve a purer pink of a flushed cheek, or King's Blue to achieve a cool reflected light. Colours can be added as and when needed but the four colours listed above essentially comprise the flesh tone palette that I use.

Lay in these general flesh tones to suggest the corresponding planes, and maintain a simplified construction of the head in broad strokes (as seen in Step 3). Once you have the basic structure of the head you can then look closer and begin defining the smaller details. It is best to add these later details whilst the blocking-in layer is still wet – this will enable you to achieve softer transitions of colour and tone, and will provide you with more control over the blending. Painting wet-into-wet like this is a must if you want to achieve a painterly and less graphic quality to your artwork.

When painting people and portraits, aim to keep your details soft. Paint the features of the face as though they are a part of the head and not just stuck on. Keep sharp edges and clear-cut lines to a minimum. You want the hairline of your portraits, for instance, to look as though the hair runs into or, more accurately, grows out of the temples and forehead and does not appear to sit on it like a wig. Note how the hair in the painting blends into the temples of each head and doesn't just stop abruptly, creating a harsh line. Where the head meets the background it is not a sharp outline all the way around the profile – there are different qualities and degrees of hardness and softness to the edge. Pay attention to these small details and your painting will improve massively.

Painting with opaque colours

The white fabrics required a different approach and had to be painted in a more opaque fashion than the red and green fabrics discussed earlier. This enabled me to block out the mid-tone ground colour and to achieve the fresh, crisp and clean look of the material, such as the shirt worn by Hannah – the figure right of centre, with her back towards us.

Looking closely at the reference photographs, it is possible to break down the white fabrics into simple planes of colour: mid-tone, shade, highlight, warm and cool tones. These mixed batches of colour are then laid out on a palette. The colours I mixed can be seen in the illustration. These colours were achieved using a reduced version of the comprehensive palette discussed in Chapter 2.

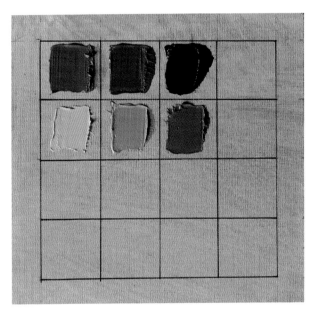

These are the colours that were premixed for the white fabrics that constitute the basic colours. The stronger highlights and reflected lights were mixed and applied in the second phase of painting. Note how the colours are mixed on a coloured base to replicate the ground colour.

Premixing colours

When faced with painting a few areas of similarity such as the white fabrics in this image, including a tablecloth and several tunics, it is always worthwhile mixing your colours in advance. When premixing your colours in this fashion it can take quite some time to achieve the exact hues needed, but in the long run it will always make life so much easier. There is already a lot to think about when painting, in terms of light, shade, form and texture and so forth. Taking the mixing of colours out of that equation as you paint is no bad thing. Painting can take a lot of hard work, and a lot of concentration, so there is little sense in making things harder for yourself.

Colours for the whites

- Flake White (hue)
- Yellow Ochre
- Vermillion (hue)
- Alizarin Crimson
- French Ultramarine

Again this is basically the red, yellow and blue of the artists' spectrum, with the addition of both a warm and a cool red.

Step 1 Again we start with the charcoal drawing – when working with light colours on top of a charcoal drawing it is even more essential to make sure the charcoal is fixed and kept to a minimum, with as little residue left on the canvas as possible, allowing the paint to cover it sufficiently.

Step 1

Step 2

Step 2 Note that, in areas of this section of canvas, the monochromatic rubbed-in layer has been omitted altogether or completely removed with the rag. These areas indicate where the lighter areas of the finished painting will be. Where the highlights will need to be at their brightest (and most opaque, in order to obliterate the ground colour), I added an underpainted highlight using a mix of Titanium White with a small amount of Yellow Ochre.

Step 3 Your first aim in this stage of the process, as with the heads, is to create the general form using simplified versions of each plane and defining it with its own colour. Again note the cool and the warm variations and the planes that are influenced by reflected light, such as the areas of the left-hand side sleeve that reflect the red of the waistcoat.

Work broadly at this stage; keep it simple, and don't fuss; the detail will come later. When laying in the initial shapes and colours try to respond quickly and intuitively, working from your first impressions

– this will encourage a loose, energetic and painterly feel to your work.

Step 4 Once you have the general form blocked in, as described in the previous step, you can then add your accents, filling in detail and strengthening areas of darkest darks and lightest lights. Try to work wet-into-wet where you can. Most murals, however, will be too big to be able to paint the whole thing in this fashion, so only bite off what you can chew, and plan your painting so that each session involves working only on an area that can be achieved in the same sitting. It is best to work wet-into-wet at this stage if you want fluidity in your work.

By employing the painting methods outlined above and moving from one area of the mural to the next, the whole image can be worked up to a satisfactory level. Using the same methods, and applying them to each relevant area of your own compositions, it will be possible for you to complete most mural projects

Step 3

Step 4

you are ever likely to work on. Although this involves working on sections at a time you should never lose sight of the bigger picture and you will need to keep stepping back to view the whole composition. It is important to constantly monitor the process of any mural you work on as an overall image and not as a series of separate details. Take a step away from the canvas from time to time and scan the entire composition, or view your murals through a looking glass to see them from a different perspective. Alternatively, take photographs and look at your mural on the much smaller scale of your computer monitor or smartphone screen. Any one of these exercises will feel like seeing the composition afresh and will ultimately help you judge progress.

With all the tips, tricks, information and advice I have given throughout this book you will be ready to attempt your own murals and have the confidence to be adventurous in both your compositional design and your approach. It is fair to say that you may possibly

not make giant strides immediately, but I guarantee that if you have read the book and followed the examples and instructions, you will see improvements straight away. And, with practice, the rest will fall into place. Whatever the case, always take great care and have pride in the work you make. Ultimately, if you want the best from your work, then give it your best. Presentation is key, and you should always want any work you produce, that has your name on it, to be your best form of advertisement.

I'd like to end by saying thank you for buying and reading this book. Writing it has not been an easy task, and trying to fit it into a really busy work schedule has meant it has taken a lot longer than originally envisaged. I would also like to add balance to that sentence, however, by saying that I have enjoyed putting the book together and learned a lot in doing so. Knowing that there will be some of you who will read this, learn from it, apply some of the advice to your own practice and enjoy doing so too makes all the hard work I've put into the book seem more than worthwhile.

Further reading

Albers, J., *Interaction of Colour* (Yale University, 2006)

Ames, J., *Colour Theory Made Easy* (Watson-Guptill, 1996)

Aristides, J., *Classical Painting Atelier* (Watson-Guptill, 2008)

Burleigh Parkhurst, J., *The Painter in Oil* (Dover, 2006)

Cole, Rex Vicat, *Perspective for Artists* (Dover, 1976)

Feibusch, H., *Mural Painting* (Adam and Charles Black, 1946)

Gottsegen, M.D., *The Painter's Handbook* (Watson-Guptill, 2006)

Gurney, J., *Colour and Light* (Andrews McMeel, 2010)

Hemenway, P., *The Secret Code* (Evergreen GmbH, Köln 2008)

Hockney, D., *Secret Knowledge* (Thames and Hudson, 2006)

Mayer, R., *The Artist's Handbook of Materials and Techniques* (Faber and Faber, 1982)

Speed, H., *The Practice and Science of Drawing* (Dover, 1972)

Speed, H., *Oil Painting Techniques and Materials* (Dover, 1987)

Storey, G.A., *Theory and Practice of Perspective* (Dover, 2006)

Contributors

Annabel's, Berkeley Square, Mayfair, London W1J 5AT
annabels.co.uk

John Biggins, Aerta Creative
aerta.co.uk

Danny Boggi, Marchio Design and Photography
marchiodesign.co.uk

Martin Brudnizki Design Studio
mbds.com

Cameron House, Loch Lomond, Inverbeg, Alexandria G83 8QZ
cameronhouse.co.uk

Lisa Crewe Read
Interior designer
lisa.crewe.read@btinternet.com

Jonathan Coulthard
myfathersheart.com

Fragrant Nature, Fort Kochi, Kochi, Kerala, India
fragrantnature.com

Fragrant Nature, Munnar, Kerala, India
fragrantnature.com

Simon Herrema
simonherremaphotography.com

Maria Hipwell and Ruth MacDonald, Parkbench
aparkbench.co.uk

Hotel du Vin, Brighton, Ship Street, Brighton BN1 1AD
hotelduvin.com

Hotel du Vin, Harrogate, Prospect Place, Harrogate HG1 1LB
hotelduvin.com

Hotel du Vin, Newcastle, Allan House, City Road, Newcastle upon Tyne NE1 2BE
hotelduvin.com

Hotel du Vin, Poole, Thames Street, Poole BH15 1JN
hotelduvin.com

Hotel du Vin, Tunbridge Wells, Crescent Road, Tunbridge Wells TN1 2LY
hotelduvin.com

Euroart Studios
euroart.co.uk

The Pilot, 56 Wellesley Road, Chiswick, London W4 4BZ
www.pilot-chiswick.co.uk/

The Vineyard, Stockcross, Newbury RG20 8JU
the-vineyard.co.uk

Index